The Art of the Autochrome

The *Art* of the

Autochrome

THE BIRTH OF COLOR PHOTOGRAPHY

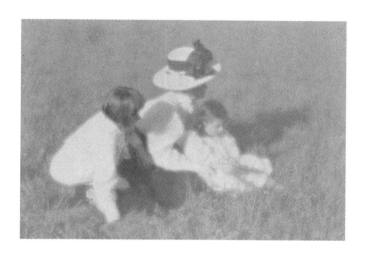

John Wood

Foreword by Merry A. Foresta

UNIVERSITY OF IOWA PRESS Ψ IOWA CITY

University of
Iowa Press,
Iowa City 52242

Copyright © 1993
by John Wood

Printed in
Singapore

Design by
Richard Hendel

Printed on acid-free paper

97 96 95 94 93 C 5 4 3 2 1

Library of Congress Cataloging-in-Publication Data

Wood, John, 1947–
 The art of the autochrome: the birth of color photography/by John Wood;
foreword by Merry A. Foresta.
 p. cm.
 Includes bibliographical references.
 ISBN 0-87745-413-2 (cloth: acid-free paper)
 1. Color photography—Autochrome process. I. Title.
TR510.W64 1993
778.6′5—dc20 92-38758
 CIP

TO CAROL

for the past twenty years

Lawes and Jenkins guard thy rest

Dolmetsch ever be thy guest

Canto LXXXI

Contents

Foreword *by Merry A. Foresta*

Recently there seems to have been a great interest in those moments when photographic art and science played each other as equals and as partners. Perhaps it is the dawning of the Computer Age which prompts us to reflect on other moments of visionary awakening. Certainly the worldwide celebration of photography's sesquicentennial several years ago alerted us to those areas that were overlooked the first time we rushed through the writing of a history of photography. Or simply, we look for something new clothed in the certainty promised by something old. Yet, in going back, we are often most captivated by those photographic images that defy the categories of history or style we had first laid out for them—those images that, while inventions or solutions to technical problems, still lift themselves into the less explainable, more evocative category of art.

For most of the twentieth century, color has been one of photography's greatest problems. How to get it right; what to do with it once it was. All his life even the inventive Man Ray was frustrated by photographic color. In the surreal 1930s when he wanted to create a billboard-size photograph of a pair of lipstick-red lips floating in the sky above Paris he could find no photographic process true enough or intense enough. His famous *L'heure de l'Observatoire—Les Amoureux*, though based on a photograph of his lover's lips, was reluctantly rendered with canvas and paint.

Late in his career, however, he found a solution. He simply sandwiched a positive color transparency between two pieces of glass and wrapped the whole package in a dark case. It glowed. When well lighted, he said, it was the only live color he had ever achieved. The technique was nothing more than a "poor man's autochrome." Yet his color portraits of women wrapped in gay fabric headdresses look intensely out at the viewer. They possess an extraordinary immediacy and

evoke a haunting Renaissance-like nobility and *richesse*. At the time, so few people knew what an autochrome was, Man Ray's "secret" process was safe.

John Wood's reconsideration of the autochrome enlarges the story we think we all know. The retelling has its own biases. From a century's distance art is more of one piece than we originally noted. The longer view is also wider: from a distance we notice that artists, writers, inventors, and scientists often shared the same convictions about the times in which they lived. We also note that there are reasons the story was originally told in certain ways. We take into account the implications of a sitter's pose or dress, or the mysterious meaning conveyed by an assembly of vegetables on a plate or knickknacks on a table.

How much this story adds to our consideration of photography can be answered simply by the list of autochrome photographers whose important work we did not know. Photographers who, in John Wood's words, worked "far from the power centers of photography" and escaped until now our limited attention. In all our feminist searches how did we overlook such independent and intriguing women photographers as Mademoiselle Mespoulet and Mademoiselle Mignon? Could we really have been so nearsighted as to have missed the talent and innovation of Leonid Andreyev or Wladimir Nikilaiovich Schohin merely because they worked in faraway Russia or Finland? How could we have failed to notice anything as grand as Albert Kahn's "Archives de la Planète"?

How too could we have missed the larger picture that contemporary accounts give us of the autochrome and its practitioners? As John Wood rightly points out, Germany's eminent international position in pre–World War I photography should not be forgotten. Have we really been so naive as to take as gospel the story that Stieglitz published in *Camera Work*? The enticing autochrome lures us to look again.

The autochrome's history gives us a different bridge to travel between prewar and postwar photography. The contexts of the turn-of-the-century art Secessions, the Symbolist movement, the visionary leaders Alfred Stieglitz, Gustav Klimt, and Franz von Stuck figure in the appearance and demise of the autochrome. In turn, offering a new way of seeing rather than a new subject matter, the autochrome itself made a contribution. A vision drawn from the things of daily life was critical to an age so dependent on science and so in love with symbols. To point out the autochrome's effect on painting during this period may be John Wood's most important reflection on the history of both mediums.

Tranquil and detached, the images rendered in autochrome suggest a reflective quality of life that we now treasure. That moment—the autochrome era—didn't last long. No matter their beauty, the fast-paced twentieth century had little room for the development of unique, difficult-

to-display objects. It was given up by those who saw the requirements of photographic art moving toward a more inclusive, dynamic, urban-oriented medium. The colors of authenticity—black and white—took precedence. Even Stieglitz came to refer to his photographs as "snap-shots." Now, in a media-saturated world, these rarest of photographic images take on a new reading. They give us access once again to a necessary language of symbol and information whose meaning we had forgotten.

Curator of Photography
National Museum of American Art
Smithsonian Institution

Preface

The autochrome is the rarest, the most fragile, and, to a great many eyes, the most beautiful of photographic processes. It represents not just the birth of color photography but color as luminous as the camera ever caught it. Its rarity and fragility are entwined because the autochrome image lies between two thin sheets of glass, one of which serves as a protective cover for the dark, delicate emulsion on the other. Autochromes are difficult to display and cannot be seen other than by projection. Over the years thousands of these first color photographs have been ruined because of breakage, humidity and damp, the lack of cover glasses, and so forth.

Though most major turn-of-the-century photographers who were part of the Photo-Secession made autochromes, the number that have survived is tragically small. Photohistorian Kevin Donovan, who in the 1980s carried out an extensive census of autochromes by photographers of the Secession, calls them "the rarest of the rare material of the Photo-Secession . . . all one of a kind pieces." In the first months of the autochrome's existence Eduard Steichen autochromed in France, England, Germany, and Italy and exposed hundreds of plates, and then continued autochroming for years, but this work was nearly all lost to World War I. The forty Steichen autochromes that have survived did so only because they were in other people's hands. Some 225 of Heinrich Kühn's autochromes are extant, the majority of which are still in the possession of the Kühn family. One hundred by Alvin Langdon Coburn survive, but these also include a great many commissioned by Charles Freer of paintings in his collection. There are fifty-five by Karl Struss, thirty-five by George Seeley, twenty-five by Alfred Stieglitz, sixteen by Clarence White, seven by Frank Eugene, six by Paul Haviland, and six by Adolf de Meyer. These figures take on greater meaning by comparison when we realize that as rare as Stieglitz's photographs on paper are, there are fourteen "major"

collections of them, the largest of which contains nearly four times as many photographs by Stieglitz as the extant autochromes of *all* the Photo-Secessionists combined!

The Photo-Secessionists tend to overshadow the other great photographic artists of the period, but they, too, have suffered a similar, and often worse, fate. I am aware of a single autochrome by Imogen Cunningham and am unaware of any extant examples by Rudolph Dührkoop, Francis Benjamin Johnston, and B. F. Falk, though surely stray examples do exist somewhere. The importance of the Secessionists did at least determine that some of their work would find its way into institutional collections. Arnold Genthe's work has also been fairly well preserved. There are 384 of his plates in the Library of Congress. The Société Française de Photographie, the Royal Photographic Society, the National Geographic Society, and the Musée Albert Kahn all have significant holdings of several major autochromists.

This book attempts to present a selection of the finest surviving examples of the autochrome process: portraiture and still lifes by the major artists of the Photo-Secession; scenes from around the world by those equally artistic professional photographers who worked for the National Geographic Society and for Albert Kahn, a wealthy Parisian banker who decided he would have the entire world autochromed; and a variety of studies, portraits, and views by brilliant, forgotten amateurs, including a famous Russian novelist, an Austrian scientist, an English aristocrat, a French gentleman, and an American gift shop owner; and finally even a few great works by completely unknown photographers.

I have provided a bibliography on the autochrome that I hope will be of use to scholars for both historical and technical purposes. Though comprehensive, it is not complete. I excluded, for example, later articles that repeated material from earlier ones but added nothing new. In each case, these were practical articles on the use of developers and intensifiers or what to do about blue stains or how to figure exposure times. I will be happy to supply this supplemental bibliography, which contains over a hundred citations, to anyone requesting it who writes me in care of the publisher. Even with over one hundred items cut, the more casual reader may find the bibliography tedious; however, if useful research is to be done in this area of photographic history and one is to understand the autochrome's impact on its time, the journals that were contemporary with it need to be studied. I know of nothing that gives one a better overview of the autochrome than to read, year by year, the Colour Photography Supplements to the *British Journal of Photography*. Those early articles are the best source for gaining an accurate historical perspective on the process. Some of their authors were the great, now-forgotten autochromists or in many cases the leading figures of

the photo-scientific community of their time. A few of their names have made it into the standard histories, but many have not. Fortunately, Louis Walton Sipley's *Photography's Great Inventors* (Philadelphia: American Museum of Photography, 1965) provides information on several of the bibliography's lesser known authors: Abney, Albert, Didier, Goerz, Goldschmidt, Huebl, Husník, Jones, Koenig, Kruegener, Luther, Miethe, Namias, Piper, Szczepanik, Valenta, Vidal, Wall, and Watkins—all of whom made important contributions to the history of photography and did pioneering work in the study of the autochrome.

Of the many individuals who helped me in this work, I am particularly grateful to Gray Little, a fine professional photographer, who made over a third of the transparencies. He worked long and hard to get the colors as exact as possible, exposed many rolls of film simply to study how effectively autochrome color could be picked up by modern films, shot several of the autochromes as many as six times to get the colors correct, and even built a special light box for use in others. I am also immensely indebted to Joanne Durand, the Inter-Library Loan Librarian at my university. For years she has been finding the impossible-to-find for me, and I owe her a great deal. Fred Pajerski, who knows the literature of photography as few people in the world do, has over the years led me to a great many obscure but important works that I cannot imagine having ever encountered without his help. His contribution to this book has been of immense importance. April Howard Goebel of the National Geographic Society's Illustrations Library was wonderfully helpful in many ways, and I owe her special thanks for all she did for me. Jeanne Verhlust of the International Museum of Photography at George Eastman House; Debbie Ireland of the Royal Photographic Society; Pirjo Porkka, curator of the Photographic Museum of Finland; and Sven Hirn, the distinguished Finnish photographic historian, also deserve my special thanks for all their generous help.

Peter Palmquist shared with me several early articles on the autochrome that he had collected. Volkmar Wentzel, former director of the National Geographic Society's Photographic Archives, was also helpful. I am grateful to Kevin Donovan for generously sharing information he had collected on the whereabouts of particular autochromes. Alan Johanson and Joachim Bonnemaison were both kind enough to share examples from their collections. Pamela Roberts of the Royal Photographic Society, Will Stapp and Joe Strubble of Eastman House, Barbara McCandless of the Amon Carter Museum, Verna Curtis of the Library of Congress, Martine Ruby and Jean-Paul Gandolfo of the Musée Albert Kahn, Richard Davies of the Leeds Russian Institute, Elizabeth Clarke of Thames & Hudson, Professor Peter Bunnell of the Princeton Art Museum, James F. Carr, Hans P. Kraus, Jr., Charles Isaacs, Laurie Platt Winfrey, Mrs. Joanna T. Steichen, and Frau Lotte

Schönitzer-Kühn were all gracious and helpful to me in many ways, and I am very appreciative. I owe a great deal to the fine staff of the University of Iowa Press, who have helped me greatly on three books now. And, of course, as always I am deeply indebted to my gifted editor and friend Charles East and to the administration of McNeese for supporting my scholarly activity and providing me the release time from my teaching in order to pursue it.

When from a long-distant past nothing subsists, after the people are dead, after the things are broken and scattered, still alone, more fragile, more unsubstantial, the smell and taste of things remain poised a long time—faithful, persistent, vital—like souls amid the ruins waiting and hoping for their moment, souls in whose tiny, almost impalpable drop of essence beats unfalteringly the vast structure of recollection.

MARCEL PROUST

Structures of Recollection

The inherent beauty of the autochrome makes it difficult at times to distinguish an autochrome that is merely beautiful from one that is a conscious work of art. It is as if the process itself had the power to confer aesthetic legitimacy on whatever was being photographed. There are, of course, exceptions, but most autochromes do seem to have the authority of art—that power to rivet our gaze and demand of our eyes that they return again and again, and the power to reward those returns with pleasure and insight. It would be interesting to know what it is about the autochrome that so compels, to know why that soft glow of suggestion, of elegant ladies in lace, of nuance and the Monet-haze of dream is so emotionally gripping, so psychologically arresting. It is as if they possess a kind of Proustian power, an ability to waken in us and summon up our collective memory—or possibly a collective mythology—of a gentler past, a world before Sarajevo and the Somme, and long, long before Dachau and Auschwitz, Dresden and Hiroshima, before all the horrors of a world less suffused in such idyllic light. And it is an idyllic light, a lying light, because it gives the world a softness, a near shimmering, it has never known. Autochromes are the color of dreams, and the real world was always harsher than they would suggest it was, but that is not the way we would have it. A nostalgic longing for a yesterday sweeter than today is as old as literature and art and probably as old as humanity. The autochrome is our visual madeleine, and it lets us slip back to where we never were and to what never was.

The process was invented by Auguste and Louis Lumière, who presented it to the French Academy of Sciences on May 30, 1904. The Lumières are also famous for having invented the

cinématographe, which they patented early in 1895, and for having made the first motion picture, *La sortie des usines Lumière*, which was first shown in December of that year. Auguste Lumière also invented nonadhering bandages and a vaccine against typhoid fever, and his work on blood and lymphatic fluids resulted in many new medicines. Though 1895 is overshadowed by their invention of the motion picture camera, the brothers published their first work on color photography that year in two apparently forgotten articles, which were followed by still two more articles in 1898 and 1901, all prior to their actual 1904 success.[1]

By June 10, 1907, when the Lumières first demonstrated the autochrome process at the Photo-Club de Paris, they not only had perfected it but had also gone into commercial manufacture of the plates and were able to make them available to photographers, who now had what they had dreamed of for generations, true color photography. One contemporary report declared, "It is the greatest discovery in photography since Daguerre made his first daguerreotype. It is to photography what the discovery of perpetual motion would be to mechanics."[2] There were, of course, other color processes prior to the autochrome, but they were more cumbersome, less practical, and less faithful.

Even in the days of the daguerreotype, scientists and photographers were working on the problem of color and possibility of color photography. In 1848 Edmond Becquerel coated daguerreotype plates with silver chloride and found he could reproduce the spectral colors, and in the 1850s both C. F. A. Niépce de St. Victor in France and Levi Hill in the United States produced color daguerreotypes; however, Niépce de St. Victor's colors were not stable, which was also probably Hill's problem, along with a general murkiness, if we are to judge from contemporary "Hillotypes." Hill's reputation as one of the early inventors of color photography has suffered because he seems to have doctored his plates with traditional photographic tinting powders to make a stronger case for his discovery.

In 1855 James Clerk Maxwell's paper "Experiments in Colour" suggested making separation negatives "on a preparation equally sensitive to rays of every color" through the use of red, green, and violet glass. The positives would then be projected from three magic lanterns and superimposed on a screen. By 1861 he was able to demonstrate this; however, in 1861 there were no panchromatic emulsions, and what was available was primarily sensitive to the blue and ultraviolet end of the spectrum. Louis Ducos du Hauron and Charles Cros both continued working within the context of Maxwell's additive color and by the late 1860s had described several methods of combining three separate transparencies to produce a single color photograph, but again the results were cumbersome. In 1891 Gabriel Lippmann announced the discovery of his interference method of color photography, which produced a plate that looked like a negative in transmitted light but turned into

a brilliant, iridescent positive when viewed by reflected light. A film of mercury in contact with the silver bromide and albumen reflected the light which passed through the emulsion back on itself to produce the wave effect one sees in soap bubbles and oil slicks, which are also produced by interference. Though Lippmann received the 1908 Nobel for his work in color photography, the process was not commercially successful. There was, in fact, no practical color process until the Lumières and the autochrome. Their process yielded the colors of nature with a single exposure and without any printing or transfer.[3] It was simple and it was beautiful, and that was what the world had been waiting for.

The Lumières' technique was based on the fundamentals of color theory. All colors are modifications of the colors of the spectrum. There are three primary colors—blue, yellow, and red—which in mixtures will produce all the other colors. Each color has as its opposite a corresponding complement, which when placed beside it makes it more brilliant. The complement of blue, for example, is orange; the complement of yellow is violet; and the complement of red is green. A given color will absorb the rays of its complement, but the rays of other colors will pass through it. The actual theoretical argument behind the Lumières' experiments was best explained by them in their May 30 presentation, "A New Method for the Production of Photographs in Colours," which was immediately published in the London *Photographic Journal*, the *British Journal of Photography*, *Camera Craft* in the United States, the *Comptes rendus* of the Académie des sciences, the *Bulletin* of the Société française de photographie, in the Vienna *Photographische Korrespondenz*, and Munich's *Photographische Kunst*. They wrote:

> If a collection of microscopic elements, of a transparent nature and coloured respectively red-orange, green, and violet, be spread on the surface of a glass plate in the form of a single thin coating, it will be found, if the intensities of coloration of these elements and their number be correct, that the coating so made does not appear coloured when examined by transmitted light, and also that this coating absorbs a fraction only of the light transmitted. The light rays in passing through the elementary screens, orange, green, and violet reconstruct white light, if the number of surfaces or elementary screens for each colour, and the depth of coloration of these, are in accordance with the relative proportions of those found in white light. This thin trichromatic coating being formed is then coated with a sensitive panchromatic emulsion. If the plate so prepared is submitted to the action of a coloured image, taking the precaution to expose through the back of the plate, the luminous rays pass through the elementary screens, and undergo, according to their colour and the screens they encounter a variable

absorption before having any influence on the sensitive coating. By this means a colour selection should be effected which acts on the microscopic elements and which makes it possible to obtain, after development and fixing, coloured images in which the tones are complementary to those of the original. . . . It follows that with a negative showing complementary colours obtained in this way it is possible to obtain with plates prepared in this manner positive prints which will be complementary to the negatives, *i.e.*, reproducing the colours of the original.[4]

Understanding these principles, the Lumières pulverized transparent potato starch, passed it through a sieve to isolate grains between ten and fifteen thousandths of a millimeter in diameter,[5] and then dyed these microscopic grains red-orange, green, and violet, the complements of the primaries. They were mixed and evenly spread over a glass plate coated with a sticky varnish. An extremely fine powder of charcoal dust was next spread over the plate to fill in any gaps in the color grains. This coating was then carefully flattened under a high pressure rolling process, thereby producing a tricolored mosaic screen. On every square inch of that screen were about four million individual microscopic screens of red-orange, green, and violet. The plate was then varnished and covered with a panchromatic silver bromide emulsion. In the camera the lens was fitted with a special yellow filter and the plate was reversed so that the rays from the lens would strike the colored grains before striking the film. The starch grains acted as tiny filters, absorbing their complements and letting the other colors pass through.

For example, in photographing an apple the red rays emanating from it would be absorbed by the complementary green grains on the plate and would not strike the film; however, the violet and orange grains would allow the rays to pass through, and the film beneath them would be acted upon. In development the silver bromide under the orange and violet would be reduced, and the green grains would appear because the silver under them was still intact. The developed autochrome plate then would be a negative of the complementary colors, and the apple would appear green. The image would be reversed and a second development would then turn the negative to a positive, and the apple would appear red.

The explanation of the process might make it appear complicated; however, photographers found it extraordinarily simple. Steichen commented that "in reality, as a process, it is—or can be made—simpler than any other photographic process in use to-day, and for facility and speed in the getting of results, it stands on a par with that delightful old process, the tintype."[6] The plate was put into an ordinary camera, exposed twenty times longer than usual, and developed in a way any photographer could learn in a few minutes. The procedure produced a single glass print, a kind of

photographic monotype. There was no traditional negative and so additional prints could not be made. This black glass print was also impossible to see without being held to the light, projected, or placed in a special viewer called a diascope that allowed light to strike the plate and cast an image onto a mirror. But what one saw when light did strike! There is such a luminosity and lushness of color that paintings like Seurat's *Baignade* and the *Grande Jatte* easily come to mind. Of course, as one critic has remarked, "An autochrome is not a Seurat; but it is impossible not to think of [him] when looking at certain plates."[7]

The Impressionists had realized that the eye mixes color better than the hand. Mixing any two of the three primary colors will produce the complementary; however, those primaries need not be mixed, merely juxtaposed, as the Impressionists had realized, to produce the complement, and this juxtaposition, interestingly enough, is more luminous, more intense than it would have been had the two colors been mixed. Scientist and color theorist Ogden Rood even demonstrated in his *Modern Chromatics* (1879) that the effects of optical synthesis were seventy-one times more luminous than those created by the actual mixing of two colors on a palette. Seurat sought to yoke nineteenth-century science and color theory to the Impressionists' vision and codify it into a technique, a technique whereby the virtuosity of the artist's hand gave way to the virtuosity of his eye, a technique of juxtaposing myriad dots of color with one another in order to create luminous vibrations. And this, though somewhat by accident, was the technique of the autochrome.

Though a five-by-seven-inch autochrome plate was made up of 140 million points of color, those individual grains, unlike the dots of a pointillist painting, could not be seen. However, an even distribution of the dyed grains was not possible, and there was always a one in three chance that grains of the same color would be adjacent. In a square inch, therefore, there is a probability that there would be thirty-three dots of twelve or more grains, and these dots *were* visible to the naked eye! They produced by accident that very effect the Impressionists sought to achieve, a shimmering world of suggestions, of haze and nuance, a world of juxtaposed colors blended and mixed by the eye itself.

Though the paintings of Seurat and his circle, as well as the works of those Impressionists who had gone before him, were clearly radical works, clearly part of an advance guard, the autochrome, other than from a technological standpoint, seems hardly radical at all in the context of what we think of as modernism. The imagery one sees in autochromes is lush and lyrical, but still part of another, stranger, more short-lived and ill-fated avant-garde.

Photography is occasionally seen as taking its direction from painting, but the advance guard in all the arts is usually equally attuned to those impulses and movements which art reflects. Most

people would agree that from about 1890, the year George Davison exhibited his revolutionary *Onion Field*, photography began to take on a distinctly different look. By 1910, the year Alvin Langdon Coburn published his collection of photographs entitled *New York*, photography was beginning to assume another new and distinct look, a look that in only six years would dominate the two final issues of Stieglitz's *Camera Work*. Coburn's innovation was his imagery. The curve gave way to the line; the organic suppleness of the natural world gave way to the abstract geometry of the industrial; in other words, the nineteenth century gave way to the twentieth.

Coburn's *Flip-flap* of 1908, his *Williamsburg Bridge* of 1909, though included in *New York* and several of the other *New York* photographs, *Station Roofs, Pittsburgh* and *Pittsburgh Smoke Stacks*, both also of 1910, are all works of radical abstraction, works that demanded leaps of the eye for them to be appreciated. Today they seem easy, beautiful things, nostalgic even, but the angularity of *Flip-flap* so offended the conservative eye of Frederick Evans that he complained to Stieglitz, "I am curious to hear if *you* will tolerate the vulgarity of his *Flip-flap*."[8] Of course, what it was that Coburn was seeing—and he was probably the first photographer to see it—was the look of a new age.[9] It is particularly interesting that these striking and radical works of photography were originating at the same time, 1908, that critic Louis Vauxcelles, who two years earlier had coined the name for the *fauves*, remarked that Braque was reducing "everything, landscape and figures and houses, to geometric patterns, to cubes." In other words, the shock of modernism, which is primarily the shock of its imagery, entered photography at about the same time it entered painting, and the twenty years between Davison's *Onion Field* and Coburn's *New York* in several ways parallel the twenty or so years between Cezanne's *Bay from l'Estaque*, 1886, or his *Still Life with Basket of Apples*, 1890–94, and Picasso's *Demoiselles d'Avignon*, 1907, and Braque's *Houses at l'Estaque*, 1908.

Though the autochrome was a product of these very days and one can sense the time's fever in it, it, as I suggested, was part of a different current of modernism. If one peruses a collection of photographs from this period, in the midst of radical works of the type I have been describing, one also sees work representative of what then was an equally powerful impulse in world literature and art—Symbolism.[10] Though not easy to define because there was no single style, Symbolism did produce a body of work with certain attitudes in common, the principal ones being that the meaning of the Symbolist work is not resident in its outward appearance; that meaning, which is always serious, never comic, is deep, mystical, or psychological and often all three; and that though the uninitiated may not grasp the imagery or understand what is being suggested, the symbols themselves are universal and easily understood if one would only unshackle the mind and unbind the

heart and/or libido. Odilon Redon, one of Symbolism's leading painters, wrote, "Everything happens by tamely surrendering to the unconscious."[11] Though many critics were hostile to the imagery of Symbolism and found it obscure and often bizarre, to the Symbolists it was a path to truth and clarity. "Symbols are the points at which ideas become concrete," wrote Emile Gallé, perhaps Symbolism's greatest decorative artist, an artist who was said to have turned "the dream into glass."[12] Symbolism and particularly its brilliant late manifestation in the Viennese Secession, however, were cut short by war. To a post-1918 world the metaphors and images of Symbolism seemed irrelevant. "The age demanded an image / Of its accelerated grimace," as Ezra Pound put it. Symbolist introspection looked and sounded like so much mumbo jumbo after the realism of the Somme. And the dreamlike Secessionist seductions of *Wien, Stadt meiner Träume* simply vanished with empire or grotesqued themselves into nightmares—or operettas.

At the source of Symbolism was an adoration of feminine beauty. The Symbolist depiction of the female ran from the strangely disquieting to the *femme fatale*, the outright vampire, while its later Secessionist depiction moved between inviting eroticism and glorified motherhood. It is this later image of the female that one primarily sees in turn-of-the-century art photography. However, both visions shared a common ground, a similar surface of easy attractiveness, a look based on male stereotypes of male fear and male desire. It is as if Symbolism were a male art form, and it is an intriguing psycho-aesthetic question to wonder why there were no female Symbolist painters, especially considering there are major female artists on either side of Symbolism—Cassatt, Morisot, and Beaux as Impressionists and Münter, Kollwitz, and Modersohn-Becker as Expressionists, to name only a few.[13] Whatever the reason for female disdain of such imagery, it was anathema to all serious artists after 1918.[14] To a man in constant fear for his life, a man who had for months been trapped in the mud and excrement of the trenches, who had watched the blasted, unretrievable bodies of his comrades rot a few feet in front of his eyes, images of Eve or Circe, Venus or the Madonna were all irrelevancies, all part of a blasted world. The very frame of reference in which such a woman might be depicted was now illusory—or just so much rubble. The Great War demythified woman and caused her to shed both her horror and her beatitude.

In the 1960s our modernistic eye, perhaps having wearied of abstract expressionism, began to turn back to those very images which a half century before we had dismissed as irrelevant. At first the proliferation of books on Art Nouveau seemed an aspect of that larger sixties anachronistic spirit that in its loftiest manifestations wished to reinvent the world between 1848 and 1914, to refight the battles of 1848 in such a way that no 1914 would ever again be possible, and in its more realistic manifestations simply inspired a variety of nostalgic, amusing, and sometimes sensible anachro-

nisms from Peter Max and leaded glass to breast-feeding and natural food. At today's distance from the sixties, we can see that its retrograde, possibly naive, late postromantic, perhaps unrealistic spirit actually did alter at least the surface of Western society. The cloak of nostalgia is still present; the anachronisms took hold. Those who see the sixties as a failed idealistic experiment do so only because their attention is focused on its grandest ideal, the refighting of 1848. But even that, too, took hold, though with certain modifications, in the Green Movement. The world before 1914 could not be reinvented, but even bleaker prospects than the present lay before us if we did not commit ourselves with all our passion and idealism to the planet itself.

In the wake of Cubism and following the Great War, we seemed to forget how to read the imagery of the previous generation. The sixties served as a kind of Rosetta Stone that has made it possible for us to reconsider not just the fine art but the decorative art of the late nineteenth and early twentieth centuries as well. There is probably no better symbol of this reappraisal than the Musée d'Orsay. Prior to its establishment, a person went to the Louvre to see the nineteenth century up to Impressionism, then to the Jeu de Paume to see the Impressionists, and then, wandering toward the Musée d'Art Moderne to look at Picasso, Braque, and the early years of this century, one wondered what had happened to a generation. The d'Orsay integrated the Pont-Aven impressionists, the neo-impressionists, the Nabis, and the Symbolists—in other words, that missing generation—into our picture of the nineteenth century. This reawakened sensitivity to the paintings of that period make a case for a better, more considered look at the photographs of the period, and of those photographs, none have been more neglected than the autochrome.

There was one artist who most ravished him—Gustave Moreau. . . . night after night

he stood dreaming in front of his picture of Salome. . . . her bosoms' rosy points stood

pouting; on the moist skin of her body glittered clustered diamonds; sparks of fire

darted from bracelets, belts, rings; over her robe bestrewn with pearls, broidered with

silver, studded with gold, a corselet of chased goldsmith's work, each mesh a precious

stone ablaze with coiling fiery serpents, crawling and creeping over the pink flesh like

gleaming insects with dazzling wings of brilliant colors, scarlet with bands of dawn

yellow and patterned like blue steel striped with peacock green. J. K. HUYSMANS

Color Fever

Just as Des Esseintes, the hero, if he could be called that, of Huysmans' curious and brilliant *À rebours*, that most impassioned literary expression of decadent Symbolism, was as obsessed with color as were the painters of the period, so too were the photographers after the invention of the autochrome. Stieglitz said, "Soon the world will be color-mad, and Lumière will be responsible. . . . The Lumières . . . have given the world a process which in history will rank with the startling and wonderful inventions of those two other Frenchmen, Daguerre and Nièpce."[15] Coburn wrote Stieglitz to exclaim, "I [too] have the color fever badly and have a number of things that I am simply in raptures over."[16] A few weeks later Coburn gave an interview in which he stated, "It's just the greatest thing that's ever happened to photography."[17] And Steichen declared, "I have no medium that can give me colour of such wonderful luminosity as the Autochrome plate. One must go to stained glass for such colour resonance, as the palette and canvas are a dull and lifeless medium in comparison."[18] Such rapturous statements were not at all uncommon, and everyone seemed to have something to say about the autochrome. In fact, during the first year and a half of the autochrome's existence on the market, there were some two hundred articles published on it in photographic journals alone; that's an average of nearly three articles per week for seventy-five weeks! The *British Journal of Photography*, in anticipation of the Lumières' dem-

onstration and the marketing of the autochrome, even began a special "Colour Photography Supplement" on January 4, 1907, and opened with "An Interview with M. Louis Ducos du Hauron," one of the fathers of color photography, who as early as 1868 had produced a three-color print. Speaking of the Lumières' work, Ducos du Hauron said, "I believe the day of colour photography has arrived."[19] The excitement that color photography initially inspired was probably best summed up by J. Nilsen Laurvik, an art critic and photographer who had his own exhibition of autochromes at Stieglitz's Little Galleries in 1909 and later became director of the San Francisco Museum of Art. He wrote, "In short, color-photography marks the beginning of a new and thoroughly scientific study of color that will, no doubt, revolutionize all forms of color processes as well as exert a strong influence on the art of painting."[20]

The immediate demand for plates after the Lumières' Paris Photo-Club demonstration in June of 1907 was so great that they quickly sold out and their factory had to increase production. Steichen had been present at that initial demonstration and subsequently taught the process to Stieglitz, who was also in Paris but ill on the day it was presented. He secured a group of plates for Stieglitz, who took them on to Baden-Baden, where he made his first autochromes. Stieglitz then traveled to Tutzing, a resort near Munich, where he was joined by Frank Eugene and taught the process to him. Steichen and Heinrich Kühn also joined them, and together these four early masters of modern photography worked enthusiastically at the process.[21] Also in July Steichen carried plates to London and made the first autochromes in England, including even one of George Bernard Shaw, and by late July was making autochromes in Venice. In September he was back in Paris and Coburn traveled there from London to learn the process from him. E. L. Brown, a Scottish amateur and early writer about autochromes, received plates from a friend in Paris in August, and made the first autochromes in Scotland on August 12.[22] But it took until September for small commercial supplies of the plates to finally reach England, and as late as October Americans were being told "a supply of the plates is expected in New York within the next few weeks."[23] In November New York professional photographer B. J. Falk, who had ordered plates in July and received them in late September and thus was the first photographer to make autochromes in New York, as well as being one of the first in America to publish on the autochrome, complained that "The demand for them far exceeds the present manufacturing capacity, and I fear it may be months before we will be able to secure them over here, in sufficient quantity."[24]

Though Falk made the first autochromes in the United States, it is to Canadian photographer M. A. Montminy that the distinction goes of having made the first autochromes on the continent. He, like Steichen, was in Paris for the demonstration and before he left France "was fortunate

enough to get sixteen of these famous plates." After his return to Quebec he made his first auto-chrome on July 10, 1907, a month after the Lumières' demonstration.[25] Upon returning to New York on the twenty-fourth of September, Stieglitz mounted an exhibition which opened on November 18 and included a large number of autochromes; however, he had an earlier press showing of his, Eugene's, and Steichen's work on September 27 and 28 and gave an interview that appeared in the September 30 issue of the *New York Times* in which he said, "I knew this thing was astounding."[26]

Two even earlier autochrome exhibitions had opened in London in September. One was a special section of autochromes included in the Royal Photographic Society exhibition, but one was an exclusive autochrome exhibition at the rooms of the L. and P. Photographic Association. It presented the work of R. Child Bayley, the editor of *Photography*, to whom Steichen had given a box of autochromes in July when he was in London. Bayley commented, "They must be seen to be believed. I did not believe in them until I saw them. And I can hardly believe in them now that I have made them myself."[27]

The photographers' enthusiasm and fever for color seemed boundless. They were now able to do something that for years they had only dreamed of doing, but color fever was also a condition, an obsession, of the time. Alexander Scriabin, who along with Debussy was Symbolism's most significant musical voice, even invented a *clavier à lumière*, a color organ to be played along with the orchestra in his *Poem of Fire* and produce effects somewhat akin to the concerts cum light shows of the 1960s. In discussions of Symbolism too much is made of Verlaine's famous *"Car nous voulons la nuance encor / Pas de couleur, rien que la nuance!"* His demand for nuance, his "No more color," was more an invitation to subtlety and suggestion than an attack on color, and no Symbolist—poet, painter, photographer, or composer—literally heeded Verlaine's advice because it was not so much color as it was the blatant and the obvious he disdained. And that, of course, was equally disdained by all the Symbolists.

The effects of "photographic" nuance, which some critics termed "fuzziness," are what is often seen as a characteristic of art photography of this period and also the subject of considerable controversy. Regardless of his apparent prescience in attacking "methods . . . that have—mark my word— . . . no future," Sadakichi Hartmann's famous 1904 "Plea for Straight Photography," a review of the Carnegie Institute Exhibition of the Photo-Secession, makes it clear at almost every point that he misunderstands his time's temper. Of the nearly three hundred prints selected by Stieglitz, Steichen, and Joseph Keiley from the work of fifty-four photographers, Hartmann writes, "It is only a general tendency towards the mysterious and bizarre which these workers have in

common; they like to suppress all outlines and details and lose them in delicate shadows, so that their meaning and intention become hard to discover." This is the same criticism that was leveled at the Symbolist painters. Hartmann complains that the photographers "overstep all legitimate boundaries," that they "practice . . . trickeries," that they are "misleading and somewhat pretentious," and that they "waste their talent on methods that have no justification to exist, and that have—mark my word—no permanent value and no future."[28] Emile Zola, one of Symbolism's fiercest enemies, in a similar vein had earlier complained that Moreau's paintings were an "astonishing manifestation of the extravagance an artist can fall into in his quest for originality. . . . [H]e has thrown himself into Symbolism. He paints pictures that consist in part of riddles, . . . gives an undue importance to the most trivial objects in his pictures. . . . He depicts his own dreams, . . . complicated, enigmatic dreams that cannot be deciphered at first. What can be the value of an art like this . . . ?"[29]

Hartmann, like so many other critics, clearly misunderstood the impulse behind such photographs, and nearly one hundred years later their imagery is still often misread. Those turn-of-the-century photographers were not trying to be "arty" or make photographs that looked like paintings; they, like the Symbolist painters and poets, were trying to express truths beneath the level of surface realism. Hartmann's very first objection to their work, the presence of "the mysterious," was one of the principal effects they were trying to achieve because Symbolism was founded upon the idea, as Mallarmé had put it, that "Whatever is sacred, whatever is to remain sacred, must be clothed in mystery."[30] Symbolist painting and Symbolist photography naturally had "the mysterious" in common, but even to say the photographers' technique resembled painting is to delimit seriously painting's scope. The photographs hanging at the Carnegie Institute did not resemble paintings of the quattrocento or of the Renaissance or Dutch genre work or any other paintings—except those strange new things of the Symbolist movement—and therein lies Hartmann's real objection. His taste in painting is no mystery. One need only scan the subjects of his numerous articles on "Masters in Portraiture" to know what he liked.

New art movements, which usually define new ways of seeing and describing the world, always offend advocates of old art movements, who are quite comfortable with the world as they see it and have gotten used to seeing it. In a review of an exhibition of drawings by Odilon Redon, Des Esseintes's other favorite painter, critic Emile Hennequin commented that Redon sought "through art, not scientific certainty, but unknown beauties, strangeness, creativity, dreams, new modes of expression."[31] This was what photography since *The Onion Field* had sought to achieve, and its technique was the repudiation of realism. Realism to a great many artists no longer seemed

a vehicle capable of communicating a message of any significance or of any truth either. Italian Symbolist Gaetano Pellizza wrote, "The reality that we see before our eyes is in constant conflict with the truth in our minds—which is the one we choose to represent. In my paintings I should not be aiming to represent *real* truth but the ideal truth. . . . If the artist sticks too closely to reality in his search for the truth, he cannot achieve his full potential. The ideal truth can only be reached by sacrificing the real world."[32]

As a philosophical position, Symbolism echoed the mysticism of the East; reality is illusion, *maya,* and truth lies beneath the veil. As an aesthetic position, it was also a reaction against illusion, for Realism had turned from those intense insights a painter like Chardin focused on the common pots and pans of a French kitchen to something mannered, theatrical, and decorative—in other words, the mannerisms of the Salon. In fact, the exhibition committee for the 1908 Photographic Salon of the Linked Ring in London was dominated by the Stieglitz circle, and their choices so inflamed the other members that a protest Salon des Refusés was organized along more traditional lines. John Taylor, in describing how the more radical selection "was a shock to the established codes," wrote, "The American work was Symbolist where the English was just anecdotal. . . . It was urban where the English was rural. . . . It was sensual where the English was full of 'refined charm.' . . . It was erotic where the English was familial. . . . It dealt with the hurly-burly of life where the English was full of peace and quiet."[33]

Hartmann, though an advocate of photographic modernism and often a sensitive critic, was no visionary. His "Plea" was an anachronistic glance backward toward traditional realism and not a visionary leap of the eye forward into the realism of those geometries lying beneath the surface of forms, geometries Cézanne and Picasso, Coburn and Strand would discover, exploit, and use to change the very direction of two arts. Hartmann's plea did eventually become in the voice of Stieglitz and others a legitimate attack on the clichés and manners of "pictorialism," the very notion of which is, of course, flawed. If a photographer's primary goal is to make his or her photograph look like a painting, to look "pictorial," then content, meaning, symbols, and everything else is obviously secondary to an affectation, to a mere look. In such a photograph, nuance seeks only to reveal the grossest and most obvious similarities to legitimate works of art, for the "pictorial" photographer is seeking to communicate not the unknown and mysterious but the well known and obvious. Further, as Alfred Buschbeck pointed out as early as 1898 in a review of an exhibition of photographs by Kühn, Henneberg, and Watzek and in answer to criticism that they had copied paintings in order to be artistic, "It would be unreasonable to claim that a photograph is a work of art for the sole reason that it resembles a painting."[34] Because the word "pictorial" at that time had

none of the pejorative connotations it does today and photography's serious Symbolists used it as freely as did those "unreasonable" or bad photographers who only sought to affect the mannerism of painters, it is important to distinguish between work which is clearly Symbolist and later work which merely apes Symbolism.

Though the autochrome offered a world of nuance, haze, and suggestion, a world of effects as wondrous as those of Moreau's Salome, it also offered an accuracy of vision that Hartmann might have approved of. In fact, the autochrome serves to bridge the gap between Symbolism and what we have come to think of as straight photography. The "trickeries" that Hartmann complained of, those manipulations of the negative or of gum and glycerine, were not possible with an autochrome plate. Stieglitz commented that "handwork of any kind will show on the plates—that is one of the blessings of the process—and faking is out of the question." However, he noted, "The Lumière process is only seemingly nothing more than a mechanical one. It is generally supposed that every photographer will be able to get fine artistic pictures in color merely by following the Lumière instructions, but I fear that suppositions are based on mere illusions. Given a Steichen and a Jones to photograph the same thing at the same time, the results will . . . in the one case reflect Steichen, and in the other case probably the camera and lens."[35] Coburn addressed this same matter in a contemporary interview.

> Look here. You see this omelette, this glass of cider, this farcically-arranged bunch of polychromatic flowers? . . . Well, that's nature. But look here. I take this omelette and place it here; I take this one flower of bright clear gold and put it on the white tablecloth beside it; and I place this glass of cider close beside it again, but in a place where the sun can catch it and give its color a little more life. . . . Well, that's art; that's photography. . . . And this new process is going to make it absolutely necessary—far more necessary than it has ever been before—for the photographer to work with clear sensitive eyes, an alert intelligence, and thoroughly sensitive nerves. Much more than the old monochromist, the new color photographer will have to select his picture, rearrange his omelettes and flowers and sunlight, pick out the single perfect picture from among the dozens of discordant pictures which nature offers him at every turn.

Coburn went on to attack those photographers who used combination printing and from multiple negatives created an image with a sky from Scotland, a mountain from Wales, and a farmyard from Kent. He said:

What I try to do is see the little piece that matters in the midst of nature's messiness, and by (dint of focal adjustments and so forth) concentrate the interest on that. That done, I use every inch of my knowledge to retain the purely photographic qualities. . . . I don't mean the sharp shrewish acidity of your ordinary cabinet photograph. I mean photographic in the sense that Whistler was photographic (it's a pity, by the way, that he didn't live long enough to use a camera, it would have saved him so much time). . . . And it's precisely because of my Whistlerian fidelity to chosen essential nature that this noo [*sic*] process interests me so much. Men like Demachy—the gummists and manipulators—the 'jugglers,' as you call 'em— simply won't touch it. But for me and Steichen and Frank Eugene—the Whistlers of photography—why, it plays right into our hands.[36]

Though flushed with the arrogance of youth (Coburn was only twenty-five at the time of the interview), he was already a recognized master, and his comments, in spite of their phrasing, are perceptive. Manipulated "pictorial" effects were not possible with the autochrome—in fact, even less possible than Coburn appeared to realize at the time; the process was, by definition, straight. However, in the hands of a Kühn, a Steichen, a Coburn, or one of the other Symbolist masters, many of those same mysteries, the same introspection, and the same beauty of their work on paper blazed out, but now in color. Speaking of this phenomenon, which, of course, is the very mystery of art and of art's mastery, Stieglitz wrote, "Why this should be so in a *mechanical* process . . . is one of those phenomena not yet explained, but still understood by some. . . . Those who have seen the Steichen pictures are all of one opinion. Lumière's own examples . . . would never have aroused me to enthusiasm nor led me to try the process myself. That in itself tells a story." Stieglitz went on to point out that there was a great deal of pure craft in addition to the mysteries of aesthetics; Steichen had spent months experimenting "to get quality and tone, . . . and beautiful pictures."[37] But, of course, it must also be recognized that this statement about "Lumière's own examples" is a classic case of the kind of self-congratulatory overstatement that the Stieglitz literature is embarrassingly crowded with.

To our own modern eyes the Lumières' plates, with all their exactitude and precision, their brightness and crispness, are not only beautiful but striking in their modernity. Though possessing that inherent autochromal beauty I earlier spoke of, their work—whether made consciously as art or as factual documents of their process—is staggeringly beautiful and joyous in its celebration of life, of family outings in the car, the morning catch of fish, or one of the Lumière brothers knitting.

Their work has something of the contemporary rawness of a Joel Meyerowitz or a William Eggleston or a Stephen Shore and may very well look to our eyes, because of Symbolism's eclipse and our own contemporary focus, more like art than Stieglitz's or Steichen's often more introspective, even brooding autochromes.

But Stieglitz was not the only one to feel that way about the Lumières' plates. Laurvik, whom I earlier quoted, speaking of the "trial plates" of the Photo-Secessionists, wrote that they "far surpass in truth and beauty anything so far accomplished, even by Lumière himself"[38]—*trial plates*! Though we can recognize that Laurvik was one of Stieglitz's mouthpieces, and though his statement might appear hyperbolic to our eyes, I doubt that it was to those whose eyes had a Symbolist set and focus. Though the autochrome in a practiced Symbolist's hands was capable of effects approaching those of other Symbolist works, its inherent straightness made it the bridge between prewar and postwar photography, the link between the early issues of *Camera Work* and its final issues. It may even have helped convert some photographers to modernism. Few photographers, if any, embraced Symbolism more fervently than George Seeley, yet he produced a body of work in autochrome that bears no similarity to his previous work. It is as if the autochrome drove him toward realism. And though the work of many of the other major photographers of the period also changed, probably as much in response to Symbolism's postwar irrelevance as to anything else, it is likely that the autochrome and the "color fever" it generated played a greater role than we have credited them with in shaping photography's new direction.

Bring me the head of Iokanaan. . . . Now I will kiss your mouth. I will bite it with my

teeth as one bites ripe fruit. . . . your tongue that was like a red snake darting poison;

how is it that the red viper stirs no more? . . . Your head now belongs to me and I can

do with it as I will. I can throw it to the dogs and the birds of the air. . . . I am hungry

for your body, and neither wine nor apples can appease my desire. OSCAR WILDE

Secessions, Sex, and Tranquility

The Photo-Secession came into being in February of 1902 when Alfred Stieg-
litz entitled the photographic exhibition he arranged at the National Arts Club "American Photog-
raphy arranged by the 'Photo-Secession.'" Those photographers exhibiting had no idea what the
Photo-Secession was or how they had become part of it, or even if they were a part of it. Stieglitz
had for some time been wanting to form a group of fellow "artistic" or "pictorial" photographers.
It gradually took shape through Stieglitz's direction as an organization whose "aim" was "loosely
to hold together those Americans devoted to pictorial photography in their endeavor to compel its
recognition, not as the handmaiden of art, but as a distinctive medium of individual expression.
The attitude of its members is one of rebellion against the insincere attitude of the unbeliever, of
the Philistine, and largely of exhibition authorities."[39] Stieglitz took hold of those photographers
working in the new international style and declared them all seceded from the salons, camera clubs,
and exhibitions dominated by the cliché, by those images of Victorian sentimentality that had been
the staple of photographers for years—excessively cute children, sturdy, rugged farmers, winsome
milkmaids, all caught in sunny, pastoral studies with cows or barnyard scenes with chickens. Of
course, clichés were not limited to photography; nineteenth-century popular culture had been built
upon kitsch.

The Munich, Berlin, and Vienna Secessions, those rebellions Stieglitz based his Photo-
Secession upon, were also revolts against the hackneyed imagery of academy and salon. However,
in each case those rebellions against the cliché did not, as rebellions often do, seek to find new and
original ways of seeing old material; they rejected the previous material, the very subject matter

itself. Impressionism, for example, was among other things a new way of seeing the same landscape the Realist had seen and painted, but these Secessions of 1892 in Munich, of 1893 in Berlin, of 1897 in Vienna, and of 1902 in New York gazed out over a landscape no one had ever before seen. It was the landscape Baudelaire described in his famous sonnet "Correspondences"—"a forest of symbols," where "Sounds, odors, colors echo each other / In a unity that's shadowy, deep / Vast as the night."

Like the Photo-Secession, the Munich and Vienna Secessions were both galvanized by and in a sense organized around a visionary: in Munich it was Franz von Stuck; in Vienna it was Gustav Klimt. Art's great visionaries in most cases are not those, like a William Blake, who have a vision so unique no one shares it, but are those who are attuned to the pulse of the moment, who both catch but, more important, exploit their time's spirit. Von Stuck, Klimt, and Stieglitz were such individuals.

Franz von Stuck was born in 1863, the year after Klimt's birth and the year before Stieglitz's. All three of these men produced work and led rebellions that were significant in their own right; however, of equal or even greater significance is their influence on several "students" who, though producing work unlike their mentors, became the major shapers of the next generation. Von Stuck was the leading painter of the Munich Academy of Fine Arts and teacher of a great many artists, most notably Klee and Kandinsky. Klimt's influence on Schiele and Kokoschka is obvious, and one can easily see a natural progression from his work to Schiele's to Kokoschka's and into Expressionism. In fact, one critic has even called Klimt their "spiritual leader."[40] And Stieglitz was certainly the spiritual father of Paul Strand and Strand's generation.

The amorphous nature of the Photo-Secession and the diversity of work that appeared under the name of Pictorialism make it somewhat more difficult to describe as an actual movement than the Munich or Vienna Secessions. Though Stieglitz was the visionary personality who shaped it, his shaping spirit dictated neither its imagery nor its technique; it dictated an attitude, an attitude of respect toward the medium phrased in the form of a demand that photography be recognized as one of the visual arts. Stieglitz was a greater artist than most of his contemporaries, but his role in the Secession was primarily as polemicist. The defining impulse of the photographic branch of the Secession might, therefore, in several ways be better seen by considering the Secession's other two visionaries, von Stuck and Klimt, instead of Stieglitz.

Von Stuck's work is obsessed with vice. In fact, he painted Sin and Vice again and again as cold, frightening nudes entwined with huge reptiles. They repel and attract and are ripe with sexuality. They are La Belle Dame sans Merci, the Demon Lover, the *vagina dentata*, and all the

other icons of male lust and fear. And in his time they were immensely popular. Von Stuck became rich painting these subjects, built himself a palace decorated with them, including an *Altar of Sin*, was called the "best painter of ideas" in Germany, was knighted, and known as the "prince of artists." Stieglitz even had copies of two large von Stucks in his living room. "One portrayed a woman, with suitably tortured expression, in the coils of a lustful serpent; in the other a rapacious Sphinx-woman held a blanched male in her blood-dripping claws."[41] There could be no clearer indication of the nature of the *zeitgeist* at the end of the nineteenth century than this acceptance and adulation of von Stuck. Though no photographer coiled his models round with snakes or produced female images as frightening as von Stuck's, one can certainly find more than a few unnerving images of women scattered throughout *Camera Work*, particularly Steichen's strange, glimmering nudes, faceless and alluring in the dark. They easily suggest that were they to turn their heads toward the viewer, he could be met by something he might not like—if not serpents and stony stares, most assuredly no invitation. These ladies may not be Medusas, but they are certainly not Venuses.

The fear of the female so clearly manifest in the society at this time and reflected in its art, I would argue, is both a reaction to the changing status of women and one final attempt to suppress it, prior to the inevitable economic emancipation of women that resulted from their entering the work force during World War I. It is no coincidence that this particular imagery of Symbolism arose early in the 1890s. By the mid-1880s Emmeline Pankhurst, like many other young women in England, was an active campaigner for suffrage, and that movement and the suffrage bills put before Parliament were known worldwide. In 1879 Ibsen's *A Doll's House* had appeared and was shocking audiences throughout Europe, and especially in Germany, where Ibsen had to write an alternate ending, one he called "a barbaric outrage," just to get it performed. In that ending Nora does not walk out on her petty, gutless husband who has emotionally betrayed her, but instead stays with him for the sake of their children. But even with that ending, German audiences were enraged. When Nora's husband asked her about a woman's "most sacred duty, . . . [her] duty to [her] husband and children," and she made her famous reply, "I have another duty equally sacred . . . my duty to myself," it was clear to everyone that something in the world had changed, and some males did have cause for fear.

Probably not an aspect of the same phenomenon but allied to it was a decided preference for the male or androgyne over the female. Though it is more obvious in the literature, it is also present in painting and photography. Perhaps it was just the love that dared not speak its name, but it had a theoretical basis within Symbolism in the ideas and writings of art critic and novelist

Joséphin Péladan. Péladan's influence in the last two decades of the nineteenth century was considerable, and even Kandinsky in the second decade of the twentieth is still reverently quoting him in *Concerning the Spiritual in Art*. Péladan founded the mystic Ordre de la Rose + Croix Catholique du Temple et du Graal, organized the extremely successful Salon de la Rose + Croix exhibitions of the 1890s, and had disciples all over Europe, most notably the Belgian Symbolist Jean Delville. Péladan's "Rules" for the Order announced the Salon's intent to "ruin realism," and though imposing no program on the artist "other than the creation of beauty, nobility, lyricism," did reject a variety of subjects: historical, patriotic, and military paintings, rustic scenes, domestic and sporting animals, and so forth—in other words, the same trite material the pictorial photographers were rejecting. And though one of Péladan's "Rules" states that "the word 'foreign' has no meaning," another says, "Following the traditions of Magic Law, no work by a woman will ever be exhibited or executed by the Order."[42]

Péladan's novels include *La vice suprême* and *L'Androgyne*, and according to him "Art has created a supernatural being, the Androgyne, beside which Venus disappears."[43] It is hardly a world of androgynes, however, that one discovers in the principal painting of Péladan's greatest disciple, Jean Delville. His twenty-foot-wide *School of Plato* places twelve youths "of harem-girl languor and Michelangelesque muscularity," as Robert Rosenblum put it, standing and seated around a robed, bearded figure, far more Christ-like than Platonic looking. Rosenblum wonders "what kind of lessons in truth and beauty are being taught" in so precious a vision of classical philosophy. He calls it a "fulfillment of a kind of *Death in Venice* dream that only a Northerner could sustain about the ancient Mediterranean world."[44] There is perhaps no better description than that of the photographs of Wilhelm von Gloeden and F. Holland Day, whose Greek statues and lyres and other assorted symbols of antiquity do not save their work from contemporary snickers, even from those attracted by the imagery.

Though one group of Symbolists depicted women as desirable but terrifying and another group simply found them undesirable, the imagery of Gustav Klimt and the Vienna Secession is a celebration of women. No harem-girl boys and certainly nothing frightening here; in fact, Klimt's work represents the most seductive and erotic depiction of the female in painting. Rubens, Boucher, and Renoir may have celebrated the flesh to a greater extent, but it is not very compelling flesh. Klimt's women are erotic idealizations captured in a glowing postorgasmic moment, and they are unlike anything else in art but Stieglitz's similar portraits of O'Keeffe. When Klimt is not celebrating this capacity for passion, it is the capacity for motherhood he returns to again and again. These are the two faces of Klimt's women, and they, too, present male stereotypes, stereotypes of female

fulfillment either through orgasm or pregnancy, both delivered like grace as the gift of a god. Though neither orgasm nor pregnancy itself finds its way into *Camera Work*, the erotic female and the mother certainly do again and again.

Klimt and Schiele, the great painters of the Vienna Secession, were characterized by fellow painter Anton Faistauer in a way that also reflects tellingly on the pictoralists of the Photo-Secession. "They both carefully avoided the middle classes. . . . Klimt was able to catch the blasé attitude, arrogance and pride of his types in detail, rather better than Schiele the outlines of his. For neither was the human being of any significance, people were more or less figurines, with Klimt a complex and subtle play of nerves, in Schiele a dark dreary crowd."[45] If one excludes the numerous images of motherhood, no general description of the imagery of the Photo-Secession is more precise than this. Figurines, symbols, and ideas are the shapes that people their photographs. To criticize such art for its lack of social conscience, its avoidance of anything outside the world of blasé sophisticates, or its disregard of human significance is to confuse art with propaganda. It is not incumbent upon art to care about anyone. Faistauer's comments, for all their accuracy and insight, are the bitter words of a survivor and are understandable, being made in 1923, after a war that tore Europe apart, destroyed a generation, pulled down empires, and a quarter of a century after the founding of what by then must have seemed a frivolous, ornate moment in Viennese art history. Though the Secessionists may have painted and photographed figurines with their nerve endings all exposed, it was their moment they captured, and to ask more from an artist than that is an unrealistic request.

It is into this context of Secessions, of von Stuck and Klimt, and Stieglitz's war on the Philistines, that the autochrome appeared and found its most passionate devotees, though in most cases their passion was rather short-lived. In the hands of those pictorial photographers who took their vocabulary from Symbolism, especially Heinrich Kühn, the autochrome achieved some of its most artistic results. Kühn, who could easily be called the Stieglitz of Germany and Austria, was born in Dresden on February 26, 1866. In 1888 he moved to Austria, where in 1894 he joined the Vienna Camera Club and became friends with Hans Watzek and Hugo Henneberg. These three photographers traveled, photographed, and exhibited together and eventually became known as the Trifolium. Though the work of all three appeared in *Camera Work*, none was actually a member of the Photo-Secession. Watzek died in 1903 and by 1905 Henneberg had abandoned photography for painting and the graphic arts. Though one issue of *Camera Work* was devoted exclusively to Kühn's work, and though he and Stieglitz autochromed together on more than one occasion and carried on an extensive correspondence, it would be inaccurate to think of him as part of Stieglitz's

circle. Other than recognizing three significant photographic facts about Kühn—his great admiration for the early Scottish calotypists Hill and Adamson; his appreciation of effects Alfred Maskell and George Davidson achieved with a monocle lens, first brought to his attention in 1891 at a Vienna Camera Club exhibition; and his interest in the gum medium, which Henneberg introduced him to in 1896 after he had seen some of Robert Demachy's gum prints the previous year—Kühn is better understood outside the context of his particular medium and within a larger art historical setting.

All three of the Trifolium had their artistic roots in the Viennese Secession. In fact, all three were invited to exhibit in the graphic arts section of the 1902 Exhibition of the Viennese Secession, and they had earlier exhibited at the 1898 exhibition of the Munich Secession. That same year their work had appeared in two issues of *Ver Sacrum*, the lavish periodical of the Vienna Secession, which appeared from 1898 to 1903 and contained original engravings, lithographs, and woodcuts, all of which were produced to exacting standards. Josef Hoffmann, the leading architect of the Secession, designed the homes of both Kühn and Henneberg, and Klimt painted Henneberg's wife. Kühn arranged an international photographic exhibition in Vienna in the spring of 1905 at Galerie Miethke, which also showed Klimt's work and other Secessionists and which, beginning in 1908, published gravure prints of Klimt's paintings, and in February of 1908 exhibited a selection of Kühn's best autochromes.[46]

Kühn's close personal connections to the artistic life of Vienna at this time are often overlooked, but they are central to an understanding of his work because he, more so than any of his European or American counterparts, was at the very center of that international movement they were all reflecting. Though this does not elevate his position in any way, it suggests that in truth one might just as easily speak of Stieglitz as the Kühn of the United States as to speak of Kühn as the Stieglitz of Germany and Austria. Kühn's life during this time was, in fact, lived on a more cosmopolitan stage than the lives of any of his fellow photographers; his contemporaries were not other photographers but the painters, architects, graphic designers, and decorative artists who were at the exact center of an international movement. Stieglitz, through his gallery and in his role as an editor of a journal, later came to occupy a somewhat similar though more limited position; however, at this time Kühn was unique among photographers. One is tempted to see his work in relation to Klimt's because, as Werner Hofmann put it, "Klimt removes motherhood to the distance of an icon,"[47] and that, too, is its position in Kühn's work. Also Klimt is known as one of the century's most masterful colorists, and Kühn even prior to the development of the autochrome was

incorporating color into his work. Ten years before the autochrome was on the market, Kühn, Henneberg, and Watzek had invented the multiple gum–bichromate print, which was capable of beautiful color effects. As Peter Galassi noted, "The Viennese were . . . preoccupied with color and produced rich monochromatic and dichromatic prints in green, blue, red and brown, as well as prints with a full range of color. Kühn was also among the first to exhibit the latter."[48]

Even though these similarities are striking, Kühn's work, apart from the obvious similarities to Watzek's and Henneberg's, is probably most like, of any of his fellow Secessionists, Carl Moll's.[49] Kühn was a better photographer than Moll was a painter. However, Moll was a far better painter than many critics have chosen to remember; his work has for political reasons alone been sadly neglected in the general reappraisal of the Secession that has been underway for several decades now. Werner Hofmann has a telling description of Moll's style that sounds as if he might just as easily be describing Kühn's:

> He has conveyed something of the lack of pretension in the bright interiors which Hoffmann designed in his villas at the time. The picturesque weight of historicism has disappeared. Uprights and horizontal lines predominate, bright colors are shown in sunlight. The square format and the carefully considered brush strokes increase the impression of friendly tidiness. It is no abstract or decorative surface geometry which surrounds these people but a three-dimensional straight-forward clarity. These are rooms which lead out into the open air. In his *Breakfast Table* . . . Moll weights the cold, sparkling smoothness of the glasses, plates, and cutlery with the sun-drenched curtain of light of the background. It is an atmosphere in which coolness and warmth are balanced. Here the 'sacred' springtime is divested of its literary pathos and becomes the appropriate season of a cultivated way of life. Moll is master of a factual, sensible, and restrained post-impressionism, which produces at one and the same time a scene of everyday life and a symbol of harmonious tranquility.[50]

The world of Kühn's photographs is certainly this world of a sacred spring, of a gentle and cultivated way of life, the world of Rilke's *Orpheus Sonnets* where "All turns vineyard, all turns grape, / Ripened in his sensitive South." His seemingly simple representations of the ordinary, of the everyday, transcend breakfast tables and mountain hikes, bowls of fruit and boys sailing boats to become symbols of harmony and tranquility, of life as it should be lived. That tranquility was soon to be shattered—and with it the Secession. But there in its moment it radiates from Kühn's photographs with such profound grace and deep thanksgiving that to look at a work of Kühn's is to

feel a sense of immediate calm. Kühn's symbolism was as deeply rooted as von Stuck's, but it was of a radically different character, a character that reminds us, as another poet, Richard Wilbur, also does, that "love calls us to the things of this world."

What is perhaps most characteristic of Kühn's autochrome work is its similarity to his work on paper, its pull toward those "things of this world." Perhaps because of his previous decade of work in multicolored gum prints, Kühn's autochromes have a kind of assurance with color not found in the work of the Photo-Secessionists. For all the competency of Stieglitz or Seeley or Coburn, their autochrome work stands apart from their work on paper and does not seem to be integrated into their photographic vision of the world. It clearly seems very different from their other work. Perhaps it is that the autochrome drove them toward a greater "straightness" of vision, a "straightness" more at odds with their paper prints than Kühn's autochromes were with his. Though this may at least partially explain why Kühn's autochromes seem to complement and harmonize so well with his work on paper, the reason also probably derives from the essential straightness of Kühn's symbolism, a vision so drawn from the things of daily life that it was unnecessary for him to drape models in sheets or pose them in dark rooms to convey the fact that the imagery suggested a greater meaning than the sum of its parts. In other words, the straightness of Kühn's subject matter and symbols led to a kind of rare versatility with the autochrome seldom seen in the work of other "art" photographers.

Though Stieglitz was certainly a photographer's photographer and possibly the best photographer of the century, Kühn was just as certainly the greater artist and as great an artist as ever took up the camera. His vision may not have been as prophetic as Coburn's or Strand's, but an artist's greatness need not be measured by the astuteness of his prophecy. Those artists who do seem to capture a moment right as it is being entered and before most of society is even aware that a new age has dawned naturally evoke our admiration—and often more for their intellect and prescience than their craft. There are few aesthetic experiences more moving than to see the fundamental moments of our history reflected in art, moments when we first stopped merely hunting and sleeping and procreating and took the time to reflect carefully on a bison or a deer and record its form in some place we held sacred or special, when medieval society seemed to awaken and see the world through Giotto's eyes, when the Renaissance focused that awakened vision on the individual, when Romanticism called it to new purpose by enlarging it and making it more embracing, and when our own age turned away from it and embraced the machine. Modern photographic criticism has lauded angularity and the imagery of the mechanical to the extent that its presence or absence has become the test of a photographer's relative importance. What could possibly hold any

universal attraction in the quirky, fetishistic images of Paul Outerbridge, a refined and stylish Irving Klaw at best? However, his complete oeuvre is taken with complete seriousness because of the *Ide Collar*, the *Saltine Box*, the *Marmon Crankshaft*, and the *Triumph of the Egg*, all of which are striking and beautiful in the simplicity of their geometries.

The photographers who have been most harmed by our using the look of modernity as a criterion for excellence are those who worked in the first decades of this century but did not embrace the imagery of modernism, while those held in the highest esteem are individuals like Stieglitz, Steichen, and Pierre Dubreiul who did, and whose work evolved with the time. One can justifiably criticize late nineties pictorialism in a photograph from the late thirties, but to criticize as anachronistic an imagery that only became out-of-date the day before is just as unrealistic as it would be to criticize an audience for being shocked by a new work of art on the first day of a new age. Our judgment of works done during transitional periods must take into consideration that even though history appears to change overnight, it does not. At distance from a time, criticism easily recognizes this. We do not complain of Duccio's adhering to a more Gothic style while Giotto forged ahead to define a turning point in the history of painting because at that moment and in that place the individual, too, was at a turning point, nor then do we criticize the younger Simone for not taking up Giotto's style but working in the more ornate Gothicism of Duccio; we recognize all three of these artists as the giants of the Trecento and admire them equally for different reasons.

Kühn would be taken with far more reverence today had he not turned his attention in the twenties to photographic research, technical innovations, and writing on photography but had begun photographing gears and shafts and German factories. Statements such as the following from a recent general history of photography have become critical clichés: "While aesthetic photography was supplanted in the 1920s and '30s by *Die Neue Sachlichkeit* (The New Objectivity), Kuehn, unlike his friend and associate Stieglitz, seems to have been unwilling or unable to embrace these new perceptions."[51] As I have said elsewhere, "Lamentable as it might be, it seems a fact that in all fields but the sciences a statement repeated several times and printed several times, regardless of whether it is patently absurd, takes on the aura of authority and is soon thought by everyone to be true."[52] Kühn's work needs to be considered for what it is, not for what it is not. And though I said his vision may not have been as prophetic as Coburn's or Strand's, his refusal to embrace the machine and images of robotic life may have been the more far-ranging and truly prophetic vision. That call to the things of this world in Kühn's work and that sense of immediate calm in the viewer generated by them should remind us that art has more functions than merely to chronicle a time and clerk down the days. As Pound said, and as I quoted earlier, "The age demanded an image /

Of its accelerated grimace." But because art is one of the things that help us live, we, particularly if we are born to "an intemperate time, an age of bone," demand more of art than the ever-present grimaces of the moment. What we are finally aware of in the presence of Kühn's art is not comparisons to Klimt or Moll or other photographers but comparisons to the very greatest of artists. His technique is not a matter of gum or autochrome or platinum, but the manipulation of light and shade alone. His tranquil, detached images do not demand our involvement, but we lose ourselves in them, are uplifted and increased by them, and finally we are lost in Kühn's universality.

At the conferring of the episcopal ring, He drew-back His hand; and demanded an amethyst instead of the proffered emerald. The ceremony halted till the canonical stone came. Cardinals noted the first manifestation of pontifical will, with much concern, and with some annoyance. . . . They brought Him before the altar; and set Him in a crimson-velvet chair, asking what pontifical name He would choose. "Hadrian the Seventh": the response came unhesitatingly, undemonstratively. "Your Holiness would perhaps prefer to be called Leo, or Pius, or Gregory, as in the modern manner?" the Cardinal-Dean inquired with imperious suavity. ". . . Hadrian the Seventh. It pleases Us; and so by Our Own impulse, We command."

FREDERICK ROLFE, BARON CORVO

Color Abandoned

Alfred Stieglitz, unlike Corvo's strange hero-Pope, Hadrian, did not simply luck into the Papacy; he assaulted photography's Vatican and took it. But he was like him in all of his imperiousness and brilliant ability. Hadrian angered his cardinals, sold the Vatican treasures, redesigned the crucifix, canonized Mary Queen of Scots, restored the Holy Roman Empire and, of course, was finally assassinated. Stieglitz certainly angered his cardinals, most of whom eventually turned their backs on him, disposed of photographers he thought no good by excluding their work from exhibitions, redesigned (and more than once) the acceptable print, created new saints, and built his own empire. He escaped assassination, but his myth has not fully.

J. Nilsen Laurvik wrote, "It is of interest, perhaps, to note that, while the honor of the discovery of both monochrome and color photography must be accorded to France, to America is due, in no small measure, the credit of having developed the artistic possibilities latent in both of these

remarkable discoveries in the scientific application of light. Much of this pioneer work has been done by that little group of earnest workers, 'The Photo-Secessionists.' "[53] It all sounds very pretty, but, of course, it is not true. It is a good example of the photographic propaganda of the period. No doubt Laurvik believed exactly what he said, as did Coburn, as did Stieglitz, most of the time, and all the rest of them too. And when they exaggerated or affected poses or lied, it was in the service of two good causes—art photography and their own careers. But that is no real criticism; if self-interest had not been yoked to men's passions, little of value, at least from a Western perspective, would have ever been accomplished. There would not have been a Renaissance, for example. The lies, the exaggerations, the excesses, and the brilliancy of their craft and the depth of their vision worked! The Photo-Secession was a tremendous success, so successful, in fact, that it has distorted our view of all the rest of the period.

Probably because our century has witnessed the collapse of all the idealisms spawned by the late eighteenth and nineteenth centuries, we look back on history with a more jaundiced eye than any other age has ever cast. Iconoclasm has come to be the hallmark of all "serious" scholarship, and we demand revisionist history even where there is nothing to be revised. We act like a mob of early Lutherans running through the great Gothic cathedrals of Germany, hammers in hand, smashing and smashing at every idol we can reach. Perhaps we have justifiably earned our cynicism with the failure of all the moral and political "isms" we have chosen to kneel before or salute and the wholesale brutality that has run rampant in the world since 1914. We must, of course, demand the factual accuracy of all our histories, including our photographic history; however, there is reason to distrust conclusions drawn from even the most accurate of facts if those conclusions are shaped by moral outrage and disappointment. Such conclusions, common in our time, would have never been drawn by a La Rochefoucauld, a Talleyrand, a Molière, or a Houyhnhnm. They are part of the legacy of the very idealisms we have turned our backs on; they are conclusions no one before Rousseau would have ever drawn. Only the Romantic is scandalized by a corrupt politician, a lascivious priest, a passionate president, or a pompous and exaggerating photographic genius.

Correcting the myth need not denigrate the man. But propelled by our embittered Romantic heritage, we too often discount the gift when we have dispelled the aura. The *argumentum ad hominem* has become the veiled and implicit hammer of the revisionist. The audience, be it the audience for recent political history or early ecclesiastical history or modern photographic history, seems to take as much delight in its wielding as did the Romans in their games, the early eighteenth century in bearbaiting or executions, or any other time in its particular blood sport. We may have

mitigated our cruelty, but we have not heightened our compassion. The particular problem in our time, though, is that our sport of presumably clarifying our history often distorts it a second time.

It is important to understand the Photo-Secession in its historical context, see through its hyperbole, see it as its contemporaries saw it, and judge its creations fairly, regardless of their makers' flaws, instead of dismissing them as products of a "pseudo art world" and "the myth of art photography," as one critic does. Such consideration might lead to an understanding of one of the biggest mysteries of the autochrome. Why did the Secessionists after such initial frenzy and fever over the autochrome seem to drop it so casually and without explanation? Why did Coburn, that young Whistler of the camera and master of color, who had called the autochrome "the greatest thing that's ever happened to photography," have no more to say about it in his autobiography than that he had photographed Charles Lang Freer's "Whistlers and oriental art treasures in colour on Lumière Autochrome plates" and "was delighted with these early colour experiments?"[54] Why did Steichen, who had called the palette and canvas "a dull and lifeless medium" in comparison to the autochrome and who ran all over Europe in 1907 and 1908 autochroming, give it a scant four paragraphs in his autobiography? Stieglitz had written, "The effects of these purely pictorial photographs when up to the Secession standards will be revolutionary, and not alone in photographic circles. Here then is another dream come true."[55]

But the dream only partially came true. The works produced by Stieglitz's circle were indeed remarkable, but for all that color fever those photographers originally burned with, it soon dissipated, and they returned to their black-and-white work. Why? It was not that the autochrome proved disappointing or was quickly replaced by other color processes. In fact, the Lumière company by 1913 was producing six thousand plates a day and kept making them until 1932. They remained just as popular as they had ever been with the amateur photographers; Fritz Paneth, for example, continued using them until 1938. It was only with those professional "amateurs" of the Secession that the process was short-lived.

James S. Terry in "The Problem of 'The Steerage,'" Ulrich F. Keller in "The Myth of Art Photography: A Sociological Analysis," and John Taylor in "The Salon des Refusés of 1908" make it clear that a great deal of photographic history is miswritten because Alfred Stieglitz was taken at his word by the photographic historians.[56] Terry carefully demonstrates that "The account Stieglitz attached to his most famous image was at best misleading, at worst apocryphal. . . . Above all, the story has become an important piece of folklore. . . . [that] fitted . . . the notions of modern photographic history they [Stieglitz's admirers] were just beginning to piece together" (p. 220).

Taylor points out that Stieglitz's individualism and influence "have structured the way history is written" (p. 277). Of course, he is correct, but the political history of the period must also be taken into consideration, for if the Central Powers had won the Great War and Germany had not slipped into economic collapse, Stieglitz's influence would probably have waned. But because it did not, the histories of photography have nearly forgotten Germany's imminent international position in pre-war photography, its influential journals, such as the *Photographische Rundschau* or the more lavish *Die Kunst in der Photographie*, which predate *Camera Work* by seventeen and six years respectively, or its major collections. The Print Room of Dresden's Staatliche Kunstsammlungen in 1899 became one of the first major institutions to incorporate photography into its collection. And Ernst Juhl, the founder of the Society for the Promotion of Amateur Photography in Hamburg, established a collection that grew out of the yearly Artistic Photography exhibitions beginning in 1893 at the Hamburg Kunsthall—a collection of over six thousand images which "restores the balance to Stieglitz's bias," as Janet Buerger puts it in her important study of "Art Photography in Dresden, 1899–1900: An Eye on the German Avant-Garde at the Turn of the Century."[57]

Taylor goes on convincingly to show how even as important a historian as Beaumont Newhall is seduced by Stieglitz's view of himself as the great progressive and modernist whose "work in photography" even "paved the way" for the 1913 Armory Show. Newhall, like a great many "conventional photohistorians," sees photohistory as progressive and evolutionary, and sees the history of photography as an "astonishing rise," as Taylor quotes him, "from a substitute for skill of hand to an independent art form" (pp. 277–78). This narrow, progressive view of history, which always flatters the present and in art and photography is built upon the concept of a genealogy of "masters," was abandoned long ago in other disciplines. It is a product of the nineteenth century's discredited idealism; everyone from Queen Victoria to Marx saw progress and direction and knew exactly where they or England or the masses were headed. History does meander about dialectically, but it is headed nowhere, and Matthew Arnold had a better understanding of the ordinary man or woman's place in it—out on the "darkling plain"—than any other nineteenth-century thinker. But notions of progression hang on in writing about photography, to no small extent, because art history, unlike any other historical discipline, is yoked to a marketplace.[58] Taylor's careful analysis of the events surrounding the 1908 and 1909 salons clearly shows Stieglitz's actions as power plays uninspired by any sense of crusading for modernism. However, as I said, this should neither surprise nor shock. Keller is not only shocked but highly indignant as well, and his essay-polemic, for all the valuable material it contains, must be read with care. He would have us finally believe that there was nothing radical at all about the Photo-Secessionists' vision, that it was a vision ripe

for mass consumption, that Stieglitz and his circle "were 'in the swim', putting picturesque subjects into universal circulation, thus increasing both the production of images and the consumption of equipment. It was for this service that the means of building a complete photographic art world were put at their disposal by the photo industry" (p. 273).

There is no appropriate adjective to describe such a conclusion but simplistic.[59] Keller's essay is important, as are the others I have mentioned, in helping to correct the "myth" of Stieglitz, but in Keller's zeal to do so, he appears to see late-nineteenth- and early-twentieth-century photographic history as a progressive and evolving matter of economic manipulation.

We should certainly keep in mind how the official historical view of Stieglitz and the Photo-Secession was carefully created by Stieglitz himself, then aided by subsequent photographic historians, along with certain accidents of history, such as Germany's postwar economic decline, and finally in recent times greatly aided by the auction house and photographic dealer. However, to forget that the Photo-Secession was primarily shaped by Stieglitz's own genius and his extensive lifelong labor at his craft, as well as the similar labor of Steichen and Coburn at theirs, is equally to misunderstand it. Technique and craft are not everything, and alone they are nothing, but the greater the artist's craft, the greater the possibility of being able to give shape to the vision. Any major criticism of Stieglitz or Steichen or Coburn must come to terms with their craft and with their vision and suggest which of their contemporaries could rival any of the three. Interestingly enough, the mystery of their loss of interest in the autochrome seems to come down to this very matter of craft and who actually might have been able to rival it.

In the summer of 1908 *The Studio* produced a lavish "Special Summer Number" entitled *Colour Photography and Other Recent Developments of the Art of the Camera.* Charles Holme, the editor of *The Studio*, was listed as editor, though the text was written by Dixon Scott and the actual selection of images, or at least of the autochromes, according to Mike Weaver, was made by Coburn.[60] Weaver quotes Coburn as saying in a December 1907 letter to J. Dudley Johnston, who is represented in the color section by a gum print, "I am only asking the very best people to contribute." That included three by Coburn himself and three by Baron de Meyer, two by Heinrich Kühn and J. Craig Annan, and one each by Frank Eugene, G. E. H. Rawlins, Bernard Shaw, and F. W. Urquhart. Weaver also concludes that Coburn "must have given [Steichen and Stieglitz] offense" when he "did not obtain examples from" them (pp. 29–30). Had he done so, we probably would have heard. It is more likely that Stieglitz had none to offer Coburn. The autochromes he had brought back from Europe and those of Clarence White were on exhibition at the Little Galleries until New Year's. Coburn, who had gone to France in September specifically to learn the

process from Steichen, would not have doubted Steichen's ability, and Steichen may simply, despite all his racing around Europe autochroming, have had nothing to offer. In April of 1908 he said, "I have hundreds that have been used merely in endless experiments."[61] Though the monochrome section of the book does not include any of Steichen's work, it does include four examples of Stieglitz's. If Coburn made the autochrome selection, there is a strong possibility he also made the monochrome selection, considering it includes two photographs by his mother! And Coburn must also have asked Dixon Scott to write the essay.

Scott had no experience in photography. The previous year he had provided a short descriptive text for a book on Liverpool illustrated by paintings, and he produced a similar book on Stratford. He wrote "literary" essays in an affected, precious style that resembled, but for their dead seriousness, the comic chatter of a Firbank heroine. Some of these were collected in a 1915 volume entitled *Men of Letters*, which carried an introduction by Max Beerbohm. Scott was the London correspondent for the *Liverpool Courier* when he met Coburn quite accidentally in a restaurant in October 1907.[62] He clearly was taken with Coburn, his junior by one year, as is evident from his "interview," if it could be called that. The piece is really a series of gushy annotations to a pompous and insulting lecture delivered by Coburn to Scott, but Scott was in awe of this "hero" with his "mournful eyes" and "Latin Quarter beard," and seemed to have no embarrassment at all in quoting Coburn speaking to him like this: "You're so helplessly and complicatedly wrong that it's scarcely worth while putting you right." Clearly they got on, though, and in a while Scott quoted Coburn saying, "Oh, Lumière's discovery has possibilities that make me—. Look here, do you care for a hansom ride?" Scott wrote, "I explained that a hansom ride was precisely the one thing needed to fill my cup of happiness to the brim." So they "went ringing up St. Martin's lane" and "twitched across Oxford street." Eventually they arrived at Coburn's, where they looked at autochromes, and Scott enthusiastically parroted Coburn's previous raptures. He concluded, "These little transparencies . . . were indeed more beautiful than many famous pictures; and as I looked at them I thought rather sadly of certain earnest friends of mine toiling in dull studios . . . , studying perspective in chilly schools, going out . . . with unresponsive pigments and stubborn, primitive tools, gallantly, unsuccessfully striving to make their stiff hands transcribe the lush splendors their eyes so longingly discerned." As he considered their "fruitless labors," he realized "Coburn was probably right in his optimism and that the laboratory had once more discovered yet another method of relieving humanity of one of the oldest of its tasks."[63]

Those concluding lines about "the laboratory" are quite significant. Coburn and Scott were in agreement and were completely enthusiastic about the autochrome in late October of 1907, but by

summer of the following year Scott had reversed himself completely—and for reasons stemming again from "the laboratory" and also quite obviously from Coburn's studio as well. In his *Studio* essay "Colour Photography," Scott now wrote, "It seems highly questionable whether the autochromist, or the colour photographer of any kind, is yet entitled to receive attentions from art critics." Scott saw him as an "adroit exponent of a singular mechanical device, a device possessing much of profound scientific value, producing results which, as records, memoranda, souvenirs, are of quite intense interest and some considerable charm" (p. 1). Had Scott forgotten that six months before he had "thought rather sadly" of those "earnest friends" of his "toiling in dull studios" and "striving to make their stiff hands transcribe . . . splendors" instead of using them to make autochromes? He questioned whether the autochrome affects a viewer as "authentic art" does and decided that the entire matter must be approached "from the point of technique" (pp. 2–3).

After explaining "the physical basis" of the autochrome process, Scott said his task was "to discover what manner of aesthetic structure it is possible to erect on such a base." He complained that "The subtlety of this autochrome instrument . . . makes it absolutely impossible for the human hand to interfere in any way. . . . The operator has to stand helplessly aside whilst these lilliputian Frankensteins of his creation automatically conduct their own unswerving campaign" (p. 4). "*L'intervention*," he declared, "is utterly impossible in autochrome work" (p. 5). He concluded his essay by saying that tomorrow "or to-morrow's morrow, will bring a fresh discovery, a new development, which will perhaps replace the right control in the worker's hands, and restore to him the sway momentarily usurped by Science. . . . Photography's true sphere, the place where she catches the hot instant on tip-toe, and perfectly prisons it for ever, must always be the world of monochrome; for colour is too frail and sensitive a thing to submit to these sudden pouncings and butterfly captures" (p. 9).

When Coburn met Scott, he had been at the autochrome process for about a month, having learned it in September. It is not difficult to conclude that a few more months of practice did not produce the results Coburn had expected. In fact, all those "best people" he had asked to contribute, excepting Kühn, may have discovered that the inflexibility of the autochrome lessened their enthusiasm for it. Kühn and Steichen clearly had the ability to make the autochrome not merely a vehicle for "records, memoranda, [and] souvenirs," but also one for their art; their skill was such that they could actually bend the form against itself, as Stieglitz early recognized, so that it was quite versatile and capable of more than that single kind of straight effect Scott (and Coburn) seemed to think it was. But Kühn and Steichen were not alone in their ability; there were others, but not, for the most part, among the ranks of the Photo-Secession.

When the Scott-Coburn *Studio* came out, it was immediately and quite perceptively attacked in the *British Journal of Photography*. It was an attack that has been forgotten today, and we have continued reverently to repeat Coburn's own self-congratulatory words. A few years ago a leading contemporary photographic historian called the *Studio* autochromes "the best examples by various photographers to date."[64] But it was far from that, as Coburn's contemporaries were quick to recognize. "We . . . doubt strongly the justness of taking the tentative groping [sic] of eight men, many of whom are opposed to 'straight' processes, and letting their experimental work go out to the world as the best that the Autochrome plate can achieve."[65] The reviewer, Frederick Colin Tilney, saw the *Studio* selection as "nothing but fourteen very indirect Autochrome results" that would "disappoint its readers." He said he hoped that the autochromes exhibited in 1907 and 1908 at the Royal Photographic Society, those exhibited at the rooms of the *British Journal*, and those at the Franco-British Exhibition would "go far to restore the balance of fair judgment in the matter of colour-screen plates in the mind of the public." Tilney complained that Annan's portrait, "practically a monochrome in green, . . . cannot be called a conquest in colour photography." He noted redundancies in Coburn's work, adding that "Mr. Coburn will expand his ready smile at this, amused at the audacity of my differing opinion." "Absolute want of relative tone ruins Mr. Urquhart's 'Christmas Roses,'" he wrote. As for G. B. Shaw's "Landscape," "the less said about it the better." Tilney called Eugene's work "brilliant" and "hard as nails," and praised the "head of the little girl" in one of Kühn's autochromes as "perhaps the best thing in the whole book," though he criticized Kühn's "Playmates" for its "incomprehensible" background.

Tilney was a leading art and photographic critic (*The Appeal of the Picture, The Lure of the Fine Arts, The Principles of Photographic Pictorialism, Expression in Pigmenting,* etc.) as well as a highly respected artist and illustrator who occasionally wrote on color and reviewed color photography exhibitions for the *British Journal*, and he was not being harsh or overly critical. There was already by 1908 something of a standard of vision in terms of the autochrome. Tilney raised a legitimate point when he asked, "Are the gentlemen who furnish these examples known as having been eminently successful as Autochromists, or have they not rather the reputation of being artistic photographers?" By September 1908, when the review appeared, quite a few names were well known to the photographic world primarily as "Autochromists," but none of them were included in the *Studio* color number.

As I suggested earlier, we have a long tradition of accepting as fact vast amounts of inherited hyperbole about the Photo-Secession. We look at the lavish April 1908 *Camera Work* with its high quality autochrome reproductions and its long and beautifully printed essay "Color Photography"

by Steichen, we recall how Steichen taught Stieglitz, who taught Eugene and Kühn, and how they all worked together, and then how White and Coburn learned, and on and on, until we are seduced into thinking that the Photo-Secessionists' activity was the center of the autochrome world, but it was not. Steichen's article is most impressive looking—a nice abridgement appears in the *British Journal of Photography*—but apart from it and a two-page technical article by Stieglitz on plate frilling, also in the *British Journal,* and his initial pronouncements in *Camera Work,* the Photo-Secessionists had nothing to say in print on the autochrome.

By the time the summer *Studio* appeared, one could have read over one hundred and fifty articles on the autochrome in photographic journals alone. In June there was an article about Gervais Courtellemont with much technical discussion of his exposures and the 1,300 (!) auto-chrome plates he had made on just one recent trip.[66] In May, J. C. Warburg, a leading autochromist in his own right, reviewed a Cannes exhibition of 185 of André Meys' autochromes.[67] Also in June, Edward John Wall, who by the following month had published seven articles on the autochrome alone, reviewed the Society for Colour Photographers' Exhibition and had high praise for Warburg, Meys, a forgotten Dr. Rosenheim, and a Mr. H. T. Malby, who had "long been famous for his flower work in monochrome," and some criticism of Rudolph Dührkoop's autochromes for having "lost their individuality" and not being stylistically recognizable as his work.[68] And the names of F. Martin-Duncan and Félix Monpillard, for nature studies and scientific autochromes, of Léon Gimpel and Étienne Wallon, the Lumières', of course, and others had been before the public for at least a year and in many cases longer. But, as I said, none of those names appeared in the Special Summer Number of *The Studio.*

In a way it is understandable that, after their initial fascination with the autochrome wore off, those individuals who labored at photography for the express purpose of creating what they called "art" might begin to give up on the process. Autochromes were difficult to display, and despite the difference Stieglitz talked about in the work of a Steichen and a Jones, if a Jones had any sense of composition and lighting, he could make an autochrome that would bear closer comparison to one of Steichen's than a Jones paper print ever could in comparison to a Steichen paper print. In a great many cases the Jones autochrome might even appear to many eyes as superior to the Steichen because, as I noted earlier, Steichen and Kühn were able to bend the autochrome to their will and use its color more subtly and in a more muted manner than other photographers, and those effects were often the kind most "autochromists" would have eschewed, as is clear from Tilney's comment about the "incomprehensible" background in one of Kühn's works.

Another significant problem the autochrome posed to the Secessionists is that it made them

have to think about color in a way most of them previously had not. It is surely no accident that Kühn and Steichen were the most accomplished of the Secessionist autochromists. Both, but especially Kühn, had worked in colored gum prints and had experience with color. Kühn's pre-autochrome color work illustrates the presence of an actual color aesthetic. Colors, and not always the colors of nature, are chosen for their effects. In other words, Kühn manipulated color in the same way a painter would. And, of course, Steichen *was* a painter. Anne Hammond's excellent essay "Impressionist Theory and the Autochrome" concludes by making the point that "What is needed now is a reappraisal of the Autochrome as an artistic medium with detailed investigation of the colour aesthetics of its individual practitioners."[69] Therein lies, I would argue, the primary reason color fever among the Photo-Secessionists cooled. In most cases, they had no formalized color aesthetics; they may have been brilliant masters of black and white, but that was all and that was not enough. Tilney's criticisms can for the most part be seen as responses to that very omission, and his praise for Eugene probably reflects the fact that Eugene was trained as a painter. The presence of color places an additional set of demands upon any photographer's craft. Youth's self-confidence, the inherent beauty of the autochrome process, and some initial successes may have made Coburn think he was photography's Whistler, but a year of autochrome work may have suggested otherwise.

Scott, and presumably Coburn, after Coburn's nine months or so of practice from September 1907 to probably early summer 1908,[70] concluded that the power of the autochrome resided primarily in the plate itself and not in the hands of the photographer; consequently, the autochrome was incapable of real art. Of course, J. C. Warburg, a "professional" autochromist and highly artistic photographer, had said, "I was asked by a well-known photographic scientist whether I did not think that the technician would produce better Autochromes than the pictorialist. My reply was that . . . the artist's selection was even more necessary than it was in monochrome work."[71] In "The Success of Color Photography," a review of the 1912 Professional Photographic Society of New York's "most noteworthy and comprehensive exhibit of autochrome portraits, landscapes, still lifes and interiors ever assembled either in America or Europe," the reviewer commented that the collection "proved that color work in the camera is not altogether an automatic process, that it can be made to answer the demands of the artist to a remarkable degree of perfection." There were "unfortunate renderings," as well, but they were "the result of unfamiliarity with the tricks of Lumière plates—experience will surely give full control."[72] Clarissa Hovey, speaking before the Women's Federation of Photography of this same exhibition, said, "One of the most interesting things to me in this wonderful exhibition of 200 autochromes was the *great* individuality in the

work. It seems hardly possible that autochromes *could* be of such different qualities that you could identify the plates of the different photographers almost as easily as you can identify paintings by artists of different schools. . . . The whole story, after all, is the 'man or woman behind the camera.' If you have a sense of color combinations, and of composition and posing, you cannot fail."[73]

Though there is truth to what Warburg and Hovey and the reviewer said, especially about the matter of experience and "a sense of color combinations," there also is truth to what Scott said. Like Daguerre, the Lumières had created a self-sufficient process, though hardly the Frankenstein that Scott described. The autochrome did possess many of the most attractive properties of the daguerreotype. If a photographer had the craft to make it and the eye to compose it, it would be good. The process itself assured that. There was probably no fiercer period of competition in American photography than the daguerreian era, and it was because so many daguerreotypists were so good. The dominance of paper brought a general lowering of quality to photography, though the most proficient of the paper photographers naturally ascended. Paper made artisanry easier to detect because the medium itself was drab and dull compared to the bright silver of the daguerreotype, the daguerreotype's precision, and the incredible variety of tones the plate could produce. Therefore, skills developed that made paper more attractive, that gave photographers great power and control over the image. They could create striking tonal gradations, haunting blacks, glowing whites, effects nearly as beautiful as any found on a daguerreotype plate, which, we might recall, was what Ansel Adams said he used as a measuring stick by which to judge his own work.[74] And then the Lumières reinvented the daguerreotype, but in color!

The only thing that is surprising about the Photo-Secessionists' involvement with the autochrome is that they did not realize that a great many photographers took the discovery of color far more seriously than they did and worked at it with far greater intensity than any of them, including even Kühn, who did, however, continue making autochromes until 1913, which also helps to account for his greater success with the autochrome than any of his colleagues. But compare Coburn's one hundred or so surviving plates, which may actually be the bulk of his work, and the 1,300 Gervais Courtellemont made on a single trip in 1908! With as many exhibitions as were being held prior to 1914 and with as much work as there was for people to see, any inferior autochrome or plate exhibiting limited "experience" would clearly stand out, as it did to the reviewer of the 1912 exhibition and to Clarissa Hovey, who commented that some she would "have thrown in the wastebasket" (p. 355). Eventually the Secessionists must have realized that if they were to continue posturing about each other's brilliance with the process, it was not just color they were dabbling with; it was their reputations as well.

... as if a magic lantern threw the nerves in patterns on a screen ... T. S. ELIOT

Color Triumphant

Though the Secessionists may have given up on the autochrome, the process continued to flourish. It is unfortunate, however, that they abandoned it. The ability, the power, and the influence of those men were such that had they continued with the autochrome and experimented as diligently as Courtellemont, for example, who admitted that of the 1,300 plates he made on that one particular trip, only 60 percent were, in his opinion, "satisfactory transparencies,"[75] then the autochrome, though neither the simplest nor the most perfect of photographic processes but clearly the most beautiful, would not have slipped into its present obscurity.[76]

Seeley seems to have continued into the mid-1920s, because a plate price list of March 1925 was in the back of his copy of the Lumière manual.[77] However, he seemed to have used it more for the purpose of making color snapshots than for making carefully composed still lifes such as those he had made earlier, the success of which, as in Eugene's case, was probably in part due to his art school background and experience with color. Steichen's abandonment is more surprising and probably had more to do with emotional matters than any lack of ability to make the autochrome perform exactly as he wished. In 1914 war drove Steichen from his home in France, and he records that Stieglitz's personal collection "contains the only surviving record of most of my early work. During World War I, we had to leave my negatives behind, uncared for, in our home in Voulangis when we left. During the four years of the war, humidity and bacterial action destroyed the emulsions. The plates were ruined."[78] If he had to leave ordinary negatives, certainly the hundreds of bulky, cumbersome glass plates were also left behind and ruined.

Steichen's work took a dramatic shift during and immediately after the war years, and so the autochrome, like his earlier Symbolist vision, may in 1918 have seemed, amid the ruin of his plates, an irrelevant vision of a lost time. Eugene was still working in the process as late as August of that year, the date on his autochrome self-portrait (plate 14); however, the particulars of his career after World War I are a mystery. Stieglitz had little opportunity to autochrome except in summers and was probably doing little work after the summer of 1911, when he made his last trip to Europe; however, Sue Davidson Lowe states that he continued until 1914 (pp. 81, 442). We can be certain

he was still working in the process as late as fall 1910, when he met Abraham Walkowitz, because autochrome portraits of Walkowitz exist. Though the quantity of Stieglitz's work is limited, it is highly impressive, if only for its compositional skill. White, Haviland, Coburn, and de Meyer, who destroyed the bulk of his work in 1935,[79] all seem to have lost interest between 1908 and 1910, though Karl Struss, who did not take up the process as early as they had, continued making plates somewhat longer, probably to about 1913.

Apart from Kühn and Arnold Genthe, the process found its greatest exponents, though, in men and women far from the power centers of photography, individuals whose names and work, despite all of their brilliance, are excluded from the standard histories of photography—Wladimir Schohin, Leonid Andreyev, Gervais Courtellemont, Helen Murdoch, Franklin Price Knott, Hans Hildenbrand, André Meys, J. C. Warburg, Fernand Cuville, August Léon, Antonin Personnaz, and those two inspired women we know so little about, Mademoiselle Mespoulet and Mademoiselle Mignon, who autochromed Ireland in 1913. These are not stray names pulled from the old hat of history; these are individuals whose work has survived in numbers significant enough to have inspired volumes of study—there are about three thousand extant Courtellemont autochromes!— and whose work, with the exception of Andreyev's, has all been housed in accessible major collections in the United States, England, France, and Finland. With very few exceptions these are not even obscure and unknown names. Courtellemont and Hildenbrand were world famous photographers whose *National Geographic* photo essays had been seen by millions, and in that fact alone lies much of the reason for their neglect.

Alfred Stieglitz instilled in the photographic community—or at least that part of it which interacted with museums and wrote about art and photography—a prejudice against the "professional" which has only recently begun to dissipate. It was as if photography had to be a function of leisure in order to be any good. He lavished praise upon the amateur and heaped derision upon the professional, often to the point of breaking off relationships with colleagues.[80] The contribution of amateurs not only to photography but to the history of the world's accomplishments is indeed significant, for art, philosophy, botany, literary study, and archeology were the exclusive province of the leisure class for centuries. Of course, it is also interesting to consider how art and how much of the look of the history would have been lost had photography remained the plaything of Fox Talbot, another brilliant and unhurried amateur, had it not been for that antithetical personality the "professional" artist-entrepreneur L. J. M. Daguerre. A work of art cannot be judged by the motive behind it or sneered at because it is to be sold. Michelangelo's work was also for sale. For whom was a work of art made and what, if anything, was exchanged for it are among the most important

questions a critic can ask; however, such questions have nothing to do with connoisseurship and should not intrude upon one's judgment of the work. That Stephen King's books are produced for a large popular audience—the same audience, by the way, that Shakespeare's plays were written for—neither damns Shakespeare nor suggests that King is worth reading.

The Age of the Amateur was a product of the eighteenth-century leisure, and those leisured amateurs' most notable accomplishments were in architecture, conversation, and the sciences. Who would not like to think of himself as a Lord Burlington, who built Chiswick, or of herself as a Madame du Deffand, whose salon was one of the centers of European civilization? And if, like Stieglitz, one is fortunate enough to have an inheritance, then a variety of charms are within one's grasp. But an aesthetic built around the luck of one's birth seems even more eccentric than a government built upon similar accidents. Nonetheless Stieglitz's prejudice is still with us; there is art photography, which is viewed reverently, and then there is commercial photography, which is viewed less reverently. The great commercial photography of Outerbridge, Zwart, Sheeler, and others has really not changed these attitudes. We might look at certain advertising photographs aesthetically, but the subcategory of their original purpose is always present and often actually referred to; it is Outerbridge's Ide Collar ad or Sheeler's work for Ford. Only recently, in Sheila Metzner's exquisite work, does purpose seem to fade in the presence of the photograph itself, and the image is judged for what it is and not why it was made. Unfortunately, though, historians and critics have not been as enlightened with regard to the past and to the autochrome in particular.

Certain aesthetic characteristics of the autochrome seem to be present regardless of whose hands worked the process. Few photographers have had a style either on paper or in autochrome as distinctive as that of Heinrich Kühn's; however, Ferenc Morvay, an amateur Hungarian autochromist about whom nothing but the month and year of his death are known and nine of whose autochromes have been published, produced a still life of apples, pears, peppers, and a cup and saucer on a tablecloth so stunning in its simplicity that anyone might mistake it for one of Kühn's. He also has a hydrangea in a vase that, were the vase not so vertical, centered, and inappropriate to the flower's shape, it, too, might be mistaken for one of Kühn's, and still another autochrome one might easily think by George Seeley.[81] The similarities do not reside in the subject matter but in the process. It is as if the process itself had rendered all of them objects of desire.

I have never seen an autochrome still life that could not have been used as a stylish advertisement, a fact that implies neither criticism nor praise, but is merely a statement of the autochrome's psychological effect. And the reason resides in the light. It is as if light's diffusion invokes, for want of a more precise word, *sentiment*. Whether this is truly psychological or a Western cultural

response, it is difficult to say, but the makers of greeting cards and advertisers of everything from diamonds to deodorant have long been aware of the effects of soft focus and filters on consumers. Such effects always suggest intimacy, nostalgia, or deeply felt emotions and signal in the viewer a kind of calm, a desire to look longer and to possess. It is the aesthetic of the veil, an aesthetic which tempts us with the forbidden, the secret, or the unknown.[82] Metzner presents all three of these temptations in her work through the effects of the Fresson process, which renders color more like an autochrome than any other paper photograph; her black-and-white work, interestingly, has been considerably less successful. Robert Farber, whose work is extremely popular, quite well known, and not taken very seriously by the art and museum crowd, describes in detail the techniques used to produce each of his photographs. They usually involve the coating of a filter "with petroleum jelly" or gauze "for added diffusion" and pushing ASA 160 film to 640 or 1000 or ASA 200 to 1000 or ASA 400 to 1600. Though we may smile at his techniques and though museums may not hang his work, much of it is clearly beautiful and clearly affecting. Once again, the reason resides in the veiled light. And though few people would deign to speak seriously of David Hamilton's work, with its blending of kitsch and soft pornography, he does achieve many of the same effects of autochromal light, and several of his individual images, lifted from their prurient context, might also seem beautiful and affecting.

The breakdown of light and the suggestion of the veil appears to be a signal for a different kind of looking than we normally perform, a kind of looking that is accompanied by an inherent and positive emotional response to what we see. I earlier suggested that the "straightness" of the autochrome made it one of the various bridges into modernism. That straightness fused to the still life, to the world of relatively dateless, pure objects produced its own kind of new objectivity, and that effect yoked to broken light—clear, precise, but diffused—produced images that caught the tensions of the modern world but were tempered by deep, positive emotional responses. That is the real magic of the autochrome, and among those less well-known masters it is seen nowhere better than in the work of Wladimir Schohin.

There is no doubt that Schohin was Kühn's equal as an autochromist and on the basis of his autochrome work alone could be considered one of the greatest photographers of the century. Like Kühn he offers an intensely tranquil vision of the things of this world, the simple stuff out of which our days are made. And though elegant and stylish, his world, unlike Kühn's, is the modern world. His autochromes look as if they could have been taken yesterday. The cropping in some of his work is as radical and as daring as one might find in a contemporary photograph. No symbols here, nothing idealized, just the objects themselves. Schohin, like Kühn, takes us to the things of this

world, but things at their most elemental levels. Of all the photographers we might apply the term "Symbolist" to, Kühn is the most subtle, the least heavy-handed; however, we sometimes feel as if Kühn is asking us to read even the simplest of his images, a still life with three apples and a checkered cloth, for example, as a metaphor for the ideal. That is never the case with Schohin. We look at his astounding *Still Life with Egg* (plate 26) and are left thinking of nothing but the purity of the egg itself. No metaphor intrudes, no philosophy, no contemplation but thoughts of the egg alone, the cracked shell, the white, the yolk—nothing else. His breakfast table, his fruit, his tea and honey are all equally objective in their presentation. Where Kühn could bend the autochrome's straightness to his own more lyrical vision, Schohin pushed that straightness to a more intense realism than is found in photography until several decades later. Both of their visions read like poetry—Kühn's like Rilke, Schohin's like Eliot.

Wladimir Nikolaiovich Schohin was born in Helsinki on December 17, 1862, and died there on January 27, 1934.[83] He and his brother operated a Russian general store in Helsinki. He was also in charge of the Russian Merchant Library, which he had founded, and for thirty years served as the librarian of the Amateur Photographers' Club, which he had joined in 1899. In a year's time he was taking awards for his work. Reviewing the 1907 exhibition, Daniel Nyblin, who opened the first photographic store in Finland and was one of the fathers of Finnish art photography, wrote of Schohin in his photographic journal *Nyblin's Magazine*, "He has a collection of the most delicious small pictures to be imagined, some in gum print, some in carbon print. What lines, what tones! All is perfection, harmony, completeness. The first prize awarded Mr. Schohin is not enough, he should be given an extra something!"[84]

At this same 1907 show Nyblin exhibited among his own work the first autochromes shown in Finland. The plates had reached Helsinki in August 1907. The commercial photographers in Finland were completely uninterested in the autochrome, a few of the other art photographers tried it, but it was really only Schohin who took to the process. Fortunately, he had both the money and time to experiment with it. According to Bert Carpelan, at the meetings of the Amateur Photographers' Club "Schohin's color pictures were admired and projected with a magic lantern that had been imported from America."[85] Carpelan also noted that Schohin's extensive knowledge of international art photography was the result of his being librarian and "supply supervisor" for the Amateur Photographers' Club and suggested that "his color pictures were influenced by contemporary painting, perhaps most by Impressionism." However, this is hardly possible.

Schohin's work has nothing in common with the Impressionists and little even with those Post-Impressionists like Seurat whom he might be compared to. Schohin's autochromes are the

least autochromal of any autochromist's work, which is precisely what gives them much of their look of such intense modernity, that look of exposed nerves. One can even see that look in the portrait of his wife, Nadezda Andreyevna (plate 29), where she sits in an imposing red blouse, turned from the camera and looking like one of those terrifying Nordic visions of the female, a vision out of Munch or Strindberg or Bergman. All those innate softening qualities of diffused light and autochromal warmth freeze up in this portrait, though there are portraits of her in which this does not happen. In fact, this is the most unnerving autochrome portrait I know of. The turn from the camera, the intensity and concentration of the red, the austerity of the backdrop all work to raise it to a pitch of near hysteria. It looks like an image from Ingmar Bergman's *Cries and Whispers.*

Schohin's familiarity with the art world of his time would make it conceivable that he could have been influenced by a painter, but certainly not an Impressionist! His contemporary from Denmark Vilhelm Hammershøi is more likely. Hammershøi was one of the European masters of the domestic interior as well as an incredible technician with light.[86] His portraits are highly photographic, intensely lit, and usually contain a figure turned from the artist. They are as beautiful as Schohin's portrait, but his interiors are not the sunny interiors of Vermeer; one can almost sense the scream forming in each of them, as pristine and beautiful as they are.

The straightness of the process seems straighter in Schohin's hands than anyone else's. The reason may have to do with another matter Carpelan refers to. "It seems probable," he writes, "that he also succeeded in influencing the autochrome color by using different tinted filters" (p. 123). Perhaps this explains something of how his autochromes seem to go beyond even the Lumières' own plates in the intensity of their color. Again, if we are to think of Schohin in the context of European painting, the brightness of Fauve color is what comes to mind; however, such Fauve influence and such color is not generally thought to have come to Finland until Tyko Sallinen's 1912 exhibition, which was as shocking and controversial as the 1913 Armory Show was in the United States.

With Sallinen the Finnish modern movement began,[87] and though some of Schohin's work might look old-fashioned next to Sallinen's, his color is far more Fauve than Sallinen's and his composition through his use of cropping and arrangement is more modern than Sallinen's. It is Sallinen's Expressionism, possible with a palette but not a camera, that gives his work at times a more modern look. But on the basis of what Schohin accomplished in his autochromes, there is good reason to date the birth of Finnish modernism five years earlier than Sallinen's 1912 exhibition. Wladimir Schohin's work, more than that of any other photographer I know, calls out for a

monograph and for more study. Though he was not influential outside of Finland, his work towers over that of most photographers—past and present. As I said earlier, the genius of Heinrich Kühn's work is that it can immediately create a sense of calm, but it is a calm we always recognize as being from the past and at an impossible distance from us. It is like looking into those beautiful slanting eyes of a Sienese saint: they affect us but are too removed from us to effect belief; too much has passed between their gaze and ours. But Schohin's genius is a calm we can believe in, one we can effect in our own lives. The nerve endings may be showing, our field of vision may be chopped off at the edges even, but order is still possible. The table can be set, bright jars placed in the light, the fruit arranged, and the potentially frightening woman in red may not be frightening at all; she might just possibly even be smiling.

And onward, as bells off San Salvador

Salute the crocus lustres of the stars,

In these poinsettia meadows of her tides,—

Adagios of islands, O my Prodigal,

Bind us in time, O Seasons clear, and awe.

O minstrel galleons of Carib fire,

Bequeath us to no earthly shore . . .

HART CRANE

Voyages

The early autochromists had, in a sense, set out on color voyages and returned with pictures that looked as if they were from some star-flecked, unearthly shore of floral tides and Carib fire. Many of these photographers were part of Albert Kahn's ambitious project to create a photographic encyclopedia of the world, a project that resulted in 72,000 autochromes. A great many were *National Geographic* photographers, also off on exotic shores capturing the world for the *Geographic*'s readers and leaving an archive of some 14,000 autochromes and other early color plates. And then there were the brilliant amateurs, like Fritz Paneth, a Viennese chemist, who used the process on his holidays but produced an impressive and important body of work. Two of the most remarkable of these voyaging autochromists were professional photographer Arnold Genthe, whose studio was in the United States but who photographed worldwide, and Russian writer and amateur photographer Leonid Andreyev, the majority of whose work was done in Finland and Italy.

Genthe was one of the great photographers of the century. He is particularly known for his dance and travel photography and his series of views of San Francisco's Chinatown. His work was equally popular in art and commercial circles. He was a professional photographer whose work was frequently in magazines; however, Stieglitz bought examples for his own collection and White had

him lecture at the Clarence White School. Genthe came from a highly literary and aristocratic German family. His father's uncle was a biographer of Hegel and occupied the chair that Kant had held at the University of Königsberg; his grandfather had written some thirty philological and literary studies; his father's doctoral thesis was on the life of Lucan; and Genthe himself discovered and edited a group of lost letters from Hegel to Goethe which dealt with Goethe's Color Theory and shed new light on aspects of Hegelian philosophy. Genthe also wrote a critical analysis in Latin of Lucan's *Pharsalia* as his doctoral thesis, and it received favorable reviews when it was published. In 1895, instead of seeking a university instructorship as he had planned, he took a position as tutor to the son of a German baron in San Francisco. This brought him to America and his first camera.

Genthe's autobiography *As I Remember* reads like a chronicle of life among the world's richest and most famous for the first thirty-five years of the century. He was friends with the great art collectors, the actresses, the dancers, the writers, the painters, the politicians—actual friends with them, not simply their photographer. Of course, de Meyer also knew *la dolce vita* and seemed to lead a charmed one, of a sort, but Genthe surrounded himself not just with the beautiful people but with the intelligent ones as well, and he never stopped reading. The only individual in the history of photography he might be compared to in terms of the breadth of his interests, his intellect, and his immense talent is Fox Talbot.

Immediately taken with the autochrome, Genthe, unlike the Secessionists, still had a great deal to say about it in his autobiography years later. He had been interested in color photography for some years and from the turn of the century had made Ives Kromscop transparencies, which were three separate, singly colored plates wedded together to produce one multicolored image. In a most telling comment made about working with color, a comment that Frederick Colin Tilney might have used in his review of the Summer 1908 *Studio*, Genthe noted that "the photographer whose eye has been trained to see the hues of nature in monochrome will find it difficult, when he tackles color photography, to see subjects as color compositions. As long as he gets color he is likely to be satisfied, regardless of any relation of values."[88]

Genthe's first work was done at Carmel in 1907 where, he commented, "the always varying sunsets and the intriguing shadows of the sand dunes offered a rich field for color experiments. I gradually made myself familiar with the intricacies and uncertainties of the process, and I now was ready to turn my attention to making color portraits" (p. 106). Shakespearean actress Julia Marlowe and her husband Edward Sothern "were the subjects of [his] first really ambitious venture in color photography" (p. 113; see note accompanying plate 46). The success of his portraits and landscapes led to a two-week exhibition in 1911 at the Vickery Galleries in San Francisco. Though this was

not "the first exhibition in America of color photographs," as Genthe thought it was, it was among the earliest. "The exhibition created a real sensation and the public as well as the press were generous in their praise," he wrote (p. 118). It included "poppy and lupin fields, cypresses and cliffs of Point Lobos, a rainbow reflected in the wet sand of the beach at low tide, and a whole series of sunsets," as well as portraits of "beautiful débutantes," "stage celebrities," and Genthe's "Bohemian friends."

In the spring of 1912 Genthe, now in New York, held another exhibition of these California autochromes, which, he said, "was a novelty for New York" (p. 122). This is a most interesting remark in terms of trying to sort out the actual history of the autochrome from the self-promotional pronouncements of the Photo-Secession. Genthe accomplished a great deal in his lifetime, which he refers to in his autobiography with pride, though never with boasting. Reading his restrained prose makes one even more embarrassed by Stieglitz's. To say that an autochrome exhibition in New York in 1912 was a "novelty" and then to back up the assertion with facts casts a curious light on those highly touted autochrome exhibitions (September 1907; November–December 1907; March 1908; January 1909; February 1909; and January–February 1910) that Stieglitz held. Were Stieglitz's exhibitions not as significant as he said they were and as the photohistory books would have us believe? Or did the work of Stieglitz, Steichen, Eugene, White, de Meyer, and Laurvik, whose autochromes were shown at those exhibitions, pale by comparison to Genthe's? It would seem that one of these possibilities is the case.

That 1912 exhibition at Genthe's studio brought out among others Dr. Alexis Carrel, a friend of the Lumières', who was so impressed with Genthe's work that not only did Carrel have him photograph his wife and himself but also made a point of having Genthe meet one of the Lumière brothers when he came from France later that year, a visit the Photo-Secessionists seem to have taken no notice of. John Patterson, the founder of Dayton Cash Register Company, also attended the exhibition and commissioned Genthe to make a series of autochromes of his plant and factory.[89] Another visitor was Belle Da Costa Greene, director of the Morgan Library, who was so impressed with Genthe's work that she introduced him to J. P. Morgan, who had Genthe autochrome his private rooms, various treasures, and many of his paintings.

Morgan liked Genthe's autochrome of his Ghirlandaio so much that he had him make copies, which he mounted in Morocco cases and gave as Christmas cards (pp. 122–24). Genthe was asked to spend Christmas with the Morgan family that year and put on a lantern slide show of autochromes that would please the children. He describes in some detail having to devise a lantern big enough to project the autochromes and a cooling device to keep the heat from harming them. He

even secretly autochromed Morgan's dog, which Morgan seldom let out of his presence, and commented that Morgan liked the dog portrait best of all. Genthe wrote, "The homey atmosphere of the entire evening was a reflection of that simplicity which is ever the mark of true greatness. The presents, displayed on tables in the living room, were just such gifts as might be exchanged in any well-bred American family of moderate means. . . . It all gave quite a different impression from the austere and unbending autocrat which has been handed down by some of his biographers" (pp. 125–26).

The extent of Genthe's autochrome work is difficult to assess. His personal collection of his own autochromes was in excess of four hundred. Toward the end of his life, he gave his friend Dorothy Wilcock Neumeyer twenty to twenty-five of them and negotiated with the Library of Congress for the sale of 384; however, according to James F. Carr, a leading Genthe collector and friend of Dorothy Neumeyer, "From the many conversations I had with Dorothy I think that most of the glass negatives, including the Autochromes went into the dumpster when the studio was being cleaned out."[90] In addition to Genthe's own collection, he made autochromes professionally, which came in expensive leather-covered, plush-lined diascopes with Genthe's name stamped into one of the metal flaps that supported the autochrome when it was in the viewing position. Possibly he got this idea from J. P. Morgan's Christmas cards. Genthe's feelings about the autochrome as he reflected on it years later is at such variance with those of the Secessionists that one becomes even more convinced that most of them simply had not adequately experimented with the process. He even returned to the autochrome in the final pages of *As I Remember* to say that color photography in 1936, with its "modern improved methods," was "sometimes neither technically nor artistically" superior to the "color reproductions which were made almost a quarter of a century ago from the simple autochrome plate" (p. 268). Genthe's own autochromes are certainly artistically superior to the majority of his contemporaries' work and to the majority of today's color photography as well.

Though Genthe was always known as a photographer, Leonid Andreyev was not. He was one of Russia's great writers. Unknown to everyone but his descendants, he was also one of Russia's great pre-Revolutionary photographers. While in Paris researching a book on Andreyev in 1978 Richard Davies, a lecturer in Russian studies at the University of Leeds and archivist of the Leeds Russian Archive, discovered Andreyev's photographs still in the possession of the family. Apart from the family and a few friends, he was the first to see them and recognize their importance. There were 1,500 black-and-white stereographs and 300 autochrome stereographs, though it was clear from Andreyev's numbered labels that between 1908 and 1914 he had made some 400 auto-

chromes. The stereograph is a pair of images that gives the illusion of depth when viewed through a special viewer because of the brain's ability to fuse slightly different images seen by each eye into a single three-dimensional image. Those 300 autochromes are now housed at the Russian Archive of Leeds University, and twenty are at the Andreyev Museum in Orel, Andreyev's birthplace, several hundred miles south of Moscow. The importance of the find has not been adequately assessed by the photohistorical community, but it is clearly one of the most important photographic discoveries ever to have been made. It would be like discovering that Eugene O'Neill, for example, had left 300 paintings as good as Monet's. Andreyev's autochromes are as fine as anyone's and better than 95 percent of all the photographers who made them. His work ranges from rigorously composed formal portraits and landscapes to lyrical snow scenes, forest studies, and portraits that seem as casual as snapshots, though they are not.

Andreyev was born in 1871 and died of a hemorrhage of the brain in 1919.[91] His first collection of stories was published in 1901 and brought him immediate fame. In four years it went through several editions and sold tens of thousands of copies. But in 1903 he became even more famous when he was attacked for writing pornography in *The Abyss* and *In the Fog*, which dealt with the sexual problems of young people. This turned him into one of Russia's most controversial writers and also one who was watched by the secret police. He was arrested and imprisoned for a while for political reasons and then had to flee to Germany following the 1905 Revolution. In 1906 he returned to Finland, a semiautonomous grand duchy, where he felt relatively safe. His plays continued to be performed in Moscow, he continued working, his reputation continued to grow, and then in 1908 he produced his masterpiece, *The Seven That Were Hanged*, which sold hundreds of thousands of copies worldwide. Andreyev supported the Kerensky government, but when it fell to the Bolsheviks, he again left for Finland. Arranging an American tour to speak out against Bolshevism, he collapsed and died on September 12, 1919, at the age of forty-eight, leaving both literature and photography robbed of a giant. More than the length of his entire lifetime later, thanks to the scholarship of Richard Davies, the history of photography demands the inclusion of a new name.

The neglect that photography has suffered until recently within the field of art history and the neglect of the autochrome within the field of the history of photography has resulted in the loss and destruction of much important work, work that might help better shape our picture of art in the first part of the twentieth century. Davies's discovery of a major autochromist is important primarily to the history of the autochrome and of photography, but photohistorian Alan Johanson's discovery of the work of B. J. Whitcomb is important to our understanding of links between painting and photography where previously they had not been evident. Again, I would argue that

the most serious artistic photography does not imitate an aesthetic that might be seen elsewhere but reflects that same aesthetic because both are part of a larger movement—in the case of the Symbolist photographers, a large international movement; in the case of Whitcomb, a smaller national movement.

By the turn of the century the Boston School of painters had created a distinctive style. "A certain Boston look was discernible," according to Trevor Fairbrother, a look from a "landscape of pleasure."[92] In the hands of Frank Benson, William Paxton, Thomas Dewing, Lillian Hale, Edmund Tarbell, and other of these Bostonians, that sybaritic vision was shaped into one of the great moments in American art. But it was also a look that entered American graphic design, commercial art and advertising, and our popular consciousness as well. It became the self-image of America, and it can be seen reflected in the pages of any magazine of the first decade of this century. However, it is conspicuously absent from our photography. Had Gertrude Käsebier worked in color, we would recognize it in her work, but it is a vision to which color is so fundamental that without it the vision itself is unrealized, as in a black-and-white reproduction of a Benson or Paxton painting.[93] Clearly it was a vision the autochrome was made for, but curiously enough most of the photographers who could have achieved it either partook of a Symbolist or modernist vision that excluded it or simply did not, as in Käsebier's case, work in autochrome—except for B. J. Whitcomb.

Whitcomb operated a studio and gift shop in Kennebunkport, Maine. The fifty autochromes that Alan Johanson discovered in an antique shop in Amarillo, Texas, in 1985 recorded a trip by the Whitcomb family to Bermuda, family and floral portraits, Whitcomb's studio, and scenes in Kennebunkport. How this box of autochromes got to Texas is a mystery, and, of course, one wonders if there were other boxes. The Kennebunk Historical Society has examples of Whitcomb's paper work and a bill of sale for his studio when he moved to Kennebunkport. The rest of his biography is guesswork based on the fifty autochromes. Although the Whitcomb studio and gift shop was modest, in the portraits the family looks well-to-do. They took an ocean liner to Bermuda. There is a beautiful, unidentified green and summery house with just the sort of porch Frank Benson would have painted his daughters on. It might have been the Whitcombs'. The flowers about it suggest the plate of Inez Whitcomb's handsome rose garden. "Jay's Play House" was big enough for a person to have lived in, but did it belong to the elegant boy in plate 55, and was he the Whitcombs' son? There are autochromes of the homes of writers Booth Tarkington and Kenneth Roberts, both identified rather informally as Booth Tarkington's and Kenneth Roberts's "Place," but does that informality suggest friendship? Could Whitcomb have been part of the world

that might actually have known Benson, who, like several of the Boston painters, spent his summers in Maine during the very years these images would have been made? All that can be assumed is that Whitcomb's fifty autochromes are unlike anything else we have in American photography from this period, and that they present that "landscape of pleasure" which was the defining quality of America's first modern image of itself.

About the same time Whitcomb was autochroming the United States, Albert Kahn, a wealthy French banker about whom little is known, decided that he would have the whole world autochromed, and he just about did. The crashes of 1929 wrecked his financial empire, but he did not stop his project, known as the "Archives de la Planète," until 1931. The result, spanning over twenty years from 1909 to 1931, was 72,000 autochromes of Albania, Germany, Great Britain, Austria, Belgium, Bulgaria, Spain, France, Greece, Hungary, Ireland, Italy, Monaco, Norway, The Netherlands, Sweden, Switzerland, Afghanistan, Saudi Arabia, Cambodia, China, Cyprus, India, Iraq, Iran, Israel, Japan, Jordan, Lebanon, Mongolia, Pakistan, Syria, Turkey, Ceylon, Vietnam, Algeria, Benin, Djibouti, Egypt, Morocco, Tunisia, Brazil, and Canada. Kahn also had films taken in most of these countries and in fifteen others that he did not have autochromes made in, the result of which is ninety-five hours of rushes primarily, though a few films were edited. He had extensive plans for the autochroming of Russia, South America, and the United States, but the crash prevented this.

Albert Kahn was a most remarkable man. Born in 1860, he took a minor position in a bank when he was nineteen and that year hired Henri Bergson, who was to become one of the century's great philosophers, as his tutor for three years to help him prepare for his *baccalauréat*, which he received in 1881. By 1892 he owned the bank. By 1898 he was awarding travel scholarships for bright young graduates to spend fifteen months forgetting about books and learning by observation from traveling around the world. He funded the chair in human geography held by Jean Brunhes at the Collège de France and in 1912 appointed him the scientific director of the "Archives de la Planète." He had also established one of the world's great private gardens at his estate in Boulogne, which became one of the intellectual centers of Europe. The Albert Kahn scholars worked there, and it was also frequented by the leading international figures in art, philosophy, and politics—people like Einstein, Marshall Foch, Rothschild, Michelin, Colette, Valéry, Gide, de Falla, Milhaud, Tagore, and royalty from the world over. Kahn established an international committee to study various political, economic, and social problems, and personally edited thirteen publications which looked into such problems and which he sent free of charge to an international elite of some three thousand people he felt should be kept abreast of such matters. By 1936 Kahn was completely

ruined; his assets were attached, and four years later he died at the age of eighty. Fortunately the Département de la Seine stepped in when there were no buyers of the estate and saved it from being simply chopped up and destroyed by real-estate promoters. Today the Département des Hauts-de-Seine administers the Musée Albert Kahn, which maintains the autochrome collection and the gardens.

Kahn was dedicated to the idea that "Life is all that matters. It has to be captured." And he insisted that his autochromists "capture once and for all those aspects, practices and fashions of human activity which are bound to disappear in time."[94] The historical importance of what Kahn left the world is immense. Were it not for him we would know far less of how the world had looked, and it is particularly fortunate that he knew Louis Lumière and decided that his photographic encyclopedia of the world should be in color. The autochromists Kahn hired were, needless to say, the finest money could buy. He had one, Roger Dumas, spend an entire year in Japan, the longest of any of the overseas assignments.[95] Kahn had seven primary autochromists who worked on the project, some off and on and some for many years running: Auguste Léon from 1910 to 1917; Stéphane Passet from 1912 to 1914 and then again in 1929;[96] Georges Chevalier from 1914 to 1917 and 1926 to 1927; Paul Castelnau and Fernand Cuville from 1917 to 1918; Frédéric Gadmer in 1919, 1921–1924, and 1926–1931; and Roger Dumas from 1921 to 1932.

And then there were Kahn's occasional operators: Léon Busy, who produced over a thousand plates of Vietnam and Cambodia;[97] Chastenet and Bernadel, who documented the trenches of 1914–1918; a Professor Brunhes, who traveled on some of the expeditions; possibly Gervais Courtellemont, to whom some of the Tunisian autochromes are attributed; and those extraordinary ladies, the Mesdemoiselles Mespoulet and Mignon, who autochromed Ireland for Kahn in 1913. One had a degree in English and the other in mathematics. Apparently they both had been Kahn scholars in 1907 and 1910 and knew the world well enough to be undaunted by the prospect of going into the most primitive and out-of-the-way regions of Ireland with their cameras and boxes of glass plates. Their work consists of pictures of monuments, ruins, and people, primarily women. Their portraits of barefoot Irish peasant women spinning their thread, selling fish, making the fringe of shawls, or proudly showing off a bright cape are among the most noble and moving portraits of women in the history of photography.

But apart from the historic and social importance of these photographs or any of the others from the Kahn Collection, many of them are indisputable artistic masterpieces that need to be removed from their documentary context and viewed as aesthetic objects. Fernand Cuville's portrait

of the girl in San Zeno (plate 58) is probably as fine a photographic work of art as there exists. The elegant balance of its composition, the striking play of light, the intensity of the black, the emotion aroused by the child—all work to bring us back again and again to look at it. And that is the mark of the greatest works of art—their demand to be reread, listened to again, looked at again. Great art will not leave us alone. Though perhaps not as insistent as the San Zeno portrait, Cuville's picture of the young Italian girl (plate 57) also continues to insist that we look again, as do a great many of the others. I have seen about 400 of the Kahn autochromes, or not quite .006 percent of the collection. The thought of what might be in the other 71,600 is humbling. There are few people in the entire history of photography we are as indebted to as we are to Albert Kahn. His legacy is so rich that it will be offering fresh, unseen treasure for generations.

Though not as rich as the Kahn Collection, the National Geographic Society's collection of autochromes is certainly the second richest. Between 1914 and 1937 the *National Geographic Magazine* published over a thousand autochromes. Gervais Courtellemont was the most prominent of the autochromists who worked for the *Geographic*, and it published 359 of his autochromes;[98] however, some of his most beautiful work (plate 40, for example) was never used and has only come to light in recent years. Unfortunately, nothing substantial about his life is known. Letters from him exist in the *Geographic*'s files, and there are scattered references to him in the literature of the time. In the *Photo-gazette* of May 25, 1908, G. Mareschal, who for several years frequently published on the autochrome, discussed a trip Courtellemont had recently taken to the Near East and the work he did while on it.[99] The June 5, 1908, Colour Supplement to the *British Journal of Photography* picked up the story, paraphrased much of it, and reported that "Considerable interest has been taken at various places on the Continent in the Autochromes of M. G. Courtellemont, who has recently returned from a tour in the Near East" (p. 46). Using two cameras that took different sized plates, Courtellemont made autochromes of the interiors of mosques, sunsets, and so forth, all of which were described as being "extremely beautiful" and "excellent." His lenses, apertures, exposure times, and development procedures were discussed as well. Courtellemont developed his plates each evening in his hotel room but postponed intensification until he returned home.

In July of 1908 Léon Gimpel, a fine autochromist in his own right, gave a paper before the Société Française de Photographie in which he made several references to Courtellemont. An abstract of it appeared in the *British Journal* the following month. Gimpel mentioned that Courtellemont wished "to duplicate some of his excellent Autochromes made in the East, for fear that the

originals might be broken," and he discussed how he did it, using "light reflected by white cardboard illuminated by two arc lamps."[100] In 1910 an article entitled "Le palais de l'autochrome" describing Courtellemont's studio appeared in France and was reprinted the following year in England.[101] A February 25, 1911, supplement to the *Illustrated London News* ran an article entitled "The Light of Egypt: Natural Colour Photographs of the Glorious Effects of Egyptian Sunsets and Sunrise" illustrated by Courtellemont. Then in 1912 the brilliant French amateur autochromist Antonin Personnaz made a brief reference to Courtellemont in a discussion of reproductions of autochromes.[102] Though his work became well known in the pages of the *Geographic*, nothing appears to have been written about him again until 1989.

Courtellemont began publishing autochromes in the *National Geographic Magazine* in 1924 and continued through 1930. By 1925 the *Geographic* was publishing over 100 autochromes a year in its pages. The number exceeded 250 in 1928 and 350 in 1929, but in 1930 it dramatically dropped below 100 as the autochromists one after another seemed to abandon the process in favor of others. Courtellemont published his last *Geographic* autochromes that year, and by 1931 he was working in other color processes. Though one Courtellemont autochrome was exhibited at the 1980 Library of Congress *Autochromes* exhibition, five at the companion National Geographic Society *Autochrome* exhibition, and four at the *Farbe im Photo* exhibition in Cologne in 1981, Courtellemont's name was forgotten in the literature of photography until April Howard resurrected it and the names of some of the other *Geographic* autochromists in a 1989 essay.[103]

Of those other autochromists, there is little that presently can be said. Hans Hildenbrand was from Stuttgart. Some 800 of his autochromes exist in the Geographic Society's collection, and he published over 150 in the pages of the magazine. An article dealing with him appeared in *Photographische Kunst* in 1902, and between 1911 and 1919 his color photographs were reproduced in five books.[104] Luigi Pellarano, forty-one of whose autochromes appeared between 1925 and 1927, wrote a 500-page autochrome manual, *L'autocromista e la Pratica Elementare dell Fotografia a Colori*, in 1914. Howard's essay included a good bit of factual information about Dr. Joseph Rock, a botanist, explorer, and photographer whose expedition to uncharted regions of China in the early twenties was sponsored by the National Geographic Society. A few of his autochromes were published in the late thirties, but there are 599 from the China Expedition that never were.

The other *Geographic* autochromists whose names appear again and again in the magazine's pages are Franklin Price Knott, whose work is particularly fine, Fred Payne Clatworthy, Charles Martin, W. Robert Moore, Jacob Gayer, Clifton Adams, and Maynard Owen Williams. And then there are names seen only once or twice: Tassilo Adam, A. Buyssens, Paul Guillumette, Helen

Murdoch, Stephane Passet, J. H. Dorsett, G. W. Cronquist, Wilhelm Tobien, G. Heurlin, Charles Hagle, Martin Hürlimann, and Anthony Stewart. Some of these photographers continued with the *Geographic,* but few facts about any of them except Hürlimann remain. At least the record of these autochromists' voyages into color is preserved, though the facts of their lives have slipped from us. But better those facts lost than their art.

. . . the end of all our exploring

Will be to arrive where we started

And know the place for the first time.

T. S. ELIOT

Returns

Was the autochrome merely a product of a time when Symbolism domi-
nated the artistic climate and influenced even the photography or does diffused and autochromal
light, that aesthetic of the veil, make us see the world so differently from the way it actually is that
we read messages into the broken color? Or is it just the reality of seeing the past in color that
seems so haunting about the autochrome? We know the look of the autochrome era from old
newsreels and are accustomed to seeing the world of the last Czar, the last Kaiser, and the old
Emperor, but we are accustomed to seeing it peopled with men and women whose legs appear stiff
and who seem to walk too quickly. Our actual physical vision of it—jerky and in black and white—
gives it a distance that makes the autochrome's effect jolting. In autochromes the past looks
possible—and attractive as well.

Whether the autochromist was an avowed Symbolist or modernist, whether he or she would
have eschewed all labels but "photographer," whether the autochrome process led photographers
to a "straighter" vision, whether photographers were actually a part of the large international
artistic movements, as I argue, or merely copiers of those movements, and whether the autochrome
is the one area of early modern photography in which the Photo-Secession actually did not excel,
or at least not to the extent of the "professionals," are all academic questions. Their perusal is useful
not for the discovery of answers but because it allows us a focus for our delight. Art demands no
more than its own contemplation, but scholarship can provide a context for that contemplation and
also—and this is when it is most valuable—lead others to take delight in what they had not
delighted in before, to find beauty where they had not seen it previously. The same facts may lead

two critics to opposite positions, but the process of coming to those positions, the process of having looked long and lovingly, is its own end. And if it has brought others to look long and lovingly, even if all the critic's conclusions were erroneous, then art has been better served than if the critic had been more accurate but made no one wish to look again. I do not write this to avoid criticism of my work but to encourage it. If anyone is ever allowed "the final word," then nothing else will ever be said, and the beauty of the autochrome demands a great many more words than mine.

It is an unavoidable fact of the autochrome that it makes yesterday look better than today, and that is certainly one of the conclusions those long and loving looks bring us to; however, it is not an aesthetic conclusion. The autochrome propels us to feelings totally unrelated to art, to feelings that are the province of ethics. It makes us return to one of the oldest of literary themes, that "The world hath mad a permutacioun / Fro right to wrong, fro trouthe to fikelnesse."[105] But perhaps this is what the autochrome's symbology is finally all about, regardless of in whose hands it was practiced. Its symbolism is really a matter of what we perceive after the fact, and the original meaning of any autochrome is irrelevant, or at least of no more consequence than a small historical footnote, in comparison to the greater meaning we give it.

The presence of color makes autochromes seem a product of our time, but the content of all but a few makes them seem at great distance from it. Yet still, when we look at them, it is as if some veiled, soft and more lovely time were close and reachable. In reality, of course, the world never made a permutation from right to wrong or from truth to fickleness; we have been wrong and fickle from the start. But there is a poignancy to the autochrome's nostalgia that the nostalgia of those who came before us did not possess. The world now really "hath mad a permutacioun." Late in the nineteenth century, after describing a "bent World" of bare soil, a world in which man is distanced from nature and can no longer "feel," Gerard Manley Hopkins was still able to write, "And for all this, nature is never spent." But barely a hundred years later, could any poet write so assured and optimistic a line? The "bent World" now may well be broken.

In Proust's musings on the past, he wondered what purpose there was in returning to it if all its inhabitants were gone and "vulgarity and fatuity [had] supplanted the exquisite." His consolation, of course, was the re-creation of that world, the re-creation of its "human atmosphere." That, I think, is the atmosphere we sense in the autochrome. Like Proust, we too know that the idea of any "Elysian Garden" has vanished and that "the real sky [is] grey" above the unpeopled, vacant, and estranged forest. The soft worlds of the autochrome, like the places Proust had known, "belong

now only to the little world of space on which we map them for our own convenience. None of them was ever more than a thin slice, held between the contiguous impressions that composed our life at that time; remembrance of a particular form is but regret for a particular moment; and houses, roads, avenues are as fugitive, alas, as the years."[106] When we look into an autochrome, it is not altogether an aesthetic experience we are even seeking. It is consolation.

Notes

1. "La photographie des couleurs, ses méthodes et ses résultants," *Revue générale des sciences* 6 (1895): 1034–38; "Sur la photographie en couleurs, par la méthode indirecte," *Académie des sciences. Comptes rendus* 120 (1895): 875–76. (Also note "Photographs in Colours: Lumière's Process," *British Journal of Photography* 43 [March 1896]: 183.) "Photographies en couleurs par la méthode indirecte," *Société française de photographie. Bulletin*, Série 2, vol. 14 (1898): 316–17; "Sur la photographie des couleurs," illus., *Société française de photographie. Bulletin*, Série 2, vol. 17 (1901): 204–11, 303–10, 441–49. Also see "The Lumière Process of Colour Photography," *British Journal of Photography* 49 (January 1902): 52–53.

2. "The Lumiere Autochrome Color Process," *Wilson's Photographic Magazine* 44, no. 610 (October 1907): 433.

3. See A. S. Godeau, "Louis-Amédée Mante: Inventor of Color Photography?" *Portfolio* 3, no. 1 (January/February 1981): 40–45, and her "The Great Autochrome Controversy," *Camera* 35 (May 1981): 26, for a discussion of Mante's autochromes, which predate the Lumières' by nine years. In the fifteen or more years since Mante's great-granddaughter, Jacqueline Millet, made her claims in 1976 and produced some two hundred of these plates, they have been published (see Philippe Jullian and Philippe Néagu, *Le Nu 1900* [Paris: André Barret, 1976], pp. 137–44, 156–57, and Jacqueline Millet, *Louis-Amédée Mante et Edmund Goldschmidt* [Paris: Créatis, 1980]), seen at exhibition (see Jacqueline Millet, *Louis-Amédée Mante, Mantechromes; Edmund Goldschmidt, Photographer* [Vancouver: Art Gallery, 1981], and *Farbe im Photo: Die Geschichte der Farbphotographie von 1861 bis 1981* [Cologne: Josef-Haubrich-Kunsthalle Köln, 1981]), and sold internationally at auction (see Sotheby's *Photographic Images and Related Material* [London, May 9, 1991], lots 92–97, and Christie's *19th and 20th Century Photographs* [London, May 7, 1992, lots 171–81]). However, depending upon which "expert" is being consulted, opinions differ on exactly what the "Mantechrome" or "Mantochrome" is. Regardless of whether it is roughly

the same process as the autochrome or not, the Lumières still deserve the credit for making color available to the community of photographers and the rest of the world.

4. *British Journal of Photography* 51 (July 1904): 605. Their *American Photography* article, "Color Photography" [8 (1914): 358–64], is another clear explanation of the process in their own words. They also include a concise technical history of color photography prior to the autochrome.

5. One can also find the figure fifteen to twenty thousandths of a millimeter in writings on the autochrome. This discrepancy arises from the fact that the smaller figure appears in their initial article on the autochrome, "A New Method for the Production of Photographs in Colours," while the larger figure comes from the various editions of the autochrome manual *Lumière's Autochrome Plates: Instructions for Their Use*.

6. Eduard J. Steichen, "Colour Photography with the Autochrome Plates," in *British Journal of Photography* 55 (April 1908): 301. Also published in a slightly longer version as "Color Photography" in *Camera Work*, no. 22 (April 1908).

7. Sylvain Roumette, *Early Color Photography* (New York: Pantheon, 1986), p. 2. Also see Anne Hammond, "Impressionist Theory and the Autochrome," in *History of Photography* 15, no. 2 (Summer 1991): 96–100.

8. Frederick Evans to Alfred Stieglitz, December 6, 1908 (Stieglitz Archives, Yale University).

9. Coburn's modernism has been somewhat overshadowed by that of Paul Strand, to whom those last two issues of *Camera Work* were primarily devoted. Strand had a most eloquent spokesman in Alfred Stieglitz; however, despite Stieglitz's polemicizing, the sharper focus of Strand's camera was not innovative but retrograde. Sharp focus had been the standard of vision from the daguerreotype through the albumen print and right up to *The Onion Field*, which was remarkable and revolutionary because of the lack of that focus. And again from the standpoint of imagery, by those last two issues of *Camera Work* Coburn had already produced his vortographic portraits of Ezra Pound, the imagery of which is still among the most radical in photographic portraiture and akin to the imagery of Picasso's only slightly earlier *L'Arlésienne* of 1911–12. See Frank Di-Federico, "Alvin Langdon Coburn and the Genesis of Vortographs," *History of Photography* 11, no. 4 (October–December 1987): 265–96, for an excellent discussion of the vortographs, which DiFederico argues are "key monuments in the evolution of Cubism in the early decades of the twentieth century" (p. 294).

10. Margaret Harker et al., *La photographie d'art vers 1900* (Bruxelles: Crédit Communal, 1983), and Erika and Fritz Kempe and Heinz Spielmann, *Die Kunst der Camera im Jugendstil* (Frankfurt: Umschau, 1986), are both excellent choices for such a perusal, though most general histories of photography have sections devoted to this period. Janet Buerger's important exhibition catalogue *The Last Decade: The Emergence of Art Photography in the 1890s* (Rochester: IMP/GEH, 1984) and her related essay, "Art Photography in Dresden, 1899–1900," in *Image* 27, no. 2 (June 1984): 1–24, are also worthy of attention. It is instructive and surprising as well to glance

simultaneously through a work like Philippe Jullian's *The Symbolists* (London: Phaidon, 1973) or Pierre-Louis Mathieu's *The Symbolist Generation* (New York: Skira/Rizzoli, 1990). Again and again one encounters paintings and photographs contemporary with each other that share the same themes and imagery. Among the kinds of striking examples are William Degouve de Nuncques' *Black Swan* of 1896 (see Mathieu, p. 135, reproduction in color, or Jullian, plate 23) and Georg Einbeck's *The Silence* of 1898 (see Kempe, plate 85; Buerger, *Last Decade*, p. 4; or Sarah Greenough et al., *On the Art of Fixing a Shadow* [Boston: Little, Brown, 1989], plate 158, reproduction in color). Not only is the imagery the same in both works, but they also evoke the same strange vaguely disturbing emotion. Einbeck's was first published in the *Photographische Rundschau* of 1898 as a blue-toned photogravure, which even matched Degouve's color. Another particularly striking example is Joseph Granié's *The Kiss* of 1900 (see Jullian, plate 20) and Clarence White's *The Kiss* of 1904 (see Weston J. Naef, *The Collection of Alfred Stieglitz* [New York: Viking Press, 1978], plate 46, or Françoise Heilbrun and Philippe Néagu, *Musée d'Orsay: chefs-d'oeuvre de la collection photographique* [Paris: Philippe Sers, 1986], plate 17). What these examples suggest, of course, is not a matter of influence, for there is little chance these artists would have known each other's work, but of distinct and separate manifestations of an international style.

11. Mathieu, p. 23.

12. Émile Gallé, *Écrits pour l'art: floriculture, art décoratif, notices d'exposition 1884–1889*, ed. Henriette Gallé-Grimm (Paris: Librairie Renouard, 1908), p. 218; Jules Henrivaux, quoted in Janine Bloch-Dermant, *The Art of French Glass, 1860–1914* (New York: Vendome Press, 1980), p. 132.

13. The imagery of Symbolism is almost as rare in the work of female photographers of this period. One sees it in the early work of Imogen Cunningham, and then it disappears. Gertrude Käsebier's work is rich in Symbolist madonna-and-child imagery, but that is all. Alice Boughton's children are Symbolist-inspired but seem more linked to Julia Margaret Cameron and the Victorians, except for their nudity. One can also find isolated examples in the work of a few female members of Stieglitz's Photo-Secession, of the Linked Ring, and certainly later in the anachronistic Pictorial Photographers of America, but it is really only in the work of Anne Brigman that one consistently finds Symbolist imagery and a Symbolist aesthetic.

14. It, of course, remained as a sentimental affectation of the Pictoralists through the late 1940s, but after World War II even the most nostalgic of eyes found it difficult to take such imagery seriously.

15. Alfred Stieglitz, "The New Color Photography—A Bit of History," in Jonathan Green, ed., *Camera Work: A Critical Anthology* (Millerton, N.Y.: Aperture, 1973), p. 126 and p. 124.

16. Alvin Langdon Coburn to Alfred Stieglitz, October 5, 1907 (Stieglitz Archives, Yale University).

17. [W. Dixon Scott], "The Painters' New Rival: Color Photography as an Expert Sees It," in the *Liverpool Courier* (October 31, 1907), two-column interview. Reprinted in *American Photog-*

raphy 2, no. 1 (January 1908): 13–19, as "The Painters' New Rival: An Interview with Alvin Langdon Coburn" by Dixon Scott. There are slight but interesting differences in the two versions.

18. Steichen, "Colour Photography with the Autochrome Plates," 302.

19. *British Journal of Photography*, "Colour Photography Supplement," 54 (January 1907): 2.

20. "The New Color Photography," *International Studio* (New York), 34 (1908): xxiii.

21. Sue Davidson Lowe, *Stieglitz: A Memoir/Biography* (London: Quartet/Or! Books, 1983), p. 384, gives June 20–July 17 as the dates Stieglitz and his family were in Baden-Baden, and July 18–August 9 for the dates in Tutzing; however, Ulrich Knapp, *Heinrich Kühn Photographien* (Salzburg and Vienna: Residenz Verlag, 1988), p. 173, dates the Tutzing meeting as July 9.

22. E. L. Brown, "The First Direct Color Photography: Lumière Process, in Scotland," *Wilson's Photographic Magazine* 44, no. 610 (October 1907): 434–35.

23. "The Lumière Autochrome Color Process," *Wilson's Photographic Magazine* 44, no. 610 (October 1907): 433.

24. B. J. Falk, "The Autochrome Process—A New Era," *Wilson's Photographic Magazine* 44, no. 611 (November 1907): 484–85. Falk, by the way, was not just any commonplace professional photographer. Writing in a 1906 essay entitled "B. J. Falk: An Exquisite Temperament," Sadakichi Hartmann said, "The name 'Falk' is as popular as any in the photographic world" (see Harry W. Lawton and George Knox, eds., *The Valiant Knights of Daguerre* [Berkeley: University of California Press, 1978], p. 227).

25. M. A. Montminy, "The Autochrome Process," *Wilson's Photographic Magazine* 44, no. 611 (November 1907): 486. Montminy, unlike other contemporary reporters who simply noted the demonstration as being in "early June," actually dates it as June 10, 1907.

26. Quoted in T. Dixon Tennant, "Exhibition of 'Autochrome' Photographs," *Wilson's Photographic Magazine* 44, no. 611 (November 1907): 483–84, and Stieglitz, "The New Color Photography—A Bit of History," in Green, p. 129. Steichen believed that Stieglitz only showed his own work at this press exhibition and "robbed" Steichen of his thunder in so doing. See Edward Steichen, *A Life in Photography* (Garden City, N.Y.: Doubleday, 1963), part 4, and Lowe, p. 187. However, it is clear from Stieglitz's letter of invitation to the press, which was published in the October 1907 *Camera Work* (see Green, p. 129), that he was presenting Steichen's and Eugene's work as well. This is also clear from Tennant's remarks and from the "Notes and Comments" in *The Photo Miniature* 7, no. 83 (November 1907): 540. There the author makes specific references to having seen "some twenty odd examples . . . selected from the work of Messrs. Steichen, Stieglitz and Eugene" at this exhibition for Stieglitz's "friends and the pressmen of New York." The September exhibition and the later November exhibition could not have been confused because the latter also included landscape autochromes by Clarence White. A Steichen solo show exhibiting fifteen autochromes and forty-seven photographs did open on March 12, 1908; it is possible that Steichen simply forgot he had also been included in the earlier exhibition.

27. "Notes and Comments," *The Photo Miniature* 7, no. 82 (October 1907): 494; R. Child Bayley, "Color Photography," *The Photo Miniature* 7, no. 81 (September 1907): 457.

28. In Lawton and Knox, pp. 108, 109, 113.

29. Quoted in Pierre-Louis Mathieu, *The Symbolist Generation* (New York: Rizzoli, 1990), p. 45.

30. Stéphane Mallarmé, "Art for All," in *Prose Poems, Essays, and Letters*, trans. Bradford Cook (Baltimore: Johns Hopkins University Press, 1956), p. 9. Colleen Denney in "The Role of Subject and Symbol in American Pictorialism" (*History of Photography* 13, no. 2 [April–June 1989]: 109–28) would have us believe that "Hartmann was a member of Mallarmé's intimate circle" (p. 113). He was not, though as a young man visiting Europe he may have met Mallarmé. She also says, "It is true that they [the photographers] imitated paintings and ideas prevalent in the Fine Arts" (p. 115). A cursory glance might suggest this, but closer scrutiny does not bear it out. They were all working simultaneously in an international style—a common occurrence in the world of art. However, her point that "art historians have not sufficiently probed the role of these symbolist overtones in American pictorialism" (p. 109) is well taken.

31. Quoted in John Milner, *Symbolists and Decadents* (London and New York: Studio Vista/Dutton, 1971), p. 44.

32. Quoted in Pontus Hulten and Germano Celant, *Italian Art: 1900–1945* (New York: Rizzoli, 1989), p. 43.

33. "The Salon des Refusés of 1908," *History of Photography* 8, no. 4 (October–December 1984): 287.

34. Quoted in Rolf Kraus, "*Die Kunst in der Photographie*, the German *Camera Work*: Part 2: Texts in Abstract," *History of Photography* 11, no. 1 (January–March 1987): 2–3.

35. "The New Color Photography—A Bit of History" in Green, p. 128.

36. "The Painters' New Rival: Color Photography as an Expert Sees It" in the *Liverpool Courier* (October 31, 1907).

37. Green, p. 128.

38. Laurvik, p. xxi.

39. "The Photo-Secession" in Sarah Greenough and Juan Hamilton, *Alfred Stieglitz: Photographs & Writings* (Washington and New York: National Gallery of Art and Callaway Editions, 1983), p. 190.

40. Nicolas Powell, *The Sacred Spring: The Arts in Vienna, 1898–1918* (Greenwich, Conn.: New York Graphic Society, 1974), p. 144.

41. Lowe, p. 129.

42. Robert Pincus-Witten, *Les Salons de la Rose + Croix, 1892–1897* (London: Piccadilly Gallery, 1968). This exhibition catalogue reproduces Péladan's 1891 "Salon de la Rose + Croix, Règle et Monitoire."

43. Quoted in Ian Fletcher, *Romantic Mythologies* (New York: Barnes and Noble, 1967), p. 42.

44. *Paintings in the Musée d'Orsay* (New York: Stewart, Tabori & Chang, 1989), p. 558.

45. Quoted in Powell, p. 144.

46. For an excellent contemporary review of the 1905 international exhibition, with photographs from it, including a photograph of Klimt and a photograph of the installation, see "Die Ausstellung des Wiener Kamera-Klubs," *Photographische Rundschau* 19 (1905): 113–19.

47. *Gustav Klimt* (Greenwich, Conn.: New York Graphic Society, 1971), p. 47.

48. *Photo-Secession* (Washington: Lunn Gallery/Graphics International Ltd, 1977), p. 39. Actually Kühn, along with Henneberg and Watzek, was the first to exhibit these. See Ernst Juhl's laudatory review of their three-colored gum prints, "Fünfte internationale Ausstellung von Kunstphotographieen, veranstaltet von der Gesellschaft zur Förderung der Amateurphotographie in der Kunsthalle zu Hamburg," *Photographische Rundschau* 11 (December 1897): 375.

49. For a particularly striking example of similarity, compare Kühn's "Mary Warner und Hans Kühn" (Knapp, plate 22) and Moll's "Salon des Wohnhauses Moll" (see Robert Waissenberger, ed., *Vienna 1890–1920* [New York: Tabard Press, 1984], plate 231, for color reproduction).

50. *Moderne Malerei in Österreich* (Vienna: Wolfrum, 1965), pp. 68, 70.

51. Naomi Rosenblum, *A World History of Photography* (New York: Abbeville Press, 1984), p. 339. Rosenblum also dates the single Kühn autochrome she reproduces as 1905, two years before the process was on the market.

52. *The Daguerreotype: A Sesquicentennial Celebration* (Iowa City: University of Iowa Press, 1989), p. 8.

53. In "The New Color Photography," p. xxi.

54. *Alvin Langdon Coburn: Photographer*, ed. Helmut and Alison Gernsheim (New York: Dover Publications, 1978), p. 62. Coburn says he met Freer and made the autochromes in 1907. An incorrect 1909 date of their meeting is given by Weston Naef in *The Collection of Alfred Stieglitz* (p. 301); by that time Coburn apparently had abandoned the process.

55. "The New Color Photography—A Bit of History" in Green, p. 129.

56. *History of Photography* 6, no. 3 (July 1982): 211–22; 8, no. 4 (October–December 1984): 249–75; 277–98.

57. In *Image* 27, no. 2 (June 1984): 1–24. Also see Buerger, *The Last Decade*; Rolf Kraus, "*Die Kunst in der Photographie*, the German *Camera Work*: Part 1: The Publication and Its Images," *History of Photography* 10, no. 4 (October–December 1986): 265–97; and Kraus, "*Die Kunst in der Photographie*, the German *Camera Work*: Part 2: Texts in Abstract," 1–12.

58. See Abigail Solomon-Godeau, "Calotypomania: The Gourmet Guide to Nineteenth-Century Photography," *Afterimage* (Summer 1983): 7–12, for an insightful and brilliant discussion of some of these matters as they relate to photographic history and its marketplace.

59. This is a position even the most doctrinaire Marxist would find untenable. In "Class and

Art," Trotsky quotes Italian Marxist Antonio Labriola on a similar matter: "Lazy minds are readily satisfied with such crude statements. . . . By this method fools could reduce the whole of history to the level of commercial arithmetic, and finally, a new original interpretation of Dante's work could show us *The Divine Comedy* in the light of calculations regarding pieces of cloth which crafty Florentine merchants sold for their maximum profit" (*Leon Trotsky on Literature and Art*, ed. Paul Siegel [New York: Pathfinder Press, 1970], p. 239). And Umberto Barbaro, another Italian Marxist critic, in his "Marxist Redefinition of Art," complained of a study of Cézanne that tried to reduce Impressionism and the *plein-air* style to new uses of tin, uses which "made possible the creation of tubes of prepared paint; for these could be carried conveniently in one's pocket, or in appropriate little boxes, into the countryside." To explain one of the finest moments in the history of painting, said Barbaro, "he needs only tin and Lefranc tubes!" (Berel Lang and Forrest Williams, ed., *Marxism and Art: Writings in Aesthetics and Criticism* [New York: David McKay, 1972], p. 163).

60. *Alvin Langdon Coburn: Symbolist Photographer, 1882–1966* (New York: Aperture, 1986), p. 30.

61. Steichen, "Colour Photography with the Autochrome Plates," 302.

62. There is a possibility he may actually have met Coburn the previous year. Scott published an article about Coburn entitled "The Function of the Camera" in the *Liverpool Courier* on May 16, 1906. See Beaumont Newhall, ed., *Photography: Essays & Images* (New York: Museum of Modern Art, 1980), pp. 201–203. The final paragraph of that article begins: "Coburn tells me that . . ." However, Scott's October 1907 interview clearly suggests that he is meeting Coburn for the first time.

63. "The Painters' New Rival: Color Photography as an Expert Sees It" in the *Liverpool Courier* (October 31, 1907).

64. Naef, p. 164.

65. F. C. Tilney, "Where We Stand in Pictorial Colour Photography," *British Journal of Photography* 55 (September 1908), Colour Photography Supplement: 66–67.

66. G. Courtellemont, "Autochromes on Tour," *British Journal of Photography* 55 (June 1908), Colour Photography Supplement: 46.

67. "Monsieur Meys' Autochrome Pictures," *British Journal of Photography* 55 (May 1908), Colour Photography Supplement: 33–34. Five of Meys' autochromes were in the 1981 Library of Congress exhibition *Autochromes: Color Photography Comes of Age*.

68. "The Society of Colour Photographer' Exhibition," *British Journal of Photography* 55 (June 1908), Colour Photography Supplement: 41–42.

69. *History of Photography* 15, no. 2 (Summer 1991): 99.

70. Coburn continued autochroming, though, at least as late as December, when he made his portrait of Mark Twain (plate 15). He devotes several pages of his autobiography (pp. 64–68) to

discussing that December weekend in 1908 when he visited Twain and they spent the mornings in photography during which he made "thirty or forty negatives." Coburn's autochrome of Twain in bed reading is certainly one of the greatest of all Twain portraits, but the extent of Coburn's comments about his autochrome work that weekend was: "A few I took in color on Lumière Autochrome plates" (p. 68).

71. "Monsieur Meys' Autochrome Pictures," 33.

72. "The Success of Color Photography," *The Craftsman* (March 1912): 687. Works by Genthe, including his famous "rainbow" autochrome, and by B. J. Falk, A. H. Lewis, H. H. Pierce, S. L. Stein, Frances B. Johnston, and F. J. Sipprell are discussed or noted.

73. "Color Photography," *Photographic Times* 64, no. 9 (September 1912): 354–55.

74. Adams wrote, "I confess that I frequently appraise my work by critical comparison with the daguerreotype image; how urgently I desire to achieve that exquisite tonality and miraculous definition of light and substance in my own prints." *The Print: Contact Printing and Enlarging* (New York: Morgan & Morgan, 1950), p. 2.

75. "Autochromes on Tour," 46.

76. In Robert Sobieszek's massive 466-page *Masterpieces of Photography from the George Eastman House Collections*, for example, there is not a single autochrome reproduced or even a reference to the process, though Eastman House houses one of the most important collections of autochromes in the world.

77. Author's collection.

78. Edward Steichen, *A Life in Photography* (Garden City, N.Y.: Doubleday, 1963), part 4.

79. In a February 15, 1940, letter in the Stieglitz Archives at Yale, de Meyer told Stieglitz, "I have in 1935 destroyed all that was superfluous, it seemed to me a burden—all my photographic work especially—what is left—is due to fortunate incidents—some of my work being elsewhere." He was writing in hopes he might borrow some prints from Stieglitz for an exhibition of his work.

80. Sue Davidson Lowe writes: "Alfred's quarrels with most of his fellow Photo-Secessionists were rooted primarily in differences in values. Alfred believed passionately that an artist could fulfill his promise only if his goals excluded all thought of monetary reward. . . . Few . . . were as devout in this belief as he. Many who had begun photography as a hobby started . . . to turn professional. In the process some, inevitably, lowered their sights [in Stieglitz's eyes, of course]. . . . If persuasion failed, a sterner lecture ensued. If that, too, failed, the apostate risked castigation and eventual excommunication" (p. 132).

81. See Gábor Szilágyi, *Leletek: A magyar fotográfia történetéből* (Budapest: Képzőmuúvészeti, 1983), plates 105 and 111. Morvay's plate 108 bears a striking resemblance to Seeley's *Still Life with Grapes*, plate 18.

82. I am indebted to Merry Foresta for this insightful term "aesthetic of the veil" and the three temptations.

83. I am indebted to Finnish photographic historian Sven Hirn for the following information on Schohin, the history of the autochrome in Finland, and for his assistance in securing transparencies of his work.

84. Quoted in Bert Carpelan, *AFK 1889–1989* (Helsinki: Amatörfotografklubben i Helsingfors r.f., 1989), p. 27.

85. Bert Carpelan, "Wladimir Schohin: An Early Color Master," in *The Frozen Image: Scandinavian Photography* (New York and Minneapolis: Abbeville Press and Walker Art Center, 1982), p. 122.

86. See Poul Vad, *Vilhelm Hammershøi* (Copenhagen: Gyldendal, 1957), and Neil Kent, *The Triumph of Light and Nature: Nordic Art, 1740–1940* (London: Thames and Hudson, 1987), plates xxxiii, xxxv, illustrations 132, 134; one might also note the Peter Ilsted interior (plate xxxiv). Ilsted was Hammershøi's brother-in-law and did similar work.

87. See Olli Valkonen, "The Breakthrough in Finland," in *Scandinavian Modernism: Painting in Denmark, Finland, Iceland, Norway and Sweden, 1910–1920* (New York: Rizzoli, 1989), pp. 35–41, and pp. 206–15 for Valkonen's discussion of Sallinen with several reproductions. No reference, of course, is made at any point in the book to any aspect of Scandinavian photographic modernism.

88. Arnold Genthe, *As I Remember* (New York: John Day and Reynal & Hitchcock, 1936), p. 268.

89. I have attempted to locate these, but without much success. Dayton Cash Register became National Cash Register, now a subsidiary of AT&T. NCR's Historical Department is in charge of the archives, which are still housed in Dayton. I was told by a member of the staff that there are "hundreds of old glass plates"; however, the public is not admitted without written permission from the Legal Department, which I was unable to obtain. The archives are understaffed, and in addition to no one there knowing what an autochrome is, I was told no one had the time to look anyway.

90. Letter to the author, May 18, 1992. Also see *Arnold Genthe, 1869–1942: Photographs and Memorabilia from the Collection of James F. Carr* (Staten Island: Staten Island Museum, 1975), which includes the essays "A Review of His Life and Work" by Jerry E. Patterson and "As I Remember Arnold Genthe" by Dorothy Wilcock Neumeyer.

91. All the factual information about Andreyev's life comes from Richard Davies' magnificent *Leonid Andreyev: Photographs by a Russian Writer* (London and New York: Thames and Hudson, 1989). Davies reproduces 110 photographs, including 80 of Andreyev's autochromes.

92. *The Bostonians: Painters of an Elegant Age, 1870–1930* (Boston: Museum of Fine Arts, 1986), pp. 64, 78.

93. I am not suggesting there is anything unrealized in Käsebier's work. I am only speaking of reproductions of her work, which naturally lose the brilliance of their photographic qualities in

halftone. There are a number of black-and-white reproductions of Benson, Paxton, Tarbell, and others in Fairbrother's book, and their resemblance to Käsebier photographs is quite uncanny.

94. Claudie de Guillebon, *Albert Kahn Museum* (Paris: Musées 2000, 1991), p. 57 and p. 25.

95. See Jeanne Beausoleil et al., *Albert Kahn et le Japon. Confluences* (Paris: Albert Kahn Museum, 1990). Many of Roger's autochromes from 1926–1927 are reproduced in this volume, as well as earlier examples from Japan by Stéphane Passet. See Bibliography under Beausoleil for books including the works of Kahn's other autochromists.

96. Passet also has sixteen autochromes of Mongolia, which he visited for Kahn in 1913, in the May 1922 *National Geographic*. Some of the plates appear to be nearly identical.

97. See L. Busy, "L'autochromie en voyage de France au Tonkin," *Photo-gazette* 22 (July 1912): 177–78.

98. Spain (26 autochromes), July 1924; France (28), November 1924; Versailles (14), January 1925; Morocco (16), March 1925; the Near East (32), November 1925; India (34), July 1926; Egypt (23), September 1926; Alsace (11), August 1927; Algiers (32), February 1928; Spain (29), August 1928; Cambodia (27), September 1928; Spain (40), March 1929; France (29), August 1929; France, World War I battlefields (23), November 1929; France (10), October 1930.

99. "Emploi de plaques autochromes en voyage," *Photo-gazette* 18 (May 1908): 130–31.

100. "Autochromes from Autochromes," *British Journal of Photography* 55 (August 1908), Colour Photography Supplement: 61.

101. *Photo-gazette* 21 (April 1910): 117–18; *British Journal of Photography* 58 (August 1911), Colour Photography Supplement: 51–52.

102. L'autochromie," *Société française de photographie. Bulletin.* Série 3, vol. 3 (1912): 58–61.

103. "Autochromes: The First Color Photography" *Darkroom Photography* (July 1989): 42–48, 57–58. Howard also discusses the matter of autochrome conservation, a subject little has been written on. See Bibliography under Wentzel and Krause for additional work in this area.

104. G. Emmerich, "Zur Turiner Ausstellung von H. Hildenbrand," *Photographische Kunst* 1 (1902): 9; *Winterpracht. Zwölf farbige Naturaufnahmen. Mit einem Geleitwort von Paul Dinkelacker* (Stuttgart: Hoffmann, [1911]); *Herbst in den Schweizer Alpen. 10 Kunstblätter im Vierfarbendruck* (Stuttgart: Farbenphot, 1912); *Herbstudien im deutschen Wald. 10 farbige Naturaufnahmen* (Stuttgart: Farbenphot, 1912); *Des Deutschen Vaterland*, ed. Hermann Müller-Bohn (Stuttgart: Belser, 1913); *Wenn alles blüht. E. Frühlingsgabe in Farbe und Dichtung* (Stuttgart: W. Hädecke, 1919).

105. Geoffrey Chaucer, *The Riverside Chaucer*, ed. F. N. Robinson (Boston: Houghton Mifflin, 1987), p. 654.

106. Marcel Proust, *Swann's Way*, trans. C. K. Scott Moncrieff (New York: Random House, 1934), pp. 324–25.

The Plates

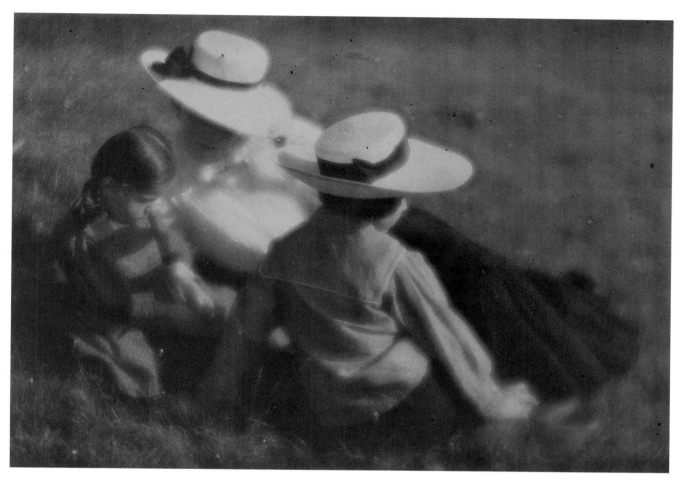

1. HEINRICH KÜHN, *Miss Mary, Lotte, and Hans*, c. 1907

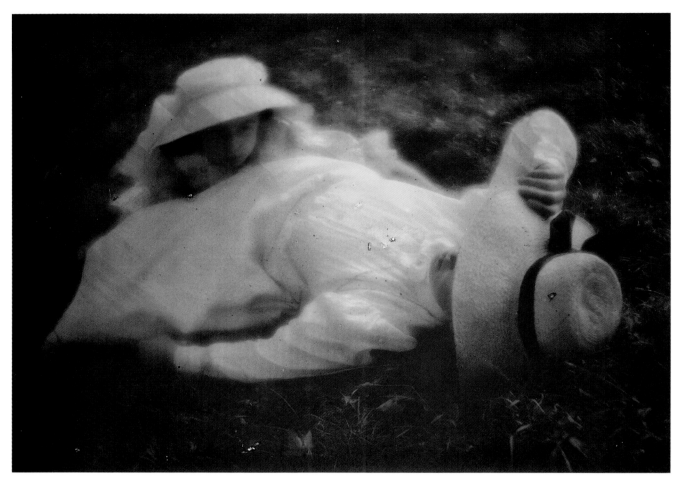

2. HEINRICH KÜHN, *Miss Mary and Lotte*, c. 1910–1912

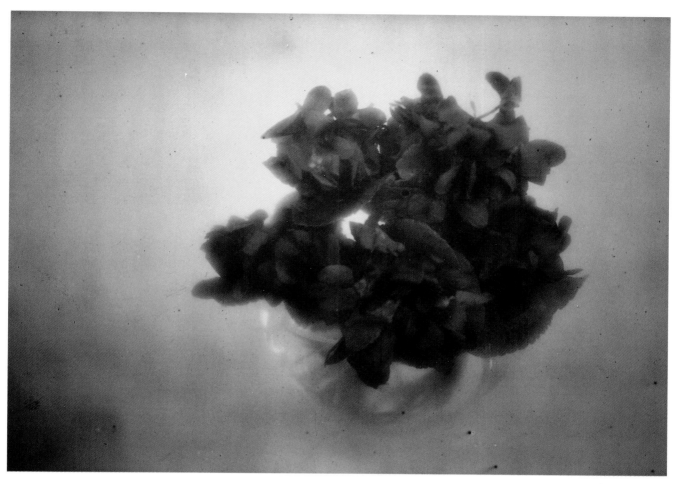

3. HEINRICH KÜHN, *Violets*, c. 1910–1912

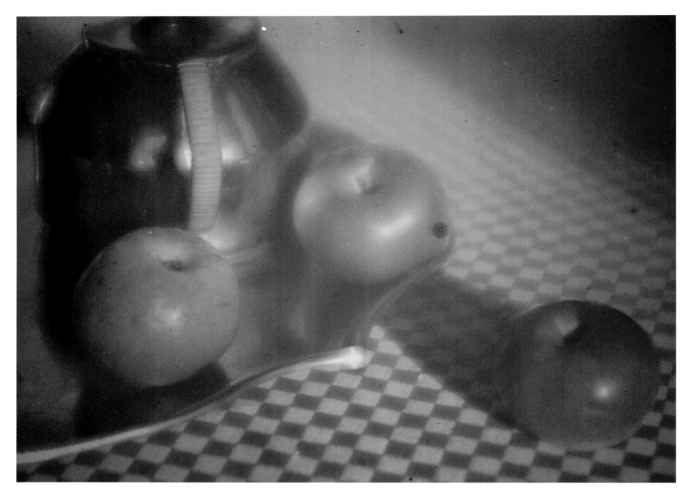

4. HEINRICH KÜHN, *Still Life*, c. 1909

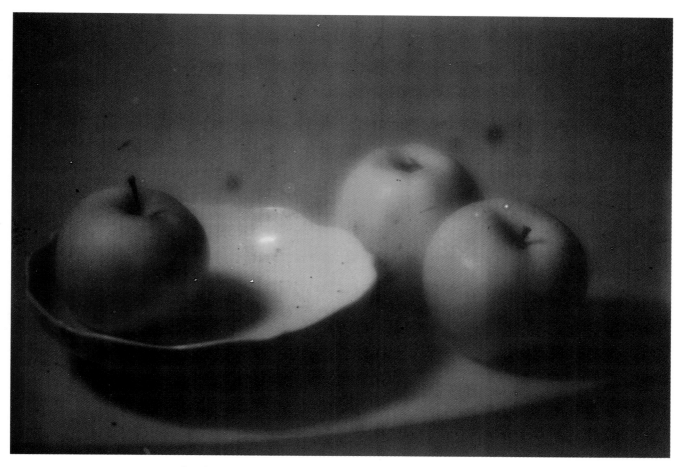

5. HEINRICH KÜHN, *Still Life*, c. 1909

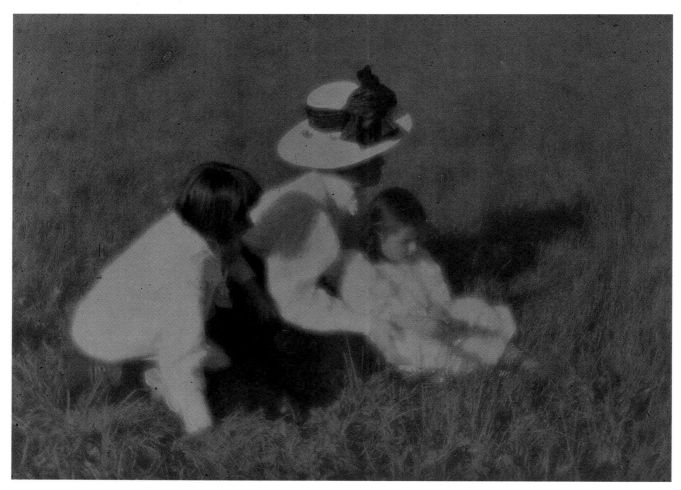

6. HEINRICH KÜHN, *Miss Mary, Lotte, and Hans,* c. 1907

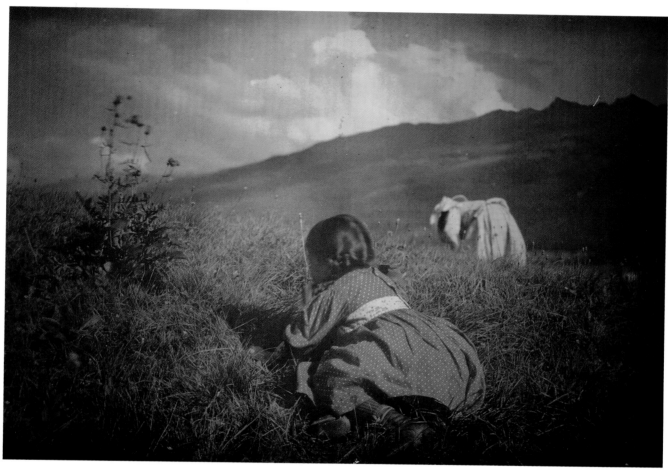

7. HEINRICH KÜHN, *Lotte*, c. 1907

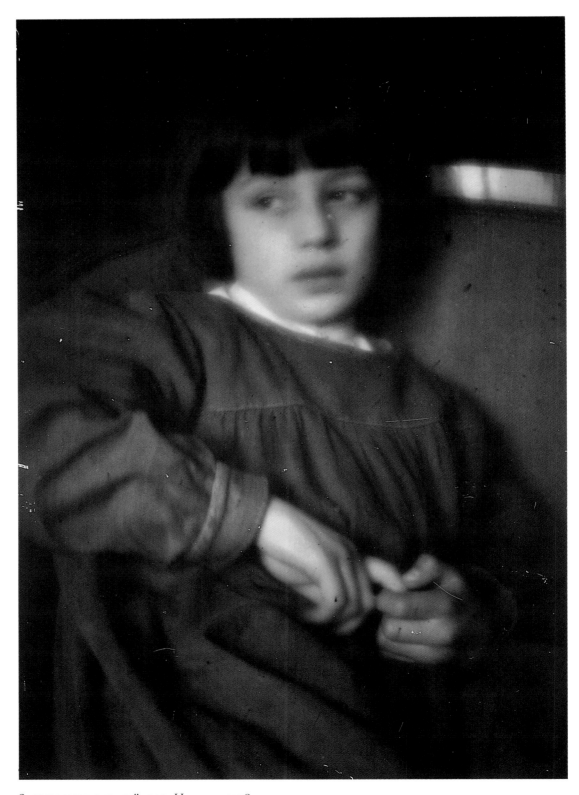

8. HEINRICH KÜHN, *Hans,* c. 1908

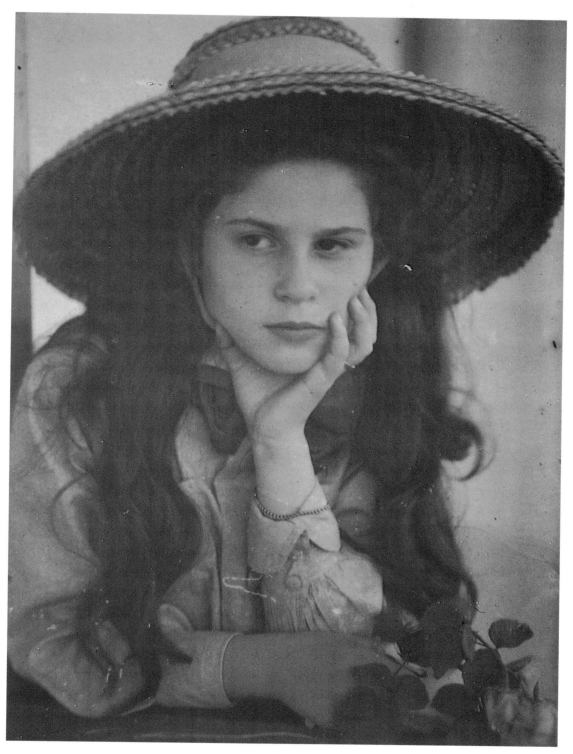

9. ALFRED STIEGLITZ, *Kitty*, 1907

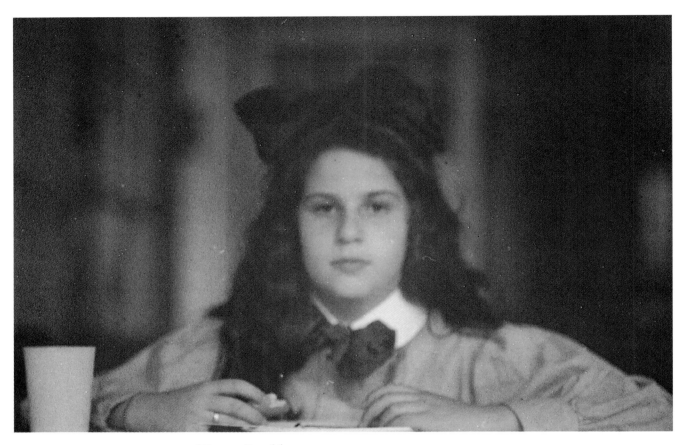

10. ALFRED STIEGLITZ, *Kitty at Breakfast*, 1907

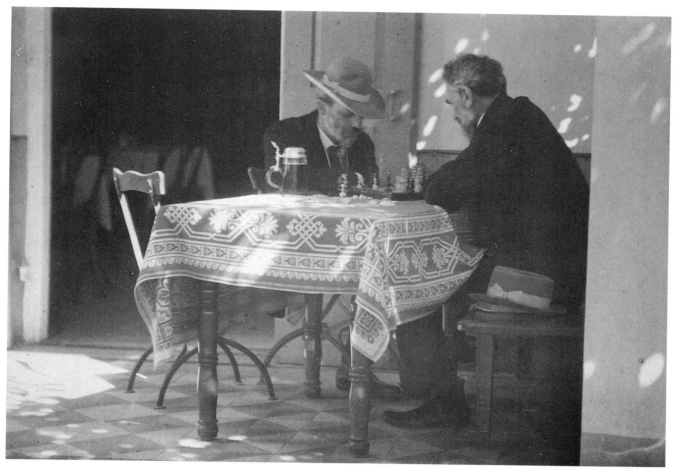

11. ALFRED STIEGLITZ, *Frank Eugene at Chess*, July–August 1907

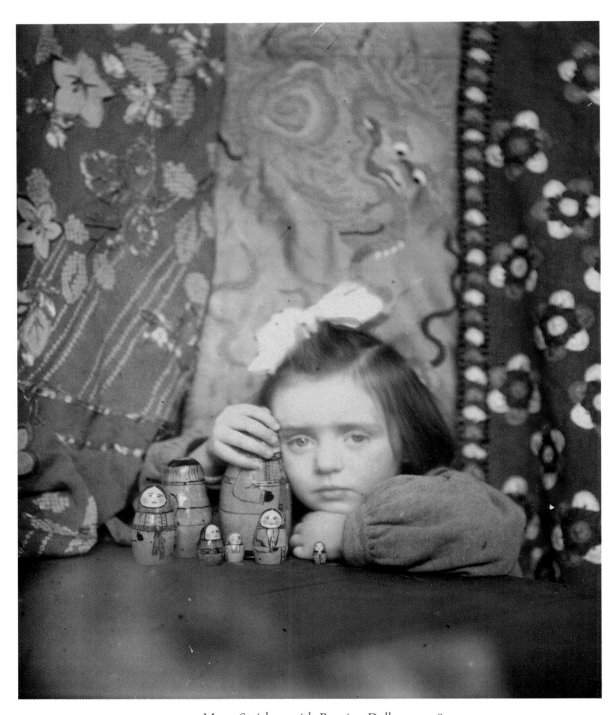

12. EDUARD STEICHEN, *Mary Steichen with Russian Dolls*, c. 1908

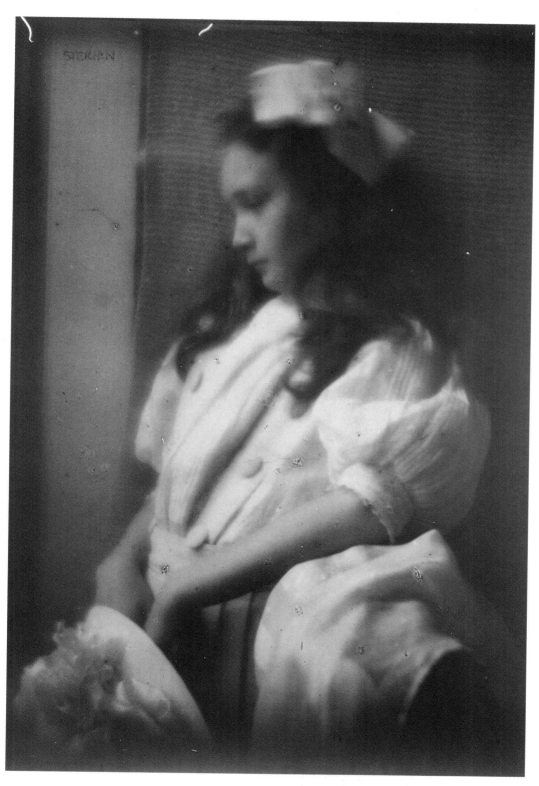

13. EDUARD STEICHEN, *Jean Simpson*, October 1907

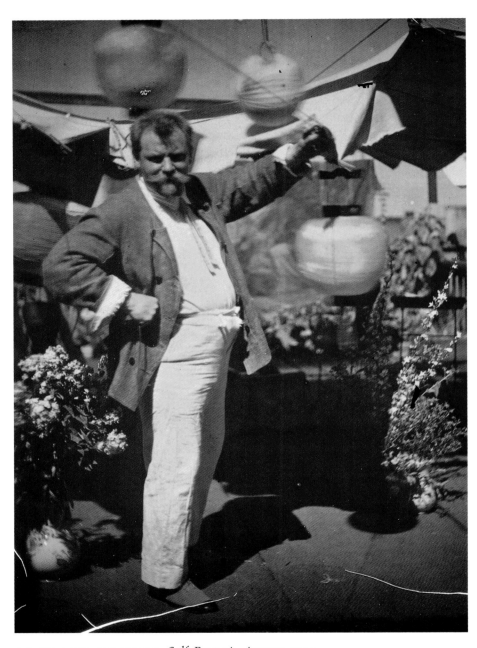

14. FRANK EUGENE, *Self-Portrait*, August 1911

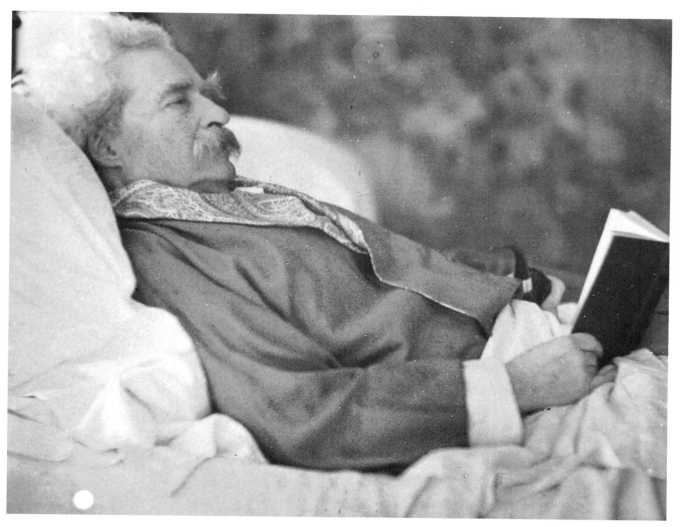

15. A L V I N L A N G D O N C O B U R N, *Mark Twain*, December 1908

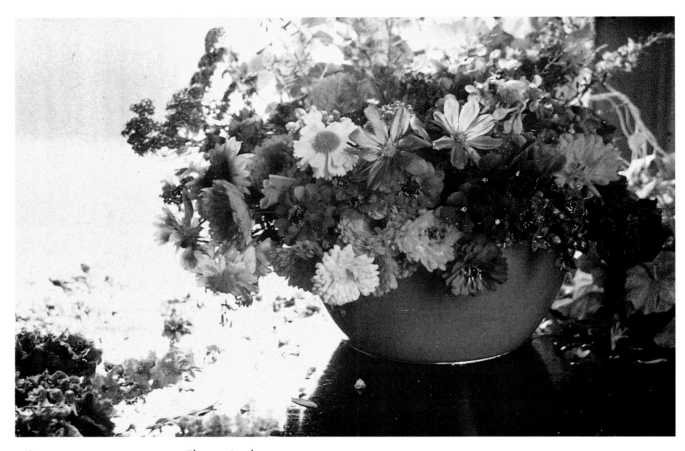

16. ADOLF DE MEYER, *Flower Study*, c. 1907–1909

17. GEORGE H. SEELEY, *Still Life with Leaves,* c. 1908

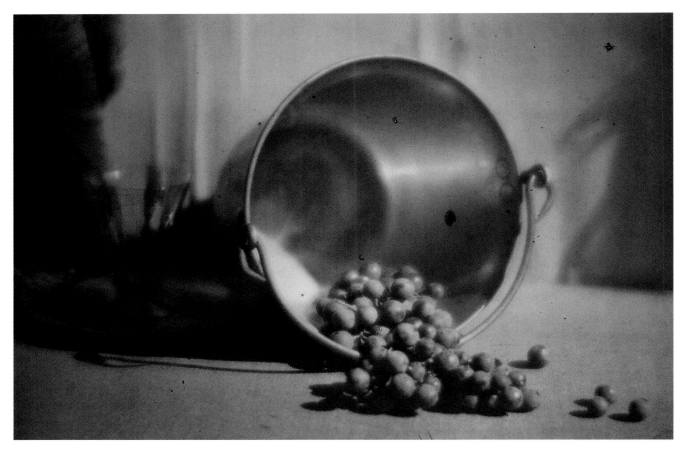

18. GEORGE H. SEELEY, *Still Life with Grapes,* c. 1908

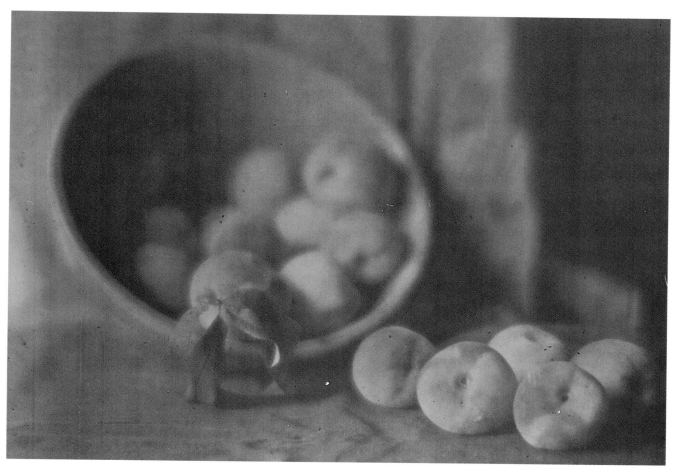

19. GEORGE H. SEELEY, *Still Life with Peaches,* c. 1908

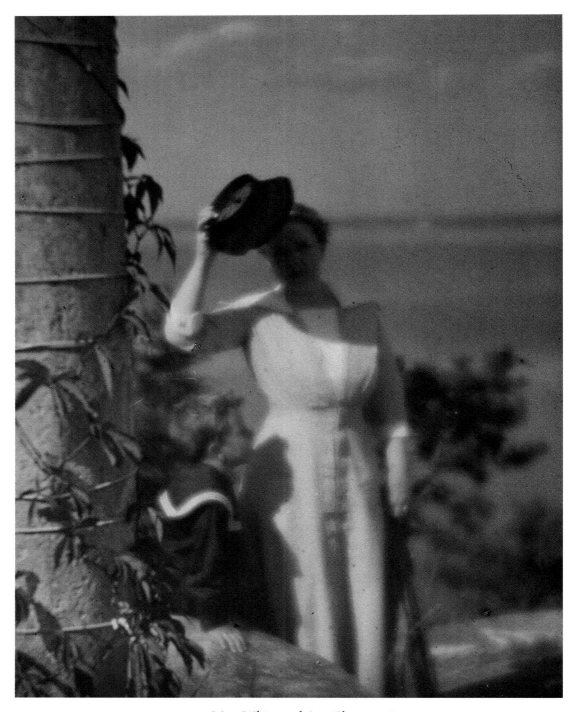

20. CLARENCE H. WHITE, *Mrs. White and Son Clarence, Jr.,* c. 1910

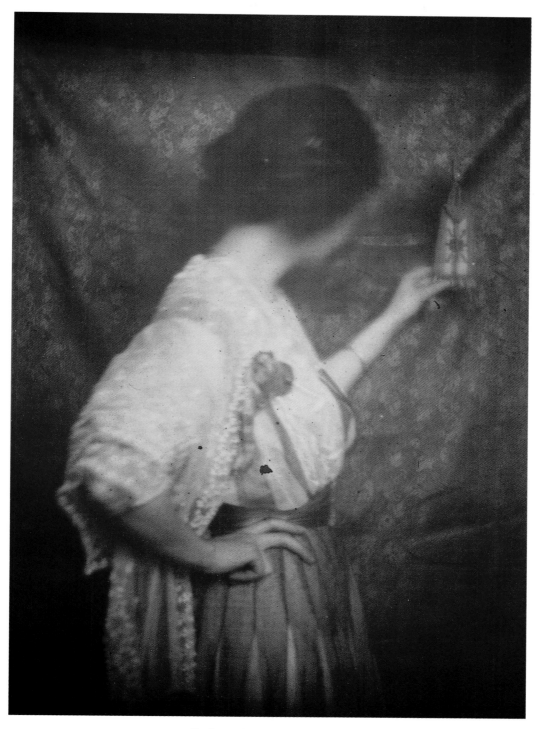

21. PAUL B. HAVILAND, *Lady in Lace*, c. 1910

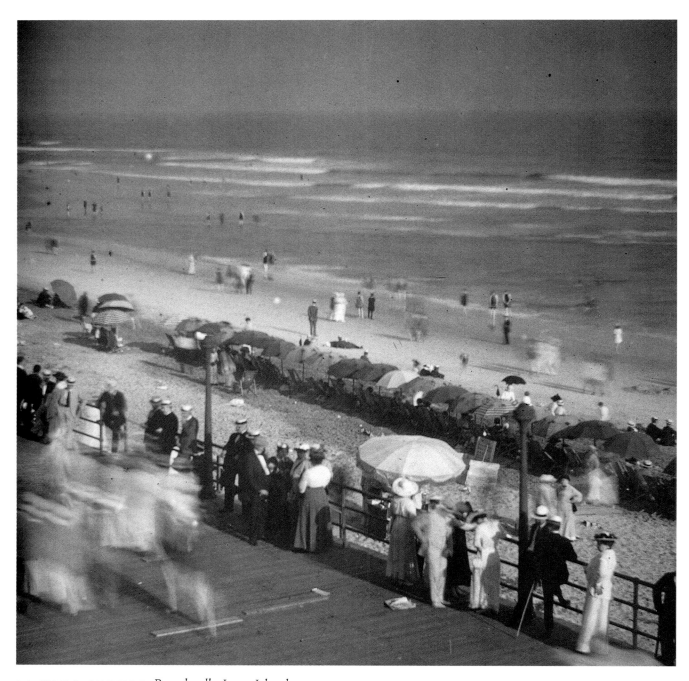

22. KARL STRUSS, *Boardwalk, Long Island,* c. 1910

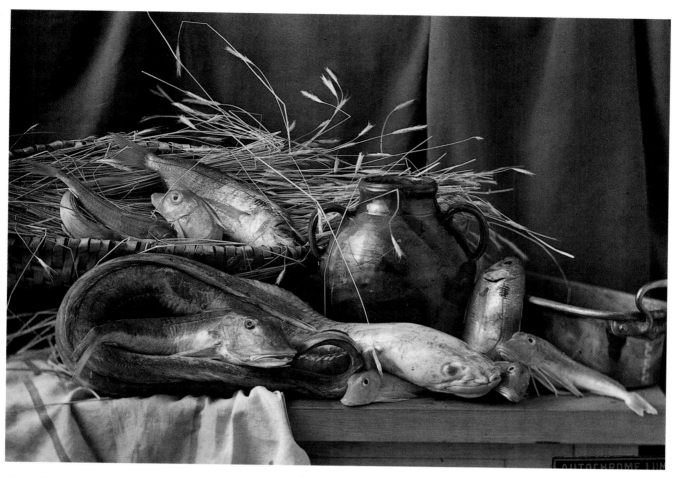

23. AUGUSTE AND LOUIS LUMIÈRE, *Still Life with Fish*, c. 1905

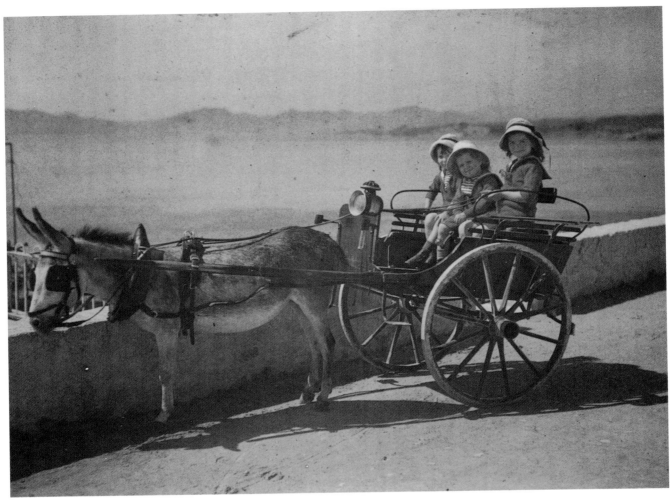

24. AUGUSTE AND LOUIS LUMIÈRE, *The Photographers' Nieces*, 1912

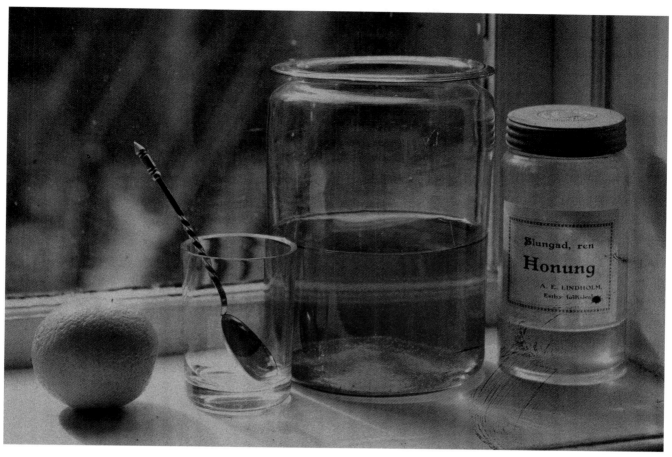

25. WLADIMIR SCHOHIN, *Still Life with Tea and Honey,* c. 1910

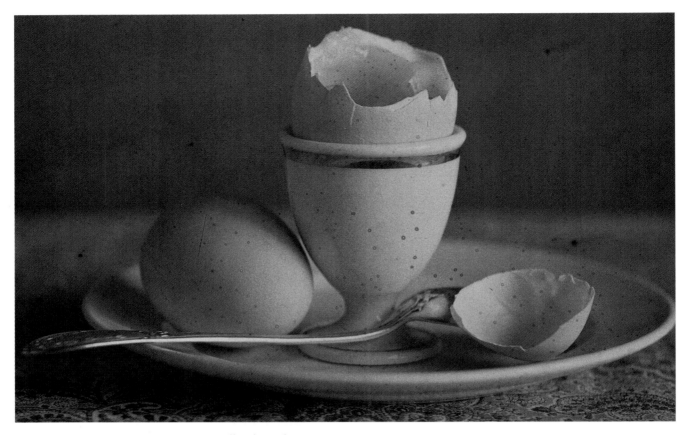

26. WLADIMIR SCHOHIN, *Still Life with Egg*, c. 1910

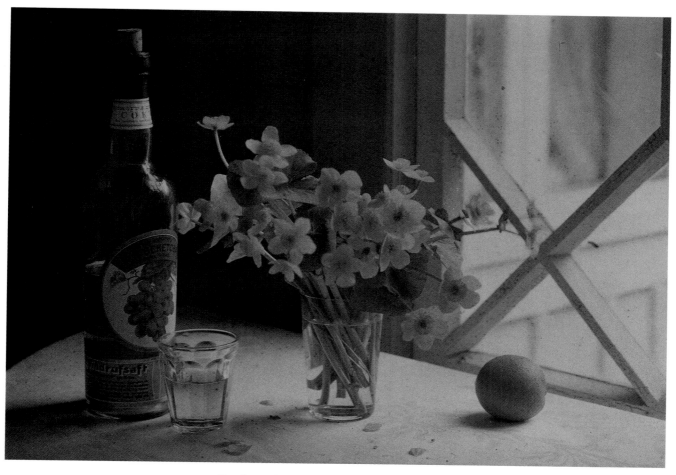

27. WLADIMIR SCHOHIN, *Still Life with Flowers*, c. 1910

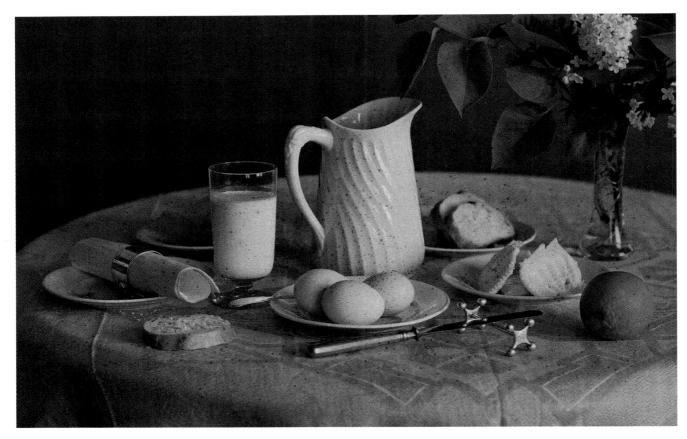

28. WLADIMIR SCHOHIN, *Still Life*, c. 1910

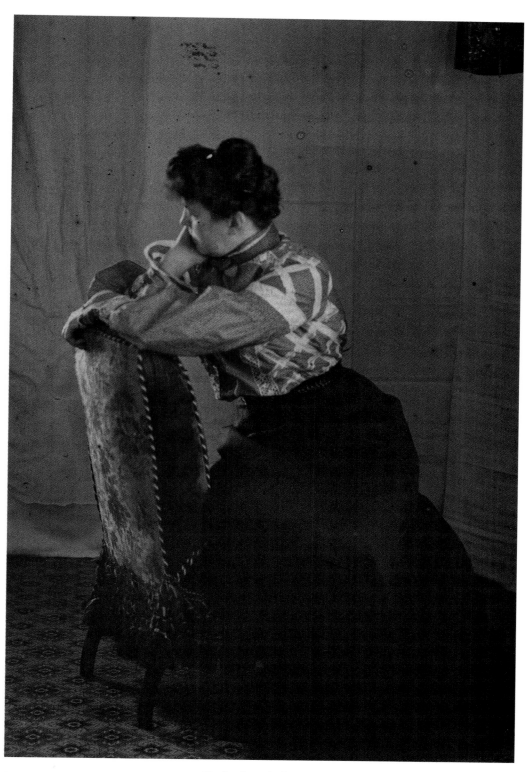

29. WLADIMIR SCHOHIN, *Nadezda Schohin*, c. 1910

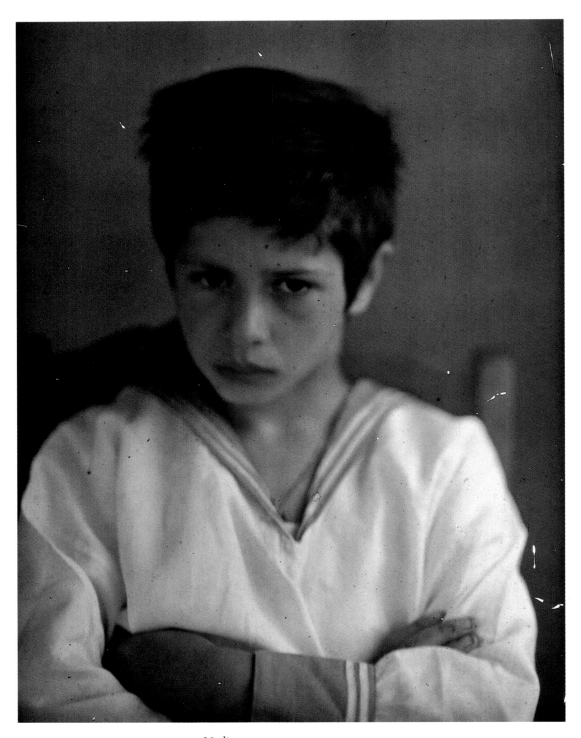

30. LEONID ANDREYEV, *Vadim*, c. 1909–1910

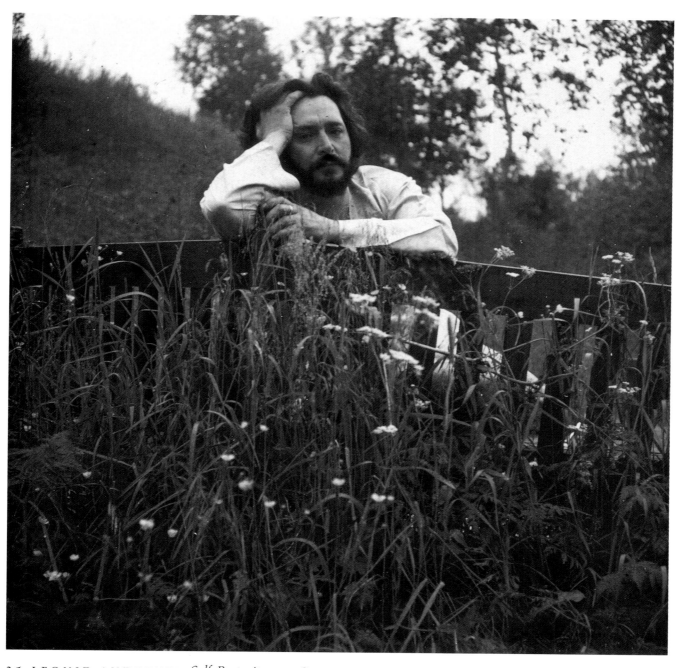

31. LEONID ANDREYEV, *Self-Portrait,* c. 1908–1909

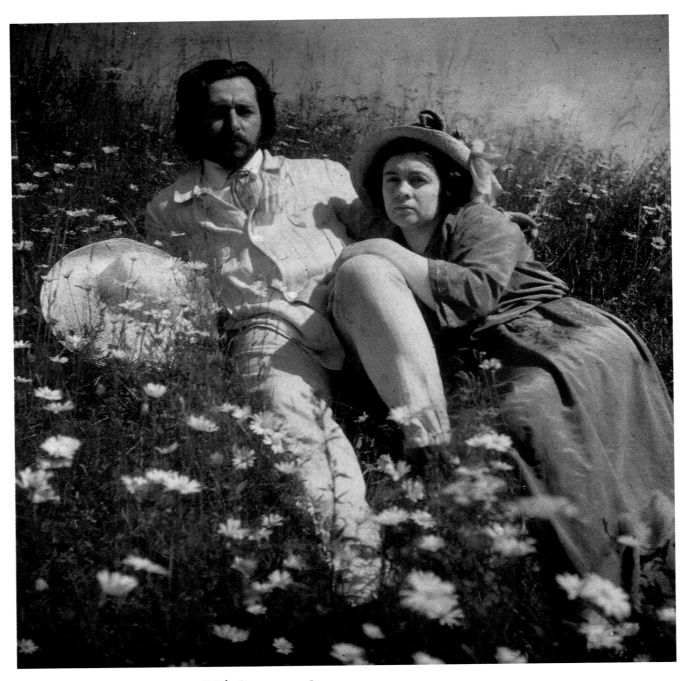

32. LEONID ANDREYEV, *With Anna*, c. 1908–1909

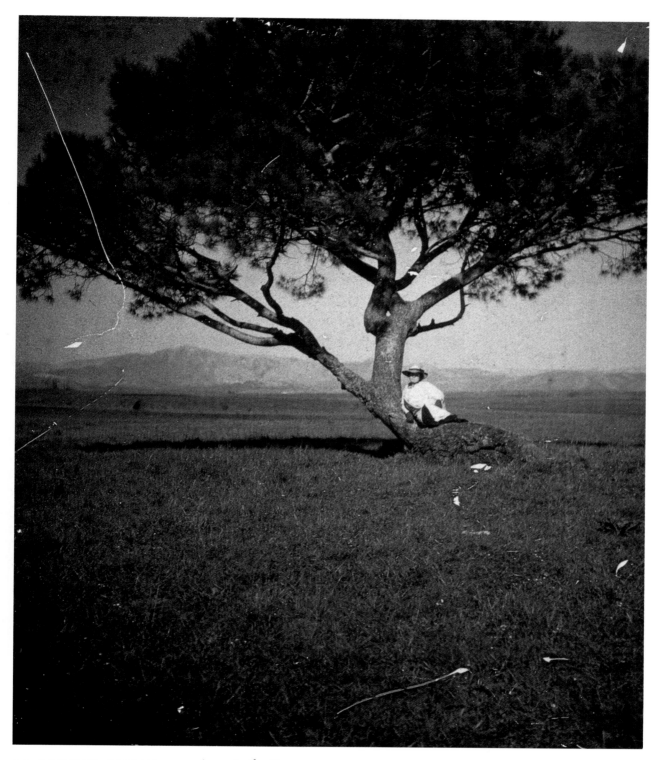

33. LEONID ANDREYEV, *Anna in the Campagna*, 1914

34. LEONID ANDREYEV, *Near Vammelsuu*, c. 1908–1914

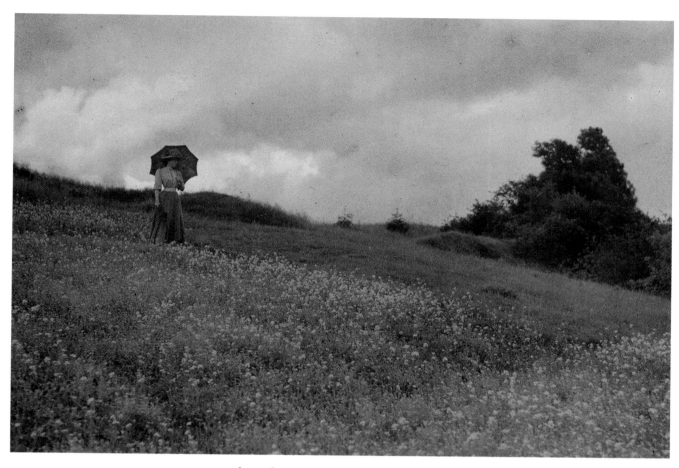

35. ANTONIN PERSONNAZ, *Lady with Parasol*, c. 1907–1910

36. ANTONIN PERSONNAZ, *Field of Poppies*, c. 1907–1910

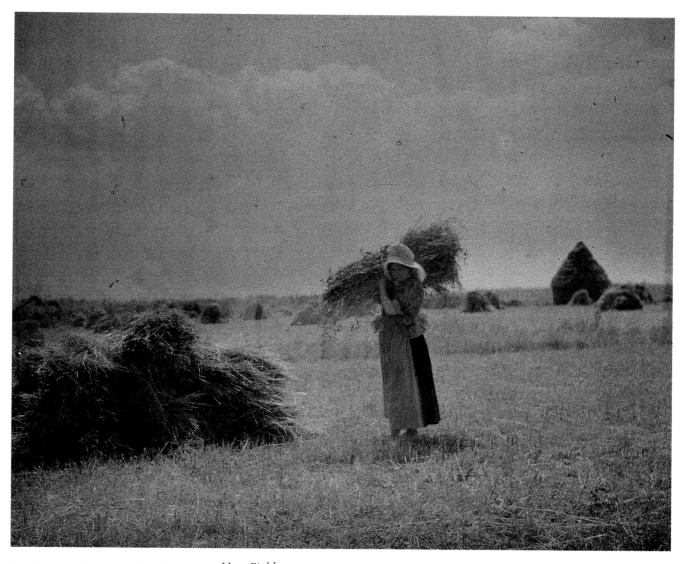

37. ANTONIN PERSONNAZ, *Hay Fields*, c. 1907–1910

38. ANTONIN PERSONNAZ, *Winter Scene*, c. 1907–1910

39. ANTONIN PERSONNAZ, *Country Road*, c. 1907–1910

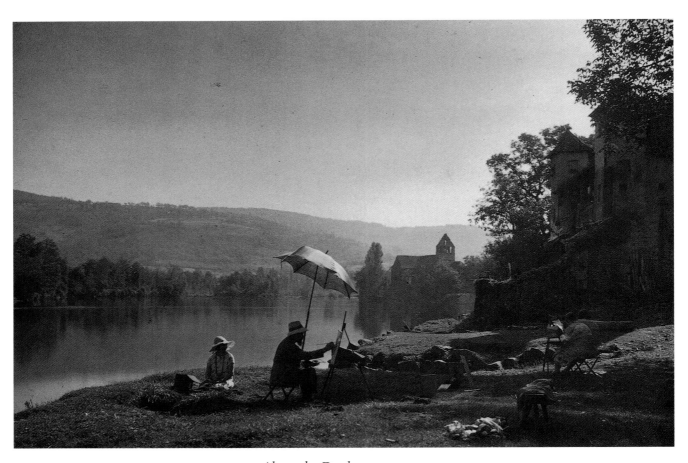

40. G E R V A I S C O U R T E L L E M O N T, *Along the Dordogne,* c. 1925

41. GERVAIS COURTELLEMONT, *The Old Pier, Brittany*, c. 1925–1929

42. GERVAIS COURTELLEMONT, *In Brittany*, c. 1925–1929

43. GERVAIS COURTELLEMONT, *The Sardine Fleet*, c. 1924

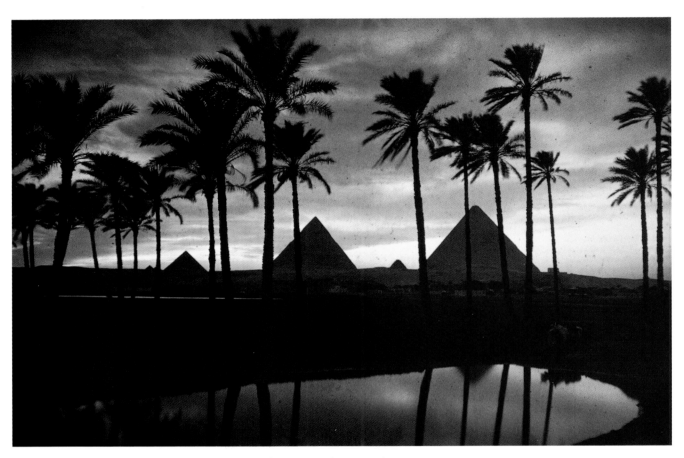

44. GERVAIS COURTELLEMONT, *The Pyramids at Dusk*, c. 1908

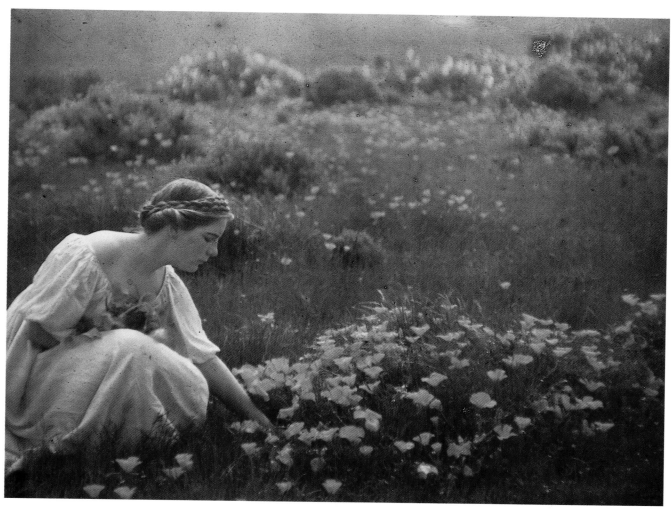

45. A R N O L D G E N T H E, *Helen Cooke in a Field of Poppies,* 1907

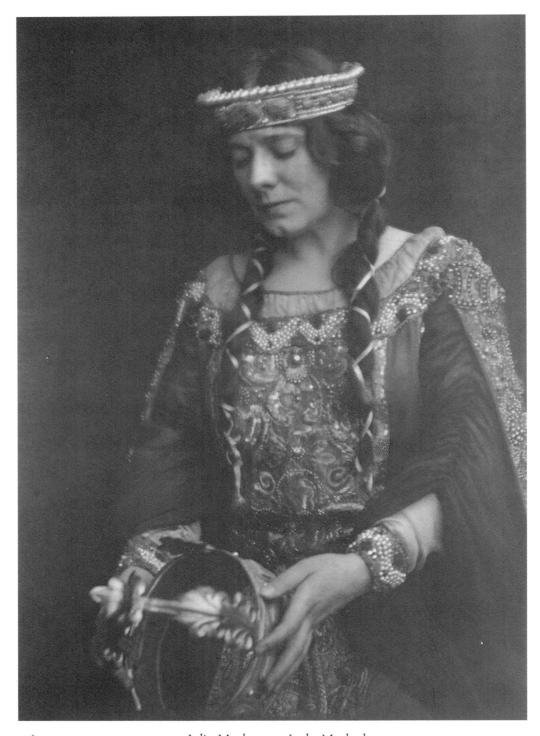

46. A R N O L D G E N T H E, *Julia Marlowe as Lady Macbeth, 1907*

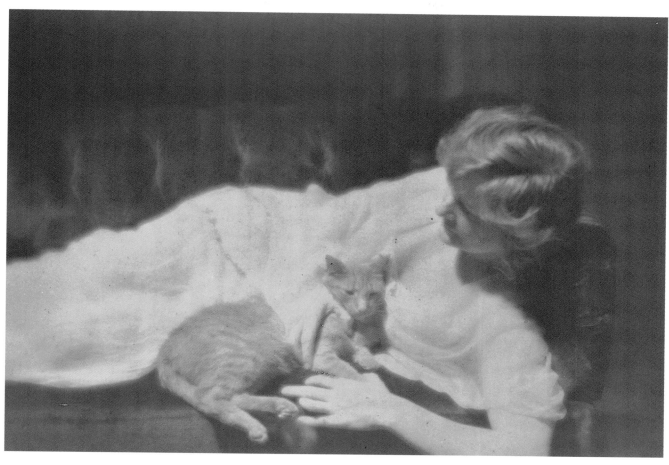

47. ARNOLD GENTHE, *Ann Murdock and Buzzer*, c. 1910

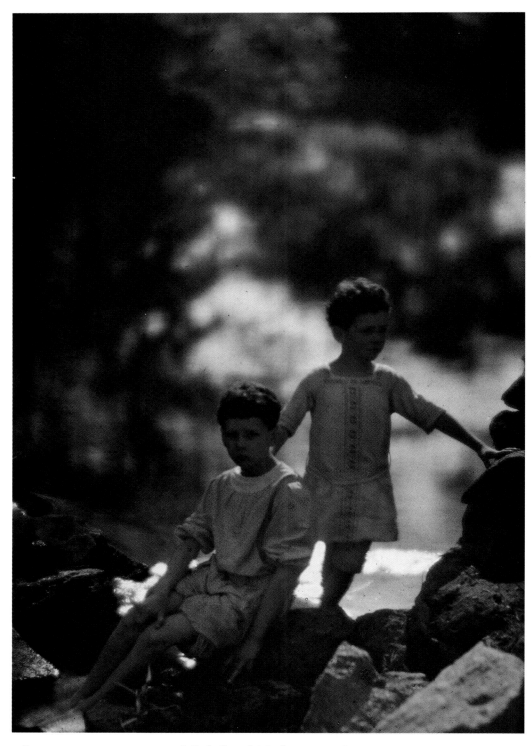

48. ARNOLD GENTHE, *Mitchell and Morley Kennerley,* c. 1912

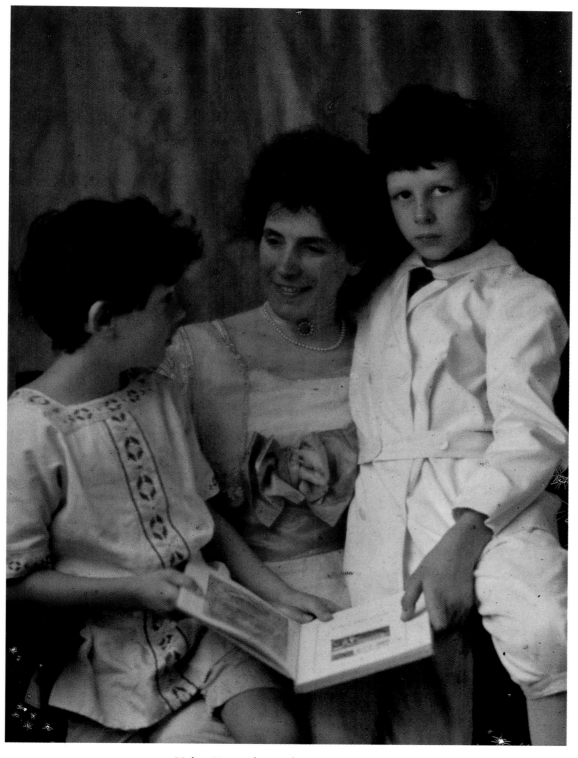

49. A R N O L D G E N T H E, *Helen Kennerley and Her Sons*, c. 1912

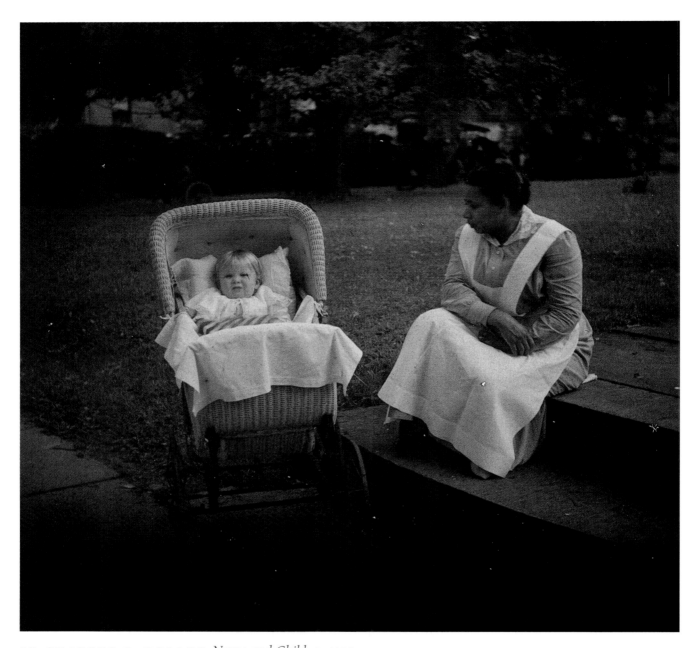

50. CHARLES C. ZOLLER, *Nurse and Child*, c. 1920

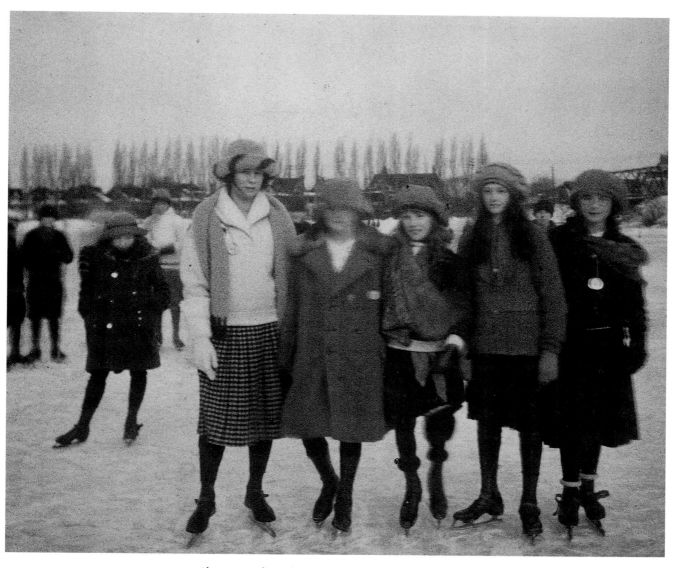

51. CHARLES C. ZOLLER, *Skaters, Lake Riley*, c. 1918

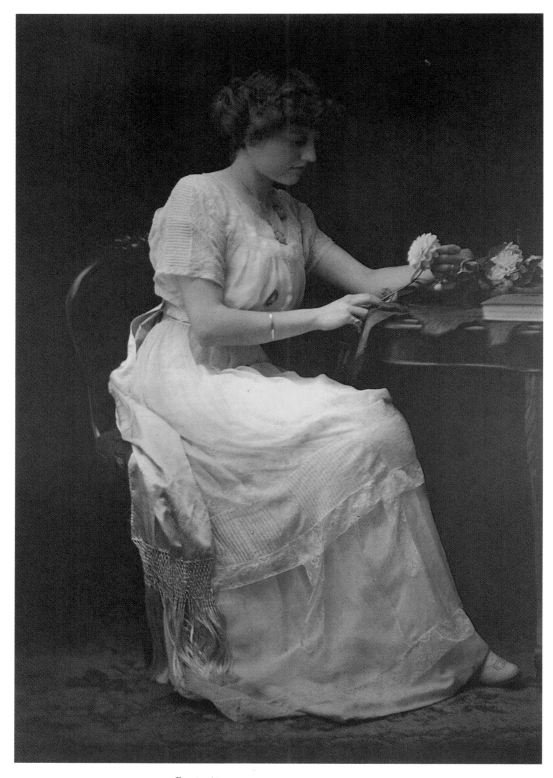

52. J. B. WHITCOMB, *Portrait*, c. 1907–1910

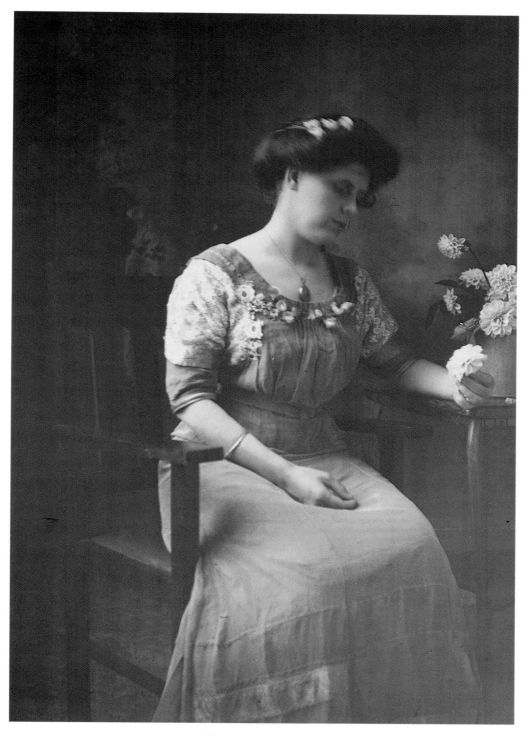

53. J. B. WHITCOMB, *Inez Whitcomb*, c. 1907–1910

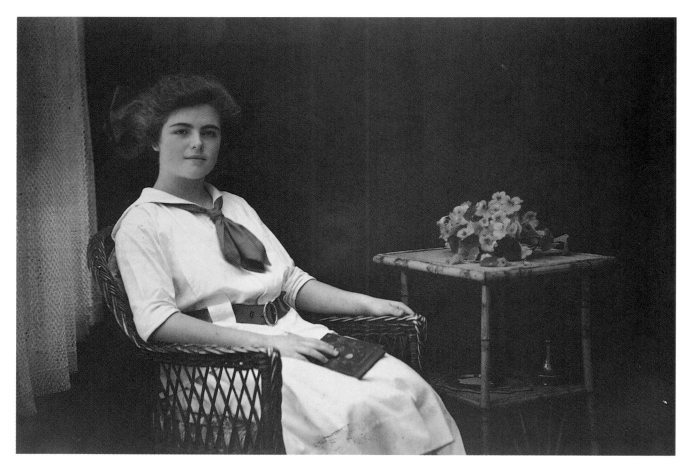

54. J. B. WHITCOMB, *Portrait,* c. 1907–1910

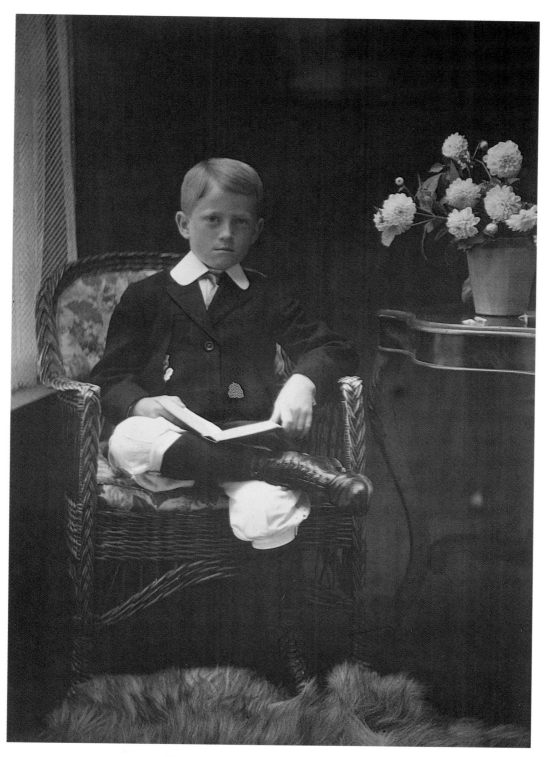

55. J. B. WHITCOMB, *Portrait*, c. 1907–1910

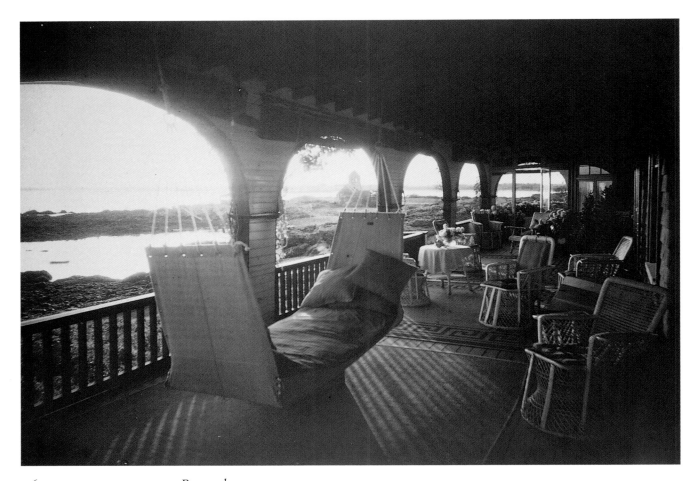

56. J. B. WHITCOMB, *Bermuda*, c. 1907–1910

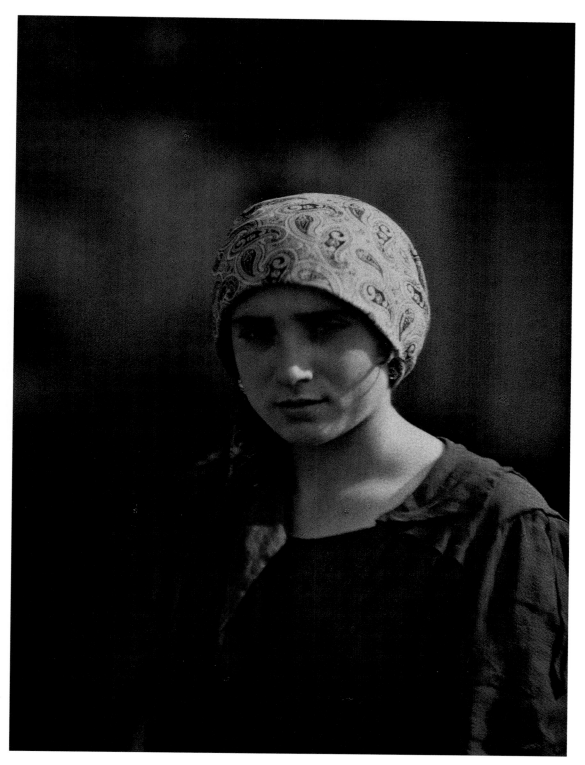

57. FERNAND CUVILLE, *Italian Girl, 1918*

58. FERNAND CUVILLE, *In San Zeno, Verona,* May 16, 1918

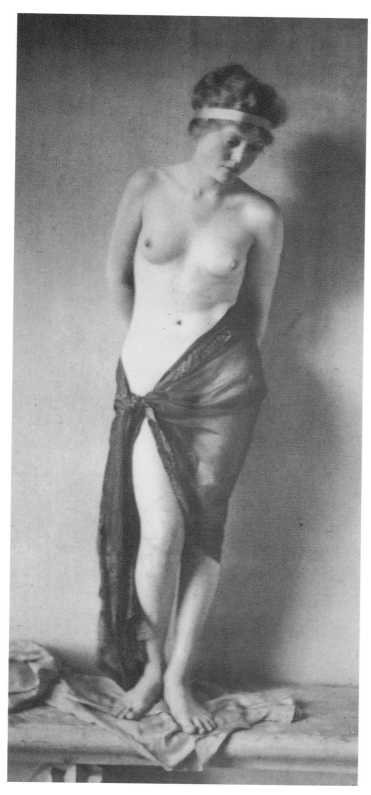

59. LOUIS J. STEELE, *Nude*, c. 1910–1920

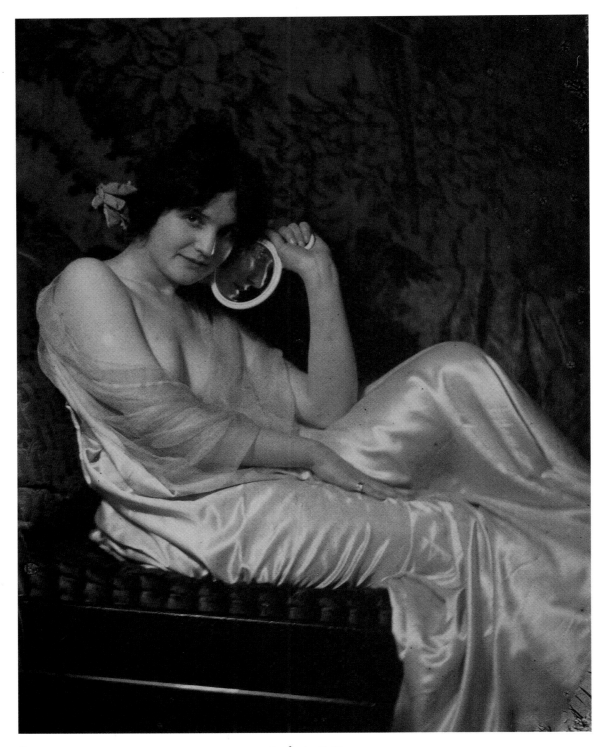

60. PHOTOGRAPHER UNKNOWN, *Lady in Satin*, c. 1910

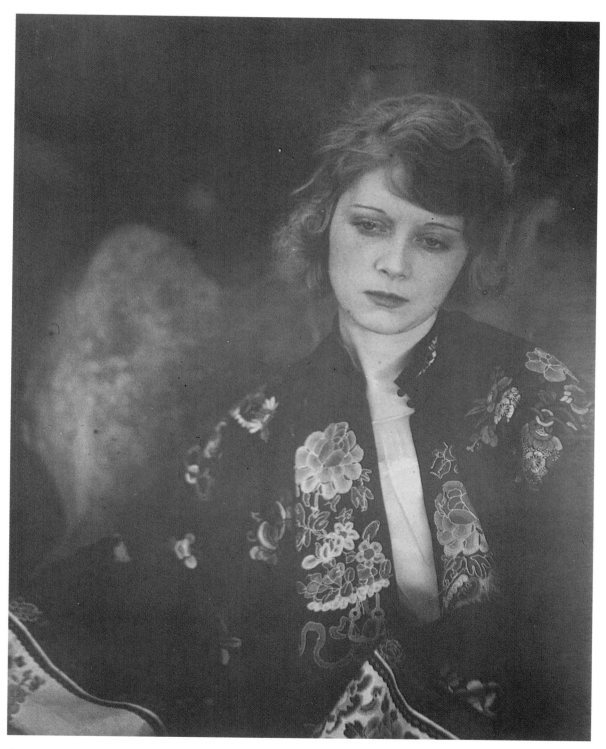

61. PHOTOGRAPHER UNKNOWN, *Portrait*, c. 1925

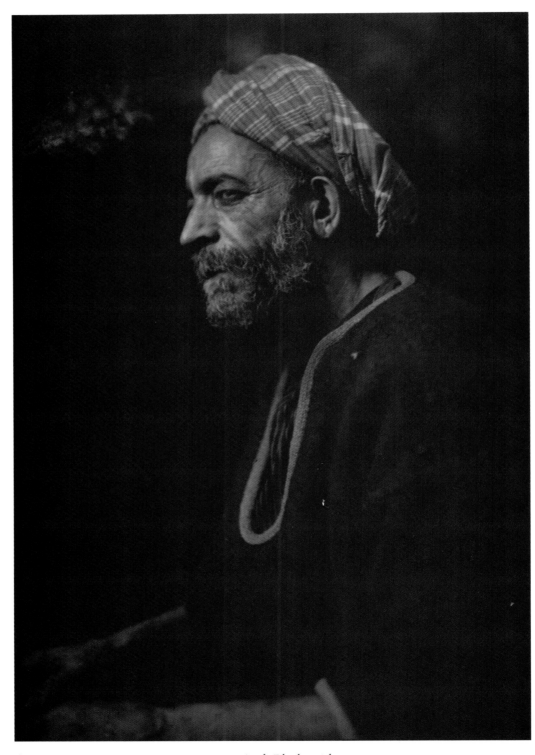

62. FRANKLIN PRICE KNOTT, *Arab Blacksmith*, c. 1915

63. MLLES. MESPOULET AND MIGNON, *Clonmacnoise*, June 1, 1913

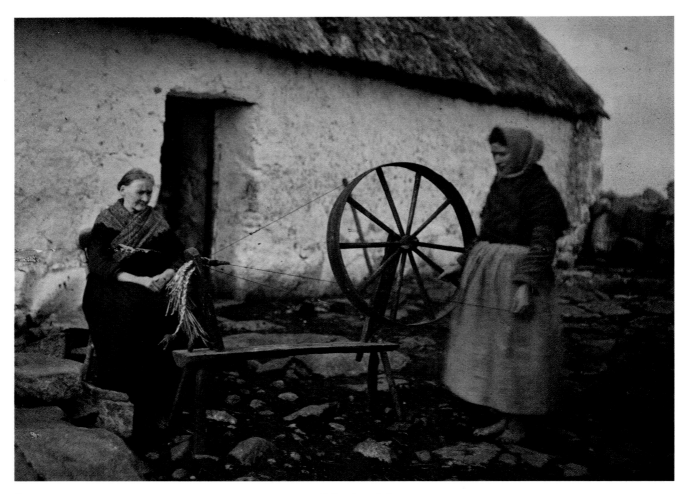

64. MLLES. MESPOULET AND MIGNON, *Spinning*, May 31, 1913

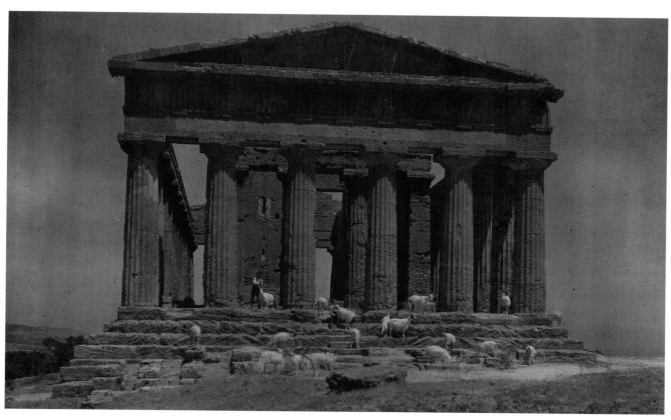

65. LUIGI PELLERANO, *Temple of Concord, Agrigento,* c. 1925

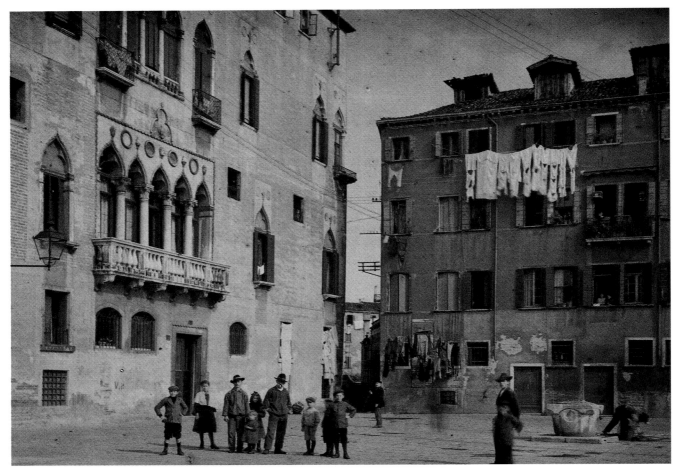

66. AUGUSTE LÉON, *Campo Bandiera e Moro, Venice,* October 1912

67. AUGUSTE LÉON, *"La Providence" in Port, Naples*, April 1, 1921

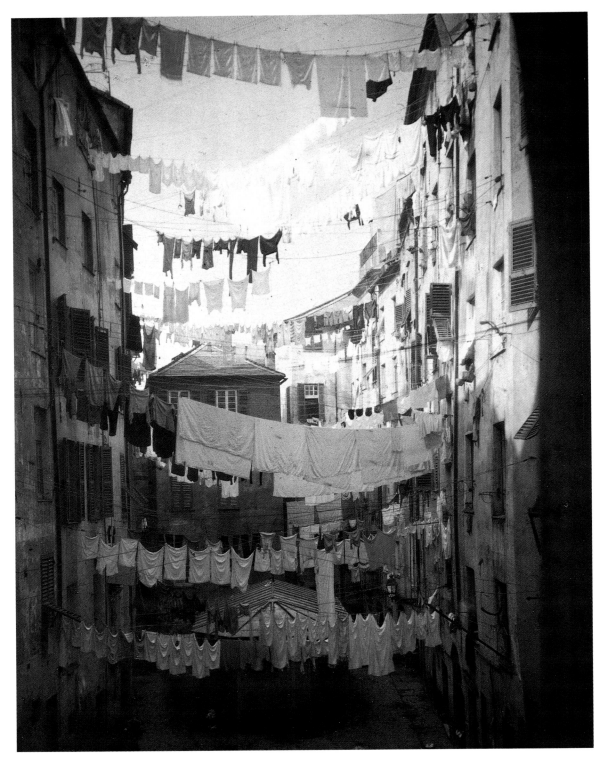

68. HANS HILDENBRAND, *Hanging Wash, Genoa,* c. 1928

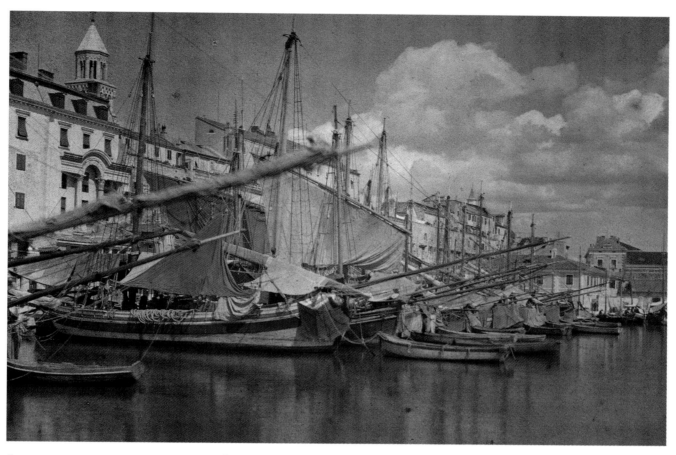

69. HANS HILDENBRAND, *Dalmatian Days*, c. 1928

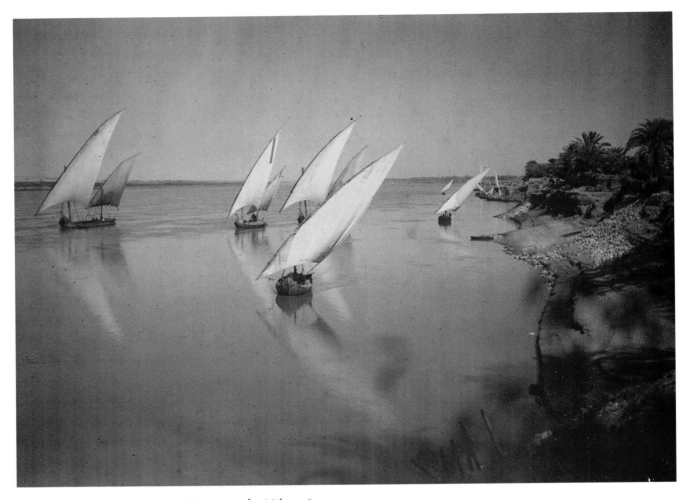

70. HELEN MURDOCH, *Boats on the Nile at Luxor*, c. 1910

71. P H O T O G R A P H E R U N K N O W N, *Alpine Scene*, c. 1910–1920

72. C H A R L E S M A R T I N, *Fields of Fragrance*, c. 1929

73. FRIEDRICH PANETH, *Elise and Eva,* c. 1925

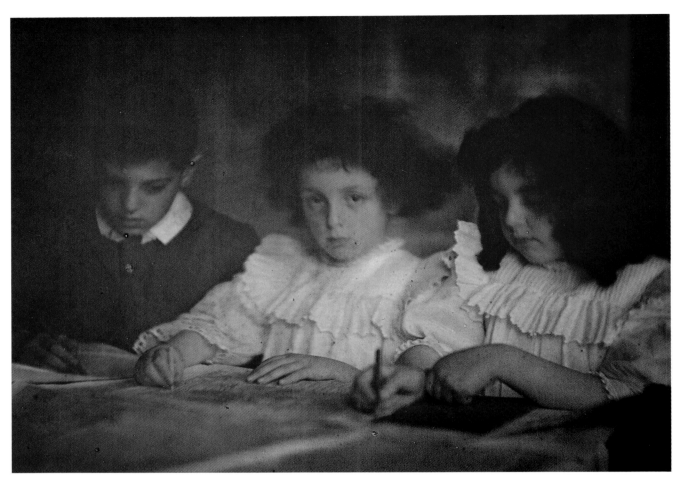

74. J. C. WARBURG, *Children Drawing,* c. 1910

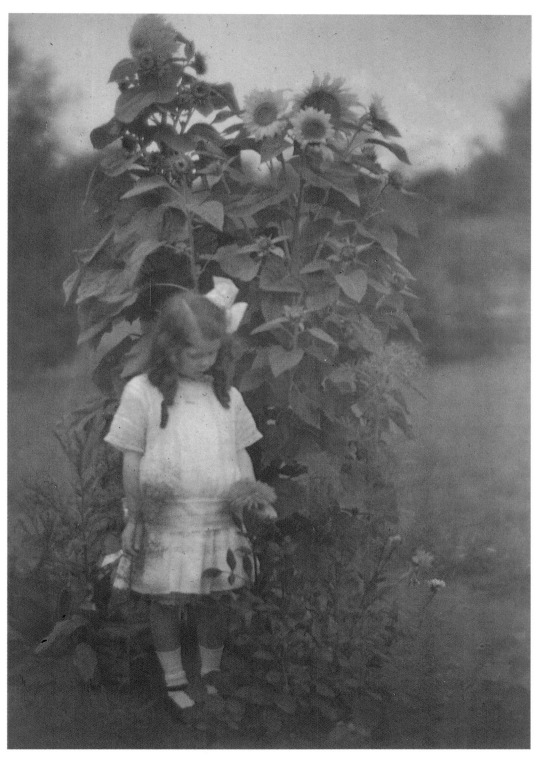

75. PHOTOGRAPHER UNKNOWN, *Girl and Sunflowers*, c. 1910–1920

Notes to the Plates

1. H E I N R I C H K Ü H N, *Miss Mary, Lotte, and Hans*, c. 1907

There is no more evocative a photograph in Kühn's work than this one of his two children and their nurse. It looks like an image from a Visconti movie, and, as autochromes often do, seems to cast us back into a more gracious, naive past. That look is the hallmark of a Kühn photograph, an invitation to tranquility. In his hands the autochrome took on a delicacy rarely seen even in this most delicate of photographic processes. Collection of the author.

2. H E I N R I C H K Ü H N, *Miss Mary and Lotte*, c. 1910–1912

Again one might be looking at a scene from Visconti. Few photographs seem more suggestive of Baudelaire's ideal world of *"luxe, calme et volupté"* than this one. But for all its voluptuous charms and a calm we would gladly linger in today, it was a scene all the clocks in Europe were rapidly ticking off to oblivion. Collection of the author.

3. H E I N R I C H K Ü H N, *Violets*, c. 1910–1912

Of Kühn's many flower studies, this is one of the most beautiful, due to the off-center composition and the contrast of the purple violets against the gray tones of the background. Two other autochrome flower studies of his have also been published: see *Geschichte der Fotografie in Österreich* (Bad Ischl: Verein zur Erarbeitung der Geschichte der Fotografie in Österreich, 1983), I, 239, and Mike Weaver, *The Art of Photography* (New Haven: Yale University Press, 1989), plate 175. Collection of the author.

4. H E I N R I C H K Ü H N, *Still Life*, c. 1909

This is an extremely satisfying and affecting image, one of the finest of Kühn's autochrome still lifes. It obviously was very appealing to him as well because there are at least three variants of

the image taken at different times during the day when the apples cast shadows of varying lengths. See Ulrich Knapp, *Heinrich Kühn Photographien* (Salzburg and Vienna: Residenz Verlag, 1988), plate 38, for one of the variants. Kühn and Schohin were probably the greatest masters of the still life in photography. Their work has a naturalness seldom seen in that genre. The objects they selected never seem arranged, as they so clearly do, for example, in Seeley's overturned bucket and single cluster of grapes (plate 18), but merely laid out as one would find them in real life on real tables waiting for use. Collection of the author.

5. HEINRICH KÜHN, *Still Life*, c. 1909
 See Knapp, plate 37, for a variant image. Collection of the author.

6. HEINRICH KÜHN, *Miss Mary, Lotte, and Hans*, c. 1907
 Collection of the author.

7. HEINRICH KÜHN, *Lotte*, c. 1907
 Collection of the author.

8. HEINRICH KÜHN, *Hans*, c. 1908
 Collection of the author.

9. ALFRED STIEGLITZ, *Kitty*, 1907
 A variant of this portrait of Stieglitz's daughter Katherine is in the collection of the Chicago Art Institute. It is one of the most beautiful of the many portraits of Kitty, who was often photographed by Stieglitz and was the subject of autochromes by Steichen and Eugene. Tragically, within days of the birth of her son in 1923, she succumbed to *post partum dementia praecox* and remained institutionalized until her death in 1971. Collection of the author.

10. ALFRED STIEGLITZ, *Kitty at Breakfast*, 1907
 Here Stieglitz in quite an atypical work has created a Vermeer-like masterpiece of casual, interior composition. Collection of the author.

11. ALFRED STIEGLITZ, *Frank Eugene at Chess*, July–August 1907
 This is one of Stieglitz's first autochromes and was made immediately after he learned the process in Paris from Steichen and then went to Tutzing to visit Frank Eugene and teach it to him. A similar autochrome of Eugene and his friend with his hat still on can be seen in Pierre Apraxine,

Photographs from the Collection of the Gilman Paper Company (New York: White Oak Press, 1985), plate 133. An autochrome of Eugene seated alone at the same table, though a vase of flowers has been added and a few inches of the beer drunk, can be seen in Aaron Scharf, *Pioneers of Photography* (New York: Abrams, 1976), plate 10.5. The note accompanying the Gilman images identifies one of the men as Fredrick Raab. Though Stieglitz did see Dr. Raab by chance at Igls bei Innsbruck in the summer of 1904, when he made his photograph of Raab's daughter, *Miss S. R.*, and though his parents were tended by Dr. Raab in Carlsbad during the summer of 1905, there is no record of Stieglitz having visited with him in 1907. It is most likely that the other gentleman is simply one of Eugene's Tutzing friends. Collection of the author.

12. E D U A R D S T E I C H E N, *Mary Steichen with Russian Dolls*, c. 1908

Unfortunately only some forty of Steichen's autochromes survive, and none are any more touching than this beautiful portrait of his daughter and her Russian nesting dolls. Collection of the International Museum of Photography at George Eastman House; reprinted with permission of Joanna T. Steichen.

13. E D U A R D S T E I C H E N, *Jean Simpson*, October 1907

Jean Simpson and her father, John Simpson, a noted attorney, art collector, and patron of Rodin's, met Steichen at Rodin's studio in 1904, when she was a young girl. Simpson bought both paintings and photographs from Steichen and commissioned him to take portraits of both his daughter and himself. Steichen continued to photograph Jean for nearly twenty years, and they remained close friends throughout their lives. The autochrome is signed by Steichen in the upper left, and a note in his hand affixed to the diascope reads "Paris Oct. 1907." Collection of the author.

14. F R A N K E U G E N E, *Self-Portrait*, August 1911

This autochrome is mounted in a mat on which Eugene has written "On my Roof-Garden! Love to you *all*. Frank, München Aug 1911." The cracks one sees in the emulsion are of a kind occasionally observed in autochromes and may be the result of expansion and contraction of the glass due to temperature changes; however, the Wentzel-Krause conservation study (see Bibliography) only showed that autochromes would turn yellow at elevated temperatures in ovens and that "no deleterious effects" were found "on the flexibility and adhesion of image layers" of autochromes stored at $0°$ F ($-18°$ C) for six months. Collection of the author.

15. A L V I N L A N G D O N C O B U R N, *Mark Twain*, December 1908

For all of Dixon Scott's complaints in his *Studio* essay about the autochrome, complaints that were in truth Coburn's, what a remarkable portrait this is. And what a wonderful experience to see

Mark Twain in color. It is a great pity that Coburn did not use the autochrome for more of his "men of mark." Though the process did not allow him—because of his limited experimentation with it—as much freedom as black and white did, what he achieved in this portrait certainly makes us regret he abandoned it. Collection of the Royal Photographic Society, Bath.

16. ADOLF DE MEYER, *Flower Study*, c. 1907–1909

De Meyer was a master of the flower study, and his famous *Still Life* of a hydrangea in a glass which appeared in *Camera Work* in 1908 is probably the most often reproduced of all flower photographs. Three of his autochrome flower studies appeared in 1908 in the Special Summer Number of *The Studio*, and one would assume that he made a great many more; however, this appears to be one of only two that survive. Collection of the Royal Photographic Society, Bath.

17. GEORGE H. SEELEY, *Still Life with Leaves*, c. 1908

Seeley's autochromes, as beautiful as they are, are completely unlike his work in black and white. Few photographers' imagery was as overtly Symbolist as Seeley's, but his autochromes are highly realistic, perfectly balanced, immaculately composed, rather traditional still lifes. It was as if the autochrome's inherent "straightness" drove the arch Symbolist to realism. A stylistically similar and similarly signed Seeley autochrome in the Gilman Collection also includes the date " '08." Collection of the author.

18. GEORGE H. SEELEY, *Still Life with Grapes*, c. 1908

Collection of the author.

19. GEORGE H. SEELEY, *Still Life with Peaches*, c. 1908

Collection of the author.

20. CLARENCE H. WHITE, *Mrs. White and Son Clarence, Jr.*, c. 1910

Peter Bunnell believes this autochrome to have been made at F. Holland Day's residence near Georgetown, Maine. White and Day were close friends, and in 1910 White bought a house near Day's and opened his summer school for photographers. A Käsebier photograph of the Whites made in Maine at about this time shows Clarence, Jr., in the same sailor suit. Collection of the Art Museum, Princeton University; the Clarence H. White Collection assembled and organized by Professor Clarence H. White, Jr., and given in memory of Mr. Lewis F. White, Dr. Maynard P. White, Sr., and Professor Clarence H. White, Jr., the sons of Clarence H. White, Sr., and Jane Felix White; Copyright © 1992 by the Trustees of Princeton University.

21. PAUL B. HAVILAND, *Lady in Lace*, c. 1910

Though Haviland was a close friend of Stieglitz's, an associate editor of *Camera Work*, and a leading figure in the Photo-Secession, his work with the autochrome was apparently extremely limited. There were only six autochromes, all elaborately matted, in Haviland's estate, a few of which, unfortunately, were marred by overexposure or yellow streaking. This was the most successful one and is the most typical of his work on paper. It is probably a portrait of Anne Brigman, who visited Stieglitz in 1910 and was photographed by Haviland several times in a similar style. As Peter Galassi pointed out in an essay on Haviland in *Photo-Secession* (see text, note 48), "He occasionally participated in a peculiarly Secessionist conceit that sacrificed the identity of the sitter to a mood of untroubled refinement" (p. 6), a mood seen in the Brigman studies. Collection of the author.

22. KARL STRUSS, *Boardwalk, Long Island*, c. 1910

Struss, a student of Clarence White's and a major figure of the Photo-Secession, also became one of the most famous of Hollywood's cameramen. His films included the 1925 *Ben-Hur*, the 1931 *Dr. Jekyll and Mr. Hyde*, *The Great Dictator*, the 1958 *The Fly*, and others. This beautiful photograph of the Boardwalk with its speeding figures at the bottom left seems to foreshadow Struss's cinematography. Collection of the Amon Carter Museum.

23. AUGUSTE AND LOUIS LUMIÈRE, *Still Life with Fish*, c. 1905

The great beauty and brilliance of this still life, which is typical of the Lumières' work, cast serious doubts on Stieglitz's 1907 comment that "Lumière's own examples . . . would never have aroused me to enthusiasm nor led me to try the process myself." Effect, of course, was often more important to Stieglitz than truth. Collection of Joachim Bonnemaison.

24. AUGUSTE AND LOUIS LUMIÈRE, *The Photographers' Nieces*, 1912

These are the children of Auguste's and Louis's sisters France and Juliette. The brothers took many portraits of these children; in this one they obviously have gone on holiday, and the autochrome's inventors, like thousands of other amateurs, carried their camera and plates with them to record their memories in color. Collection of the author.

25. WLADIMIR SCHOHIN, *Still Life with Tea and Honey*, c. 1910

Just as Kühn was able to bend the "straight" autochrome process toward the dreamlike delicacy of Symbolism, Schohin was able to manipulate it to a more intense realism than is seen in anyone else's work, possibly through the use of colored filters. Kühn's and Schohin's works seem to present the opposite poles of the autochrome's possibility and charm. Schohin's has a modernity

about it that Kühn usually eschewed. Schohin's compositions are more radical, his cropping more daring, and his color harder than Kühn's. Collection of the Amatörfotografklubben i Helsingfors; courtesy of the Photographic Museum of Finland.

26. WLADIMIR SCHOHIN, *Still Life with Egg*, c. 1910

Not only is this one of the great autochromes, it is also one of the greatest of color photographs. Our desire to use science and its progress as a metaphor for the way we read history, art, and our other endeavors is always a mistake; however, it has so insinuated itself into our thinking that we expect to find every tomorrow superior to today and today always an advance upon yesterday. It is interesting that with eighty-five years of color photography, nearly a century to perfect the craft, there is still nothing to surpass this autochrome by Wladimir Schohin taken in color's infancy. Collection of the Amatörfotografklubben i Helsingfors; courtesy of the Photographic Museum of Finland.

27. WLADIMIR SCHOHIN, *Still Life with Flowers*, c. 1910

Schohin's composition in this early photograph is surprisingly modern with its juxtaposition of the orange circle and the angles of the white *X* in the window balanced on the opposite side of the autochrome by the bottle and glass but equally surprising in its juxtaposition of those modernistic geometries and the lyrical abandon of the daffodils. Collection of the Amatörfotografklubben i Helsingfors; courtesy of the Photographic Museum of Finland.

28. WLADIMIR SCHOHIN, *Still Life*, c. 1910

Collection of the Amatörfotografklubben i Helsingfors; courtesy of the Photographic Museum of Finland.

29. WLADIMIR SCHOHIN, *Nadezda Schohin*, c. 1910

See text for a discussion of this image. Collection of the Amatörfotografklubben i Helsingfors; courtesy of the Photographic Museum of Finland.

30. LEONID ANDREYEV, *Vadim*, c. 1909–1910

Andreyev was one of pre-Revolutionary Russia's finest writers, but his autochromes were not discovered until 1978. Vadim was the first son of Andreyev's marriage to Aleksandra Veligorskaya, who died in 1906 following the birth of their second son, Daniil. Following Andreyev's 1908 marriage to Anna Ilinichna and the birth of another son in 1909, Vadim and his father became estranged. His sad and angry face in this portrait clearly reflects what the child must have been feeling, but beyond the factuality of the portrait what stands out is that this is one of the most beautiful and touching of children's portraits. Even without knowing the facts of the situation, this

portrait tugs at us and our feelings go out for this obviously unhappy child, whomever he might be. Though this is perhaps Andreyev's most deeply moving portrait, there are several others of Vadim with much of the same power and one of Daniil, whom Andreyev gave over to his mother-in-law to raise, that is nearly as affecting. Collection of the Leeds Russian Archive.

31. LEONID ANDREYEV, *Self-Portrait*, c. 1908–1909

Though this is a rather romantic self-portrait, it is another excellent example of the brilliance of Andreyev's portraiture. The effect of the image in stereo is even more dramatic with the wild-flowers registering in three dimensions before Andreyev on the round bench. Collection of the Leeds Russian Archive.

32. LEONID ANDREYEV, *With Anna*, c. 1908–1909

Andreyev's autochromes are not only beautiful but are masterful stereoscopic compositions as well. He heightened the three-dimensionality of his images by being certain that objects were clearly delineated from foreground to background. Most of Andreyev's autochromes are particularly conscious of this fact and utilize it to advantage, as in this portrait of his wife. Collection of the Leeds Russian Archive.

33. LEONID ANDREYEV, *Anna in the Campagna*, 1914

Collection of the Leeds Russian Archive.

34. LEONID ANDREYEV, *Near Vammelsuu*, c. 1908–1914

This is as finely composed a landscape as any photographer of Andreyev's time was capable of producing and is typical of the kind of balance he achieved in his work. He has positioned his camera so that the road at the base of the image curves slightly below the exact center of the composition. This effect steadies the photograph as the road curves and runs off into the distance below the floating clouds and between the fence and the house. Equally remarkable is an autochrome of Andreyev's yacht in which the large yacht and a pier in the foreground on one side of the image are balanced with a stand of trees and a finger of land jutting out into the water in the background on the other side (see *Leonid Andreyev*, plate 70). Such surprising and striking examples of his composition are not at all uncommon and, again, in every case intensify the three-dimensional stereoscopic effects. Collection of the Leeds Russian Archive.

35. ANTONIN PERSONNAZ, *Lady with Parasol*, c. 1907–1910

Personnaz was a member of the Société Française de Photographie for over forty years, from 1896 to 1937. He was one of the finest of autochromists and occasionally wrote on the subject (see Bibliography). His work is the most painterly of all autochromists'. No one would deny its

clear and striking beauty, but it raises an interesting aesthetic question. Personnaz's autochromes look like what a serious photographic artist working in color photography might have produced in 1875—not 1910! As I point out several times in the text, many autochromes seem to resemble certain kinds of paintings *not* because the photographer was imitative of a painter but because both painter and photographer were part of an international movement working in an international style. This was not the case with Personnaz, however.

His regard for Monet is clear both in his writing and in his autochromes. It is impossible to look at this particular photograph and not think of Monet's countless *Femmes à l'Ombrelles* in settings similar to this one. But Monet and Personnaz were not part of the same movement. Monet's parasoled young ladies were all approaching old age by the time Personnaz posed his lady with a parasol. Is it possible to look at Personnaz's *Field of Poppies* without thinking of Monet's *Poppy Field near Giverny* or Personnaz's *Hay Fields* without thinking of Monet's great *Meule* series with one of Millet's peasants dropped in, as well? Does Personnaz's *Winter Scene* not call up Monet's *Neige à Argenteuil*? A completely legitimate response to such observations could be "So what? If it is beautiful and it moves the viewer, does the fact that it seems out of place in time really 'mean' anything?" The answer seems to depend on the distance and the scope of the borrowing.

The greater the gap of history and the more extensive the borrowing, the more unforgiving the eye seems to be. Richard Polak's photographic pastiches of Dutch paintings, for example, are masterpieces of bad taste, unequaled in the history of photographic kitsch—even by William Mortensen's lurid ghouls and nudes; they are embarrassing enough to offend even the most untutored of eyes. But Personnaz was never involved in such outright plagiarism. His work does not try to imitate Monet's style, which would not be possible with a camera anyway, but alludes to its content in such a way that we find ourselves thinking of particular paintings. Though we accept allusion as a legitimate device in the other arts, including the visual arts, its presence in photography seems curiously troublesome, as is evidenced by contemporary quibbling over Joel-Peter Witkin's uses of it. It seems more contrived and out of place in photography than elsewhere because it draws more attention to itself in the photograph than it does elsewhere. It is more contrived, quite literally, because more contrivance was involved in its production.

That *Déjeuner sur l'herbe* alludes to Giorgione's *Fête Champêtre* or that *Olympia* recalls Titian's *Venus of Urbino* is not the first thing one notices about Manet's two paintings. The allusions do not so overwhelm the eye that in looking at Manet we first see Giorgione or Titian. We never feel the allusions are ends in themselves; however, that greater contrivance it takes to stage a photographic allusion seems to insist that the allusion is primary. On the other hand, even though Personnaz's work reminds one of Monet's, Étienne Clémentel's 1917 autochromes of Monet and the gardens at Giverny, including some of the very subjects Monet painted, do not seem particularly reminiscent of Monet's paintings at all, which does suggest that Personnaz's art, as

difficult as it is to say what it was, was not simply a matter of lifting Monet's images and transporting them to the autochrome plate. Collection of the Société Française de Photographie.

36. ANTONIN PERSONNAZ, *Field of Poppies*, c. 1907–1910
Collection of the Société Française de Photographie.

37. ANTONIN PERSONNAZ, *Hay Fields*, c. 1907–1910
Collection of the Société Française de Photographie.

38. ANTONIN PERSONNAZ, *Winter Scene*, c. 1907–1910
Collection of the Société Française de Photographie.

39. ANTONIN PERSONNAZ, *Country Road*, c. 1907–1910
Collection of the Société Française de Photographie.

40. GERVAIS COURTELLEMONT, *Along the Dordogne*, c. 1925
This is certainly one of the most beautiful of Courtellemont's autochromes, and, interestingly enough, it was one that the *Geographic* never used. Though Courtellemont's name has been forgotten today, in the early days of the autochrome he was one of the most talked about, written about, and prolific of autochromists. The *National Geographic* published 359 of his autochromes between 1924 and 1930. Collection of the National Geographic Society.

41. GERVAIS COURTELLEMONT, *The Old Pier, Brittany*, c. 1925–1929
From an August 1929 photographic essay. Courtellemont's marine views are among the most artistic of all his work. Collection of the National Geographic Society.

42. GERVAIS COURTELLEMONT, *In Brittany*, c. 1925–1929
From an August 1929 photographic essay. Collection of the National Geographic Society.

43. GERVAIS COURTELLEMONT, *The Sardine Fleet*, c. 1924
From a November 1924 photographic essay. Collection of the National Geographic Society.

44. GERVAIS COURTELLEMONT, *The Pyramids at Dusk*, c. 1908
From a September 1926 photographic essay. Collection of the National Geographic Society.

45. A R N O L D G E N T H E, *Helen Cooke in a Field of Poppies*, 1907

In *As I Remember*, Genthe's autobiography, he writes that both he and Sinclair Lewis were "devoted" to "the lovely Helen Cooke." She later married novelist Harry Leon Wilson. This autochrome made in Carmel was one of Genthe's earliest and certainly one of his most beautiful. Collection of the Prints and Photographs Division, Library of Congress.

46. A R N O L D G E N T H E, *Julia Marlowe as Lady Macbeth*, 1907

Marlowe, one of the greatest of Shakespearean actresses and wife of actor Edward Sothern, was particularly known for her beauty and a voice that, once heard, was supposedly never forgotten. Genthe records the making of this autochrome in *As I Remember*. "Julia Marlowe and Edward Sothern, whom I had known for many years, were the subjects of my first really ambitious venture in color photography. In the garden of my cottage studio, I took them in a number of scenes from *Macbeth*. The weathered boards of my kitchen annex looked like the gray walls of Glamis Castle and were a good background for the colorful costumes. I made plates of both of them on the throne, of Sothern as Macbeth alone, and a whole series in fifteen different poses of Marlowe as Lady Macbeth in the sleep-walking scene, which formed a frieze that might have been taken from a motion picture" (p. 113). Some of this series was reproduced in a 1912 article on Genthe by Will Irwin in the *American Magazine*. "This was the first time in America that any magazine of large circulation had direct reproductions of color photographs," Genthe noted (p. 122). Speaking of Marlowe in 1936, he wrote, "I recently sent to her all the color plates I had made of her and Sothern. She had looked through them at my studio after her husband's death and had asked me to send her the whole collection" (p. 115). Genthe was not being completely honest because he had kept this one of Marlowe holding the crown. Collection of the author.

47. A R N O L D G E N T H E, *Ann Murdock and Buzzer*, c. 1910

Genthe's cat Buzzer IV once had a whole page of the *Boston Herald* devoted to him in an article entitled "Buzzer, The Most Photographed Cat in America." Genthe wrote that he made "innumerable photographs of him" and was fond of posing him with beautiful actresses. Dorothy Neumeyer, writing in "As I Remember Arnold Genthe" (see text, note 90), commented that "there were four cats, at different times, each one named Buzzer. He often photographed them, and said, 'There is nothing lovelier than a cat in the hands of a beautiful woman.' One picture he liked very much was of the beautiful red-haired actress Ann Murdock holding Buzzer IV, a lovely, soft red-haired cat" (p. 23). Collection of the author.

48. A R N O L D G E N T H E, *Mitchell and Morley Kennerley*, c. 1912

Genthe met Mitchell Kennerley, Sr., in 1911 soon after Genthe's arrival in New York from California. Kennerley was one of his closest friends and published both his *Pictures of Old China-*

town (1913) and *The Book of the Dance* (1916). Eventually Kennerley became president of Anderson Galleries. Genthe speaks of him many times in *As I Remember* and credits him with having introduced him to many of his most interesting friends. Collection of the International Museum of Photography at George Eastman House.

49. ARNOLD GENTHE, *Helen Kennerley and Her Sons*, c. 1912
 Collection of the International Museum of Photography at George Eastman House.

50. CHARLES C. ZOLLER, *Nurse and Child*, c. 1920
 Zoller was a Rochester, New York, furniture dealer and amateur photographer who happened to be in Paris in 1907. It would not have been possible to have been there then and not heard of the autochrome. Zoller also caught the "color fever," but unlike the more celebrated amateurs of the Photo-Secession, he did not soon quit the process. In fact, he labored at it for nearly twenty-five years and produced thousands of autochromes. Some were used for scientific purposes, some in advertising, and many in his "parlor talks." Though his work displays superb craft and has an artistry about it, its real beauty lies in its documentary quality. Several of the *Geographic's* photographers made autochromes of the United States, but for the most part their photographs were all of "scenic wonders." Zoller's autochromes of people at the swimming pool, kids sitting on a pier, skaters, boys and girls dressed as Indians, a fraternal convention of "knights" in their mystic garb, a little boy dressed as Uncle Sam are the first real pictures of America in color. It is a touching portrait that offers a glimpse into our past that can be found nowhere else. Charles Zoller was in a sense the great American autochromist, and his rich document of us as we were is a deeply moving portrait of America that deserves to be better known. Collection of the International Museum of Photography at George Eastman House.

51. CHARLES C. ZOLLER, *Skaters, Lake Riley*, c. 1918
 Collection of the International Museum of Photography at George Eastman House.

52. J. B. WHITCOMB, *Portrait*, c. 1907–1910
 As I said in the text, there is no one in photography whose work is exactly comparable to Whitcomb's. One must look to Frank Benson, Edmund Tarbell, William Paxton, those painters of the Boston School, and their ethereal women caught up in soft color and elegant interiors, in a "landscape of pleasure," to find anything comparable. Whitcomb was a master of the autochrome, but his work was forgotten—though perhaps, as in Andreyev's case, it had never been known outside the family—until it was accidentally discovered in 1985. Collection of Alan Johanson.

53. J. B. WHITCOMB, *Inez Whitcomb*, c. 1907–1910

There are three portraits of Whitcomb's wife among the fifty that were discovered. This is the most formal and probably the most beautiful. Collection of Alan Johanson.

54. J. B. WHITCOMB, *Portrait*, c. 1907–1910

This is apparently Whitcomb's daughter, and one would assume that the sitter in plate 52 was also a daughter. The green discoloration often seen on autochromes and seen at the edge of this plate is due to moisture entering the broken binding tape. The autochrome's green dye is the most water soluble and is the first to break down. Collection of Alan Johanson.

55. J. B. WHITCOMB, *Portrait*, c. 1907–1910

This portrait and the previous three all seem products of the same sitting. They share in common either the flowers or the furniture. On the basis of another autochrome in the collection entitled *Jay's Play House*, one could probably conclude that this was Jay Whitcomb, the photographer's son. Collection of Alan Johanson.

56. J. B. WHITCOMB, *Bermuda*, c. 1907–1910

This is probably the hotel the Whitcomb family stayed in on a trip to Bermuda which is recorded in the autochromes. It is a remarkable photograph for its spangling light and for that same ease and elegance which characterized the style of the Boston School of painters. Collection of Alan Johanson.

57. FERNAND CUVILLE, *Italian Girl*, 1918

In 1917 and 1918 Cuville worked in Italy on Albert Kahn's immense autochrome project "The Archives of the Planet." Little of Cuville's work survives, but his autochromes of Italy are among the most beautiful in the Kahn Collection and some of the finest ever made. Collection of the Musée Albert Kahn, Département des Hauts-de-Seine.

58. FERNAND CUVILLE, *In San Zeno, Verona*, May 16, 1918

This portrait from inside Verona's eleventh-century church of San Zeno is probably Cuville's finest autochrome and one of the great photographs of the century. Collection of the Musée Albert Kahn, Département des Hauts-de-Seine.

59. LOUIS J. STEELE, *Nude*, c. 1910–1920

Little is known about Louis Steele. His work appeared in some of the journals of the time. It included nudes as well as European and Near Eastern studies. This one is signed "Louis J. Steele, The Royal Dockyard, Portsmouth." Collection of the author.

60. PHOTOGRAPHER UNKNOWN, *Lady in Satin*, c. 1910

The autochrome was a voluptuous process, and all autochromes are richly sensual, but in a photograph of this sort, one in which the photographer was consciously creating an atmosphere of sensuality, the results can be, even with a clothed model, quite erotic, as in the case of this anonymous French autochrome. Collection of the International Museum of Photography at George Eastman House.

61. PHOTOGRAPHER UNKNOWN, *Portrait*, c. 1925

What is most amazing about this beautiful portrait is that it is an autochrome. It looks years too late for the process, even though autochromes were manufactured into the mid-1930s. However, most photographers as good as this photographer clearly was had abandoned the process by the time a scene such as this would have been composed. Perhaps this unknown and talented photographer was, like Fritz Paneth, an amateur who simply was devoted to the process. Collection of the author.

62. FRANKLIN PRICE KNOTT, *Arab Blacksmith*, c. 1915

This is one of Knott's most moving portraits, an insightful, thought-provoking image that originally appeared in the September 1916 issue of the *National Geographic Magazine* with a group of sixteen of his autochromes of India. Twenty-two of Knott's autochromes of California and the American West had appeared a few months earlier in the April 1916 issue, which was the first to feature autochrome color photographs. Autochromes did not appear again in the *Geographic*'s pages until 1921, and Knott's work was not seen again until twenty autochromes of Bali appeared in March 1928 and thirty more from India in October 1929. Two of his autochromes of North Africa appeared in the National Geographic Society's 1981 exhibition *Autochrome: The Vanishing Pioneer of Color*. Collection of the National Geographic Society.

63. MLLES. MESPOULET AND MIGNON, *Clonmacnoise*, June 1, 1913

Few facts are known about these two women who in May and June of 1913 set out for the most primitive and out-of-the-way regions of Ireland as part of Albert Kahn's grandiose project to autochrome the entire planet. Even their first names are unknown, but their legacy of seventy-four autochromes is a remarkable and beautiful photographic document. Collection of the Musée Albert Kahn, Département des Hauts-de-Seine.

64. MLLES. MESPOULET AND MIGNON, *Spinning*, May 31, 1913

Mespoulet's and Mignon's portraits of Irish peasant women are among their most moving works. The poverty here is obvious, but so is the pride of these ladies who have brought their

spinning wheel out of their cottage to be photographed with them. Collection of the Musée Albert Kahn, Département des Hauts-de-Seine.

65. LUIGI PELLERANO, *Temple of Concord, Agrigento*, c. 1925
 Pellerano was an early autochromist and one of the first writers on the autochrome (see Bibliography). His work for the *Geographic* appeared between 1925 and 1927; this particular image is from an October 1927 photographic essay. Collection of the National Geographic Society.

66. AUGUSTE LÉON, *Campo Bandiera e Moro, Venice*, October 1912
 Léon and Cuville may have been Albert Kahn's finest autochromists. Their beautiful photographic portrait of Italy made three quarters of a century ago is still unrivaled. Collection of the Musée Albert Kahn, Département des Hauts-de-Seine.

67. AUGUSTE LÉON, *"La Providence" in Port, Naples*, April 1, 1921
 Collection of the Musée Albert Kahn, Département des Hauts-de-Seine.

68. HANS HILDENBRAND, *Hanging Wash, Genoa*, c. 1928
 This autochrome, though possibly taken years earlier, appeared as part of a photo essay on Italy in the April 1928 *National Geographic*; however, it transcends any kind of documentation of Genoa to become a deeply moving work of art. Hildenbrand has caught something so clearly joyous that it sings out from the image, sings out in the voice of the great American poet Richard Wilbur. I earlier mentioned his well-known poem "Love Calls Us to the Things of This World" in reference to Kühn's work. Here the poem has actually come alive. "The eyes open to a cry of pulleys," Wilbur writes, and "The morning air is all awash with angels." They are in bedsheets, blouses, and smocks, "but truly there they are." And the soul cries, "Oh, let there be nothing on earth but laundry." Wilbur captures what it is that is so joyous in Hildenbrand's image, a sense that something wondrous is happening, that an ordinary street has filled with angels. Collection of the National Geographic Society.

69. HANS HILDENBRAND, *Dalmatian Days*, c. 1928
 From a January 1928 photographic essay. Collection of the National Geographic Society.

70. HELEN MURDOCH, *Boats on the Nile at Luxor*, c. 1910
 Helen Murdoch was an American and also a Fellow of the Royal Photographic Society. In 1913 she addressed the society, obviously at J. C. Warburg's invitation. Her work was well received, especially her autochromes of the Grand Canyon, but Warburg cautioned the audience not to judge her too harshly because some of her autochromes had been developed on location with water from

melted snow. Seven of her autochromes of India were published in the February 1921 *National Geographic*. Though some of her work was exhibited at the Library of Congress's 1981 autochrome exhibition, it was credited to "Photographer unknown." Despite her obvious ability and importance to the history of color photography, Murdoch has been completely ignored, even in books devoted exclusively to women photographers. Collection of the Royal Photographic Society, Bath.

71. PHOTOGRAPHER UNKNOWN, *Alpine Scene*, c. 1910–1920

An image such as this is typical of the majority of autochromes one sees. The photographer has been forgotten, though the quality of the work is remarkable. It appears to be Switzerland, but is it by a Swiss photographer or someone on holiday? It looks more finely composed than most holiday snaps, but the amateur autochromists often had far greater experience with the autochrome plate and a better sense of composition with colors than many famous photographers who primarily worked in black and white. For each question we raise, there is no answer. Most autochromes, like most daguerreotypes, remain a perpetual but fascinating mystery. Collection of the author.

72. CHARLES MARTIN, *Fields of Fragrance*, c. 1929

From a June 1929 photographic essay. Collection of the National Geographic Society.

73. FRIEDRICH PANETH, *Elise and Eva*, c. 1925

Dr. Friedrich (Fritz) Paneth was a Viennese chemist who brought an artist's eye and a scientist's exactitude to the autochrome. He kept elaborate notes about each of his exposures, which he calculated proportionally on the basis of the amount of time the sun was behind a cloud to the amount of time it spent emerging. He felt this aided in contrast and also created a three-dimensional effect when the autochrome was projected. Paneth continued autochroming until 1938. He had fled Germany for England in 1933 and died there in 1958. His daughter Eva presented his archive of four hundred autochromes to the Royal Photographic Society in 1979. Collection of the Royal Photographic Society, Bath.

74. J. C. WARBURG, *Children Drawing*, c. 1910

John Cimon Warburg was born in 1867 and died in 1931. His 1909 complaint in the *British Journal of Photography* about the high prices of autochromes (see Bibliography) is often referred to and might lead one to think he was a poor, struggling amateur. Warburg in fact was immensely wealthy and lived a life of great leisure. He and his family spent half the year in the south of France and the other half in London, but he was still complaining of the price of autochrome plates in England in 1923 (see Bibliography). He wrote extensively on photography, published a book entitled *Pictorial Landscape Photography*, and even had an article in *Camera Work* no. 6. He was a leader in the Royal Photographic Society, a master of gum bichromate printing, and a brilliant,

pioneering autochromist. He stopped autochroming in 1914, but according to the 1923 article took the process up again that year. He and his sister Agnes, also a fine photographer, were well known for their intimate and affecting studies of Warburg's children. Agnes also has a portrait, a red gum print, of Joan Warburg, the child in the middle, drawing (see Margaret Harker, *The Linked Ring*, plate c.2). Collection of the Royal Photographic Society, Bath.

75. PHOTOGRAPHER UNKNOWN, *Girl and Sunflowers*, c. 1910–1920

Here is another anonymous and frustrating work. There are few portraits in this book any more beautiful than this one. It is a masterful work, a great autochrome in every respect, but who the girl is and who made it, whether the photographer might have been a professional or an amateur, whether this is a skillfully crafted image or a piece of good luck, will probably never be known. Again and again one encounters such autochromes—great images whose history has been forgotten and which, were it not for some lucky accident, would have slipped into the trash heaps of oblivion. Though the little girl has no name, what a loss for our eyes it would have been had we not seen her standing there beside her towering sunflowers eighty years ago when someone loved her enough to suspend the scene in the grains of colored starch. Collection of the author.

A Bibliography of the Autochrome

Abney, Sir William. "The Autochrome Process."
British Journal of Photography 54 (October
1907): 804–805.

Adrien, Charles. "Essais d'hypersensibilisation au
trempé des plaques autochromes." *Société fran-
çaise de photographie. Bulletin.* Série 3, vol. 2
(1911): 400–402.

———. "Lanterne de projection portative et écran
démontable pour autochromes." *Société française
de photographie. Bulletin.* Série 3, vol. 10 (April
1923): 114–16.

———. "Note sur la désensibilisation des auto-
chromes." *Société française de photographie.
Bulletin.* Série 3, vol. 8 (1921): 110–12.

———. "Note sur la stéréoscopie autochrome sur
plaques 9 x 12 et divers accessoires de chambre
noire." *Société française de photographie. Bulle-
tin.* Série 3, vol. 8 (1921): 24–26. Also printed
in *British Journal of Photography* 58 (February
1921), Colour Photography Supplement: 8; and
Camera Craft 28 (1921): 94–95.

Albert, August. "Farbenlichtdruck und Farbenauf-
nahmen mit Autochromplatten usw." *Jahrbuch
für Photographie und Reproductionstechnik für
1911* 25: 103–104.

Altender, J. V. "Paper Prints from Autochromes."
American Annual of Photography for 1911 25
(1910): 128. Also printed in *British Journal of*
Photography 53 (January 1911), Colour Photog-
raphy Supplement: 7.

Austin, A. C. "The Autochrome Plates in Photo-
lithography." *British Journal of Photography* 55
(April 1918), Colour Photography Supplement:
13–14.

Autochrome, 8oe anniversaire (Paris: Grand Palais,
1984).

"Autochrome Items." *British Journal of Photogra-
phy* 54 (November 1907): 839–40. On green
stains.

"Autochrome Plates under Modification Treat-
ment." *British Journal of Photography* 54 (Octo-
ber 1907): 772–73.

"The Autochrome Process in a Nutshell." *Photo-
graphic News* 52 (September 1907): 304. Also
printed in *Wilson's Photographic Magazine* 44,
no. 611 (November 1907): 487–89.

"Autochrome Work." *British Journal of Photogra-
phy* 57 (July 1910): 563–64.

Autochromes: Color Photography Comes of Age
(Washington: Library of Congress, 1980). Check-
list of autochromes included in the Library of
Congress exhibition.

"The Autochromes at the New Gallery." *British
Journal of Photography* 55 (September 1908):
734–35.

"Autochromes from Autochromes." *British Journal of Photography* 54 (November 1907): 858.

The Autochromes of Charles C. Zoller, 1909–1930: Rochester in Color (Rochester: IMP/GEH, 1988). A booklet of postcards reproducing twenty autochromes with a short note on Zoller and the process.

"Autochromes of the Lunar Eclipse." *British Journal of Photography* 67 (July 1920), Colour Photography Supplement: 28. Involved a forty-minute exposure.

Autochromie: 80e anniversaire (Paris: Conseil général des Hauts-de-Seine, 1984). Kahn Collection exhibition catalogue.

Balagny, Georges. "Application du diamidophénol en liqueur acide au développement des plaques autochromes." *Société française de photographie. Bulletin.* Série 2, vol. 24 (1908): 55–58. Also printed in Série 3, vol. 3 (1912): 371–78; *British Journal of Photography* 60 (February 1913), Colour Photography Supplement: 6–8.

Bartlett, John. "Autochromes and Art." *Bulletin of Photography* 11 (September 1912): 373–74.

Bayley, R. Child. "Color Photography." *Photo Miniature* 7 (September 1907): 449–57.

———. "Copying Autochromes in the Camera." *British Journal of Photography* 54 (November 1907): 831.

———. "Lantern Slides of Autochrome Plates." *Camera Craft* 15 (1908): 177–80.

———. *Real Colour Photography* (London: Iliffe, 1907). Abridged in *Wilson's Photographic Magazine* 44, no. 612 (December 1907): 530–36.

———. "Reproduction par contact et par réduction des chromotypes sur plaques autochromes." *Société française de photographie. Bulletin.* Série 2, vol. 24 (1909): 325–29.

Beausoleil, Jeanne, et al. *Albert Kahn et le Japon. Confluences* (Paris: Albert Kahn Museum, 1990). Beautiful reproductions of Roger Dumas's autochromes of Japan from the world's largest autochrome collection.

———. *Autochromes 1906/1928: les premiers chefs-d'oeuvre de la photographie en couleurs* (Paris: André Barret, 1978). A striking book with many wonderful reproductions.

———. *L'Auvergne au Quotidien: 1911–1917* (Paris: Albert Kahn Museum, 1992). Autochromes from the Auvergne by Léon, Passet, and Chevalier.

———. *Irlande 1913* (Paris: Albert Kahn Museum, 1988). One of the most beautiful of the Kahn Museum books. Illustrates the work of two of the greatest female autochromists, Mespoulet and Mignon.

———. *Italie: Points de Vue 1912–1925* (Paris: Albert Kahn Museum, 1991). Probably the most beautiful of the Kahn Collection books; forty-nine stunning autochromes by Léon, Cuville, and Dumas.

———. *Tunisie: Aperçus de 1909 et 1931* (Paris: Albert Kahn Museum, 1983). Early work by Courtellemont and Souvieux.

———. *Turquie-Türkiye 1912–1923* (Paris: Albert Kahn Museum, 1980). Work by Léon, Passet, and Gadmer.

———. *Villages et villageois au Tonkin* (Paris: Albert Kahn Museum, 1987). The work of Léon Busy.

———. *Visage de l'Auvergne* (Paris: Albert Kahn Museum, n.d.).

Belden, Charles J. "Making Autochromes by Artificial Light." *American Annual of Photography for 1918* 32 (1917): 88–92. Also printed in *British Journal of Photography* 66 (July 1919), Colour Photography Supplement: 25–26.

Bellieni, H. "Utilisation, pour la photographie ordinaire, des écrans destinés aux plaques autochromes." *Société française de photographie. Bulletin.* Série 3, vol. 2 (1911): 82–83.

Biermann, E. A. "Autochrome Work." *British Journal of Photography* 52 (January 1915), Colour Photography Supplement: 2–3.

———. "Autochromy Up to Date." *American An-*

nual of Photography for 1916 30 (1915): 170 –
73.

———. "Individualised Autochromy." *Amateur Photography & Photographic News* 60 (July 1914): 56.

Bordeaux, Jules. "La photographie et les couleurs." *Revue général* 90 (1909): 905 – 22.

Boucher, L. "Renforcement des autochromes." *Photo-gazette* 22 (June 1912): 157 – 58.

Bouldoyre, R. "The Use of Ordinary Plates in Determining Exposure for Autochromes." *British Journal of Photography* 57 (November 1910), Colour Photography Supplement: 86 – 87.

Bourke, Walter. "An Autochrome Experience." *British Journal of Photography* 56 (September 1909): 735. Asks why color disappeared from a plate; answered in the October issue, p. 80.

Bourrée, H. *Notes pratiques sur l'emploi des plaques autochromes* (Paris: C. Mandel, 1909?).

Bouton, L., and J. Feytaud. "La photographie stéréoscopique en couleur et ses applications scientifiques." *Académie de sciences. Comptes rendus* 150 (May 1910): 1424 – 25.

Brown, Edward Lumsden. "Color Photography." *Photographic Times* (1907): 471 – 76. A paper read in October 1907 before the Midlothian Photographic Association.

———. "On Direct Colour-photography by the Lumière Process." *Royal Scottish Society of Arts. Transactions* 18 (1908): 154 – 57.

———. "The First Direct Color Photography: Lumière Process, in Scotland." *Wilson's Photographic Magazine* 44, no. 610 (October 1907): 434 – 35.

Brown, George, and C. Welborne Piper. *Colour Photography with the Lumière "Autochrome" Plates* (London: Houghtons Limited, 1907).

Burchardt, Ernest A. "Negatives for Three-Colour Printing from Autochromes." *British Journal of Photography* 68 (September 1921), Colour Photography Supplement: 33 – 34.

Burnham, J. Appleton. "Observations on the Auto-

chrome Process." *Photo-Era* 24 (May 1910): 197 – 201.

Busy, L. "L'autochromie en voyage de France au Tonkin." *Photo-gazette* 22 (July 1912): 177 – 78.

Carpentier, J. "La photographie des couleurs par les plaques autochromes de MM. Lumière frères." *Société des ingénieurs civils de France. Mémoires.* Série 6, vol. 51 (1908): 962 – 72.

Carr, Sydney Herbert. "The Intensification of Autochromes." *British Journal of Photography* 56 (August 1909), Colour Photography Supplement: 64.

Carrara, Achille. "Reproductions of Autochromes on Paper by Three-Colour Carbon Printing." *British Journal of Photography* 51 (March 1914), Colour Photography Supplement: 10. Also printed in *Camera Craft* 21 (1914): 407 – 408.

Carter, Charles M. "Painting and Color Photography." *American Annual of Photography for 1909* 23 (1908): 41 – 42.

Chaboseau, Robert. "Observations sur l'emploi des plaques autochromes." *Société française de photographie. Bulletin.* Série 2, vol. 24 (1908): 349 – 58.

Chevrier, Henri. "Montage des épreuves obtenues sur plaques autochromes." *Société française de photographie. Bulletin.* Série 2, vol. 24 (1908): 257.

———. "Observations sur le traitement des plaques autochromes." *Société française de photographie. Bulletin.* Série 2, vol. 23 (1907): 477 – 85.

———. "Traitement des plaques autochromes." *Photo-gazette* 18 (December 1907): 21 – 26.

Claudy, Carl Harry. "The Autochrome Plate and the Microscope." *Bulletin of Photography* 2 (1908): 105 – 106, 125 – 26, 145 – 46.

Il colore della bella époque. I primi processi fotografici diapositivi (Venice: Palazzo Fortuny, 1983).

"Colour in Autochromes." *British Journal of Photography* 55 (October 1908): 765. A response to criticism of autochromes.

"Colour Photographs of Rock Sections." *Nature* 77 (January 1908): 206.

"Colour Photography and Crime." *British Journal*

of Photography 55 (June 1908): 445. Refers to autochromes of bloody garments.

"Colour Prints from Autochromes." *British Journal of Photography* 59 (June 1912): Colour Photography Supplement: 31.

Comley, Henry J. "Color Photography" in J. B. Schriever, *Complete Self-Instructing Library of Practical Photography* (Scranton, 1909), VIII, 507 – 56. Detailed instructions for autochrome, three-color photography, and pinatype.

———. "Three-colour Carbon and the Autochrome Process." *British Journal of Photography* 54 (November 1907): 853 – 54, 875.

Coonoor. "On Working the Autochrome Plate in India." *British Journal of Photography* 60 (January 1913), Colour Photography Supplement: 3 – 4.

Cooper, James. "Amateurs and the Autochrome." *Photo-Era* 31 (August 1913): 80 – 85.

Coote, Jack. "First Colour." *Amateur Photographer* (June 23, 1990): 54 – 56.

Corke, H. Essenhigh. "The Autochrome Process." *Photographic Journal* 36 (December 1912): 338 – 45.

Courtellemont, G. "Autochromes on Tour." *British Journal of Photography* 55 (June 1908), Colour Photography Supplement: 46. Courtellemont exposed some 1,300 plates on a tour of the Near East.

Cousin, Ernest. "Contribution à l'obtention des reproductions d'autochromes sur autochromes." *Société française de photographie. Bulletin.* Série 3, vol. 4 (1913): 330 – 35. Also printed in *British Journal of Photography* 61 (February 1914), Colour Photography Supplement: 7; *Photographische Mitteilungen* 50 (1913): 373 – 74.

Coustet, Ernest. "Conseils pratiques sur l'emploi des plaques autochromes." *Photo-gazette* 18 (February 1908): 72 – 78.

———. "Le temps de pose des plaques autochromes." *Photo-gazette* 18 (April 1908): 111 – 15.

Crémier, Victor. "L'automne et l'autochrome." *Photo-gazette* 22 (November 1911): 11 – 15.

———. "Coucher de soleil sur autochromes." *Photo-gazette* 21 (1910): 21 – 26. Also printed in *British Journal of Photography* 58 (February 1911), Colour Photography Supplement: 9 – 10.

———. "Détermination du temps de pose pour autochromes." *Photo-gazette* 19 (November 1908): 5 – 15.

———. "Ordinary Negatives from Autochrome and Other Screen-Plate Transparencies." *British Journal of Photography* 58 (April 1911), Colour Photography Supplement: 28 – 29.

———. *La photographie des couleurs par les plaques autochromes* (Paris: Gauthier-Villars, 1911). Reprinted in R. Sobieszek, ed., *Early Experiments with Direct Color Photography* (New York: Arno, 1979).

———. "Les plaques autochromes et la stéréoscopie." *Photo-gazette* 17 (August 1907): 186 – 89.

———. "Pour les débutants 'Autochromistes.'" *Photo-gazette* 19 (April 1909): 101 – 108.

———. "Some Essential Points in the Autochrome Process." *British Journal of Photography* 56 (December 1909), Colour Photography Supplement: 94.

———. "Sur la traduction des couleurs par la plaque 'autochrome.'" *Photo-gazette* 19 (November 1909): 4 – 12.

Cuenot, J. *Les Archives de la Planète* (Paris: J. Cuenot/Hachette Réalités, 1978).

"A Curious Case of Frilling with Autochromes." *British Journal of Photography* 58 (April 1911), Colour Photography Supplement: 52, 55 – 56.

Cust, Leopold. "Notes upon the Working of Autochromes." *British Journal of Photography* 59 (March 1912), Colour Photography Supplement: 1 – 3, 5 – 7.

Dalmas, R., Comte de. "Du développement des plaques autochromes en voyage." *Société française de photographie. Bulletin.* Série 3, vol. 2 (1911): 106 – 108. Also printed in *British Journal*

of Photography 58 (May 1911), Colour Photography Supplement : 34–35; *Photographische Mitteilungen* 48 (1911): 177–79.

———. "Enlèvement des points noirs sur plaques autochromes." *Société française de photographie. Bulletin.* Série 3, vol. 3 (1912): 158–59. Also printed in *British Journal of Photography* 59 (June 1912), Colour Photography Supplement: 36.

———. "Observations sur le nouvel emballage des plaques autochromes." *Société française de photographie. Bulletin.* Série 3, vol 2 (1911): 271–72.

———. "Produit pour l'inversion des plaques autochromes en voyage." *Société française de photographie. Bulletin.* Série 2, vol. 25 (1909): 102–103. Also printed in *British Journal of Photography* 56 (May 1909), Colour Photography Supplement: 40.

———. "Sujets encadrés sur plaques autochromes." *Société française de photographie. Bulletin.* Série 3, vol. 1 (1910): 396–98. Also printed in *British Journal of Photography* 58 (January 1911), Colour Photography Supplement: 7–8; *Photo-gazette* 21 (August 1911): 187.

———. "Utilization des plaques autochromes d'une ancienneté relative de fabrication." *Société française de photographie. Bulletin.* Série 3, vol. 1 (1910): 102–103. Also printed in *British Journal of Photography* 57 (April 1910), Colour Photography Supplement: 32.

David, Albert. "Chromium Intensification of Autochromes." *British Journal of Photography* 59 (September 1912), Colour Photography Supplement: 44.

———. "Intensification of Autochromes." *British Journal of Photography* 59 (June 1912), Colour Photography Supplement: 31–32.

Davies, Richard. *Leonid Andreyev: Photographs by a Russian Writer* (London: Thames and Hudson, 1989). Includes eighty Andreyev autochromes reproduced in color.

Deisch, Noel. "Illumination of the Subject in Deter-mining the Colour Quality of Autochromes." *Photographic Journal of America* 54 (November 1917): 467–69. Also printed in *British Journal of Photography* 65 (August 1918), Colour Photography Supplement: 30–31; abstracted in *Camera Craft* 25 (1918): 244–46.

"A Development Accessory for Autochromes, Panchromatic Plates, etc." *British Journal of Photography* 55 (February 1908), Colour Photography Supplement: 16.

"The Development of Autochromes." *British Journal of Photography* 55 (October 1908), Colour Photography Supplement: 79–80.

Didier, Léon. "Pinatype Prints from Autochromes and Other Screen-Plate Transparencies." *British Journal of Photography* 55 (May 1908), Colour Photography Supplement: 35–37.

Dillaye, Frédéric. "Autochromes of Bluish Tones." *British Journal of Photography* 55 (March 1908): 221.

———. "L'autochromoscope Elgé" and "L'écran jaune des plaques autochromes" and "Les grands contrastes avec plaques autochromes." In his *Les nouveautés photographiques 1911–1912* (Paris, 1912), pp. 113–15, 104–109, 102–104.

———. "Développement des plaques autochromes en lumière rouge très vive." *Société française de photographie. Bulletin.* Série 3, vol. 3 (1912): 68–71. Also printed in *British Journal of Photography* 59 (August 1912), Colour Photography Supplement: 37–38; and in his *Les nouveautés photographiques 1911–1912* (Paris, 1912), pp. 115–25.

———. "Le développement surveillé des plaques autochromes" and "Exposé et critique d'un nouveau mode de traitement des plaques autochromes." In his *Les nouveautés photographiques 1909* (Paris, 1909), pp. 108–24.

———. "Écrans pour plaques autochromes exposées à la lumière artificielle" and "Reproduction par contact des chromotypes obtenus sur plaques autochromes." In his *Les nouveautés photogra-*

phiques (Paris, 1910), 112–14, 122–24.

——. *La photographie par autochromes* (Paris, 1908).

D'Osmond, H. "Le portrait instantané sur autochromes." *Photo-gazette* 19 (June 1909): 141–46. Also printed in *British Journal of Photography* 56 (August 1909): 60–61; and see 57 (October 1910), Colour Photography Supplement: 76–77, for additional material.

Dowier, Charles A. "Acid Amidol for the Development of Autochromes." *British Journal of Photography* 55 (April 1908), Colour Photography Supplement: 32.

Downes, William Howe. "Influence of the Autochrome Process upon Art." *Photo Era* 20 (January 1908): 41–42.

Drake-Brockman, H. G. "Autochrome Photography for the Tourist." *British Journal of Photography* 55 (June 1908), Colour Photography Supplement: 47–48.

——. "Autochromes and Extremes of Contrast." *British Journal of Photography* 56 (October 1909), Colour Photography Supplement: 73. Also printed in *Photo-gazette* 20 (March 1910): 86–89.

Emery, C. F. "Autochrome Plates in Landscape Work." *British Journal of Photography* 55 (June 1908), Colour Photography Supplement: 48. Notes that tones are colder in early summer than in September.

Evans, C. Willard. "Developing Autochromes." *British Journal of Photography* 58 (January 1911), Colour Photography Supplement: 3–4.

"The Exhibition of Colour Photography." *British Journal of Photography* 55 (June 1908): 449. Second exhibition of Society of Colour Photographers.

"Exposure with Autochromes." *British Journal of Photography* 54 (December 1907): 918.

"Exposure with Autochromes." *British Journal of Photography* 55 (February 1908), Colour Photography Supplement: 10–11.

"The Fading of the Autochrome Colour Screen."
British Journal of Photography 56 (July 1909), Colour Photography Supplement: 540.

Fabry, Charles. "La photographie des couleurs." *Société scientifique industrielle de Marseille. Bulletin* 36 (1908): 7–21.

Falk, B. F. "The Autochrome Process—A New Era." *Wilson's Photographic Magazine* 44, no. 611 (November 1907): 484–86.

Fanstone, Robert M. "After-Treatment of Defective Autochromes." *British Journal of Photography* 70 (July 1923), Colour Photography Supplement: 15. Beginning in 1920 Fanstone became one of the most prolific writers on the subject of color photography, publishing in some years on average an article a month.

——. "Autochrome Lantern Slides." *British Journal of Photography* 69 (September 1922), Colour Photography Supplement: 37.

——. "Cleaning Autochromes and Fixing after Intensification." *British Journal of Photography* 67 (November 1920), Colour Photography Supplement: 44.

——. "Clouds in Autochromes." *British Journal of Photography* 68 (June 1921), Colour Photography Supplement: 24.

——. "The Intensification of Autochromes." *British Journal of Photography* 67 (November 1920), Colour Photography Supplement: 44. Also see 68 (December 1921), Colour Photography Supplement: 45–46.

——. "Some Causes of Failure in Autochrome Work." *British Journal of Photography* 69 (May 1922), Colour Photography Supplement: 17–18.

Farbe im Photo: Die Geschichte der Farbphotographie von 1861 bis 1981 (Cologne: Josef-Haubrich-Kunsthalle Köln, 1981). Exhibition catalogue with essays; the best history of color photography.

Farmer, Howard. "The Reproduction of Autochromes." *British Journal of Photography* 56 (September 1909), Colour Photography Supplement: 71–72.

Ferrars, Max. "Die Autochrom-Platte von Lu-

mière." *Photographische Welt* 22 (January 1908): 2.

———. "Weitere Erfahrungen mit der Autochromplatte." *Photographische Welt* 22 (January 1908): 3–4.

La Filmcolor Lumière: photographie des couleurs sur film par le procédé Autochrome Lumière (Paris: Société Lumière, n.d.).

Fingerhuth, C. "Schwarzweisskopien von Autochromaufnahmen." *Photographische Rundschau* 52 (1915): 81–82. Also see "Black and White Prints from Autochromes." *British Journal of Photography* 63 (August 1916), Colour Photography Supplement: 32.

Fitzsimons, R. J. (firm). *Color Photography with Autochrom Plates* (New York: Fitzsimons, 1916).

"Flashlight Autochrome Portraits." *British Journal of Photography* 56 (February 1909), Colour Photography Supplement: 16; and 58 (March 1911), Colour Photography Supplement: 23–24. Discusses B. J. Falk.

"Flower Studies in Colour." *British Journal of Photography* 54 (November 1907): 822.

Franck, Charles E. "Frilling of Autochromes." *British Journal of Photography* 58 (November 1911), Colour Photography Supplement: 64.

Fraprie, Frank. "Simple Color Photography Achieved." *American Photography* 1 (August 1907): 59–64.

Frederking, H. "Das neue Verfahren der Naturfarbenphotographie von A. und L. Lumière." *Dinglers polytechnisches Journal* 322 (1907): 713–16.

Friedberg, L. H. "Ueber die Photographie in Farben." *Technologist* 14 (1909): 137–57.

Friese, H. "Der Dreifarbendruck unter besonderer Berücksichtigung der Teilplatten nach Lumiereschen Autochrom-Diapositiven." *Photographische Korrespondenz* 47 (1910): 584–88.

G.S.G. "A Method of Retouching Autochromes." *British Journal of Photography* 59 (December 1912), Colour Photography Supplement: 5.

Gandolfo, Jean-Paul. "Problèmes posés par la duplication des plaques autochrome: solutions envisagées au musée Albert Kahn" in *Sauvegarde et conservation des photographies, dessins, imprimés et manuscrits* (Paris: Association pour la Recherche Scientifique sur les Arts Graphiques, 1991), pp. 104–11.

Génard, Paul, and André Barret. *Lumière: les premières photographies en couleurs* (Paris: André Barret, 1974). Includes twenty-four excellent reproductions.

Genthe, Arnold. "Some Remarks on Colour Photography." *British Journal of Photography* 52 (October 1915), Colour Photography Supplement: 39–40.

Gérard, Louise. "La retouche des autochromes." *Société française de photographie. Bulletin.* Série 3, vol. 4 (1913): 337–38.

Gimpel, Léon. "Amélioration dans la reproduction et l'agrandissement des plaques en couleurs." *Société française de photographie. Bulletin.* Série 3, vol. 2 (1911): 101–103. Also printed in *British Journal of Photography* 58 (September 1911), Colour Photography Supplement: 53–54.

———. "Application du procédé Artigue (à deux plaques) à la reproduction en noir des plaques autochromes." *Société française de photographie. Bulletin.* Série 3, vol. 10 (January 1923): 23–26.

———. "Le centième de seconde en autochromie et l'instantané nocturne sur plaques noires avec l'éclairage ordinaire par l'ultrasensibilisation de M. F. Monpillard." *Société française de photographie. Bulletin.* Série 3, vol. 9 (May 1922): 130–45. Also printed in *British Journal of Photography* 69 (July 1922), Colour Photography Supplement: 26–27.

———. "La photographie des couleurs à l'Illustration." *l'Illustration* no. 3355 (June 1907): 387–88.

———. "La projection en relief à la portée de tous par anaglyphes sur plaques autochromes." *Société française de photographie. Bulletin.* Série 3, vol. 8 (1921): 194–204.

———. "Reproduction sur plaques autochromes

des épreuves obtenues sur ses mêmes plaques." *Photo-gazette* 18 (October 1908): 222–25. Also printed in *Société française de photographie. Bulletin.* Série 2, vol. 24 (1908): 317–20. Also see his "Autochromes from Autochromes," *British Journal of Photography* 55 (August 1908), Colour Photography Supplement: 61; and his "Duplicates of Autochromes," 57 (October 1910), Colour Photography Supplement: 75–76.

Godeau, A. S. "The Great Autochrome Controversy" in *Camera* 35 (May 1981).

———. "Louis-Amédée Mante: Inventor of Color Photography?" *Portfolio* 3, no. 1 (January/February 1981): 40–45.

Godefroy, L. *Guide pratique pour réussir la photographie en couleurs. Développement rationnel des plaques autochromes* (Paris: J. Lamarre, 1921).

Goerz. "Châssis spécial pour plaques autochromes de Lumière." Illus. *Société française de photographie. Bulletin.* Série 2, vol. 24 (1908): 308–10.

"The Goerz Autochrome Dark-Slide." *British Journal of Photography* 56 (March 1909), Colour Photography Supplement: 24.

Goldschmidt, Robert. "La photographie des couleurs." *Université de Bruxelles. Revue* 13 (1908): 317–36. Also printed in *Société chimique de Belgique. Bulletin* 22 (1908): 20–37.

Goutcher, A. Winton. "The Fixing Bath in Autochrome Work." *British Journal of Photography* 55 (March 1908): 227.

Grange, Dr. *Pour faire une bonne autochrome* (Paris: C. Mendel, 1914?).

Grant, Thomas. "The Autochrome Process." *Photographic Journal* 31 (December 1907): 395–401.

———. "Autochromes." *British Journal of Photography* 55 (November 1908): 895–96.

Gravier, Charles. "Daylight Development of Autochromes by the Gravier Method." *British Journal of Photography* 55 (January 1908): 34.

———. "Observations nouvelles sur les plaques autochromes." *Société française de photographie. Bulletin.* Série 2, vol. 33 (1907): 475–76.

———. "La photographie des couleurs simplifiée." *Société française de photographie. Bulletin.* Série 2, vol. 25 (1909): 411–12. On simplified autochrome process.

———. "La photographie des couleurs sur les plaques autochromes." *Société française de photographie. Bulletin.* Série 2, vol. 23 (1907): 415–17.

———. "Plates for Colour Photography." *British Journal of Photography* 58 (January 1911), Colour Photography Supplement: 2–3.

Gray, Edward. "An Amateur's First Experience with Autochrome Plates." *Camera Craft* 15 (April 1908): 132–34.

Grove, J. M. C. "Prismatic Fantasies of Colour on Autochrome Plates." *British Journal of Photography* 60 (January 1913), Colour Photography Supplement: 4.

Guébhard, Adrien. "Sur le procédé de photographie des couleurs de MM. A. & L. Lumière." *Académie des sciences. Comptes rendus* 145 (November 1907): 792–95.

———. "Sur le rôle de l'inversion dans le procédé de photographie des couleurs de MM. A. & L. Lumière." *Société française de photographie. Bulletin.* Série 2, vol. 23 (1907): 534–37.

———. "Ueber den Lumièreschen photographischen Farbenprozess." *Jahrbuch für Photographie und Reproductionstechnik für 1908* 22: 164–67.

de Guillebon, Claudie. *Albert Kahn Museum* (Paris: Musées 2000, 1991). A guide and souvenir book of the Kahn Collection (Boulogne–Billancourt) of over 70,000 autochromes.

"A Half-guinea Autochrome Outfit." *British Journal of Photography* 56 (March 1909), Colour Photography Supplement: 24.

Hammond, Anne. "Impressionist Theory and the Autochrome." *History of Photography* 15, no. 2 (Summer 1991): 96–100.

Harberisser. "Autochrome Filters." *British Journal of Photography* 54 (October 1907): 816.

Hartmann, Sadakichi. "Lumière's 'Autochrome.'" *Stylus* 1 (January 1910): 13–18.

Hervé. "Le portrait sur autochromes à l'atelier et en plein air." *Société française de photographie. Bulletin*. Série 3, vol. 7 (1920): 34–36. Abstracted in *British Journal of Photography* 68 (April 1921), Colour Photography Supplement: 16; and *Camera Craft* 38 (June 1921): 202–203.

Holme, Charles, ed.; text by Dixon Scott. *Colour Photography and Other Recent Developments of the Art of the Camera* (London: Offices of "The Studio," 1908). Special Summer Number of *The Studio* reproducing autochromes by J. Craig Annan (2), A. L. Coburn (3), Frank Eugene (1), Heinrich Kühn (2), Baron de Meyer (3), G. E. H. Rawlins (1), George Bernard Shaw (1), and F. W. Urquhart (1).

Houdaille. "Recherches expérimentales sur la détermination du temps de pose des plaques autochromes." *Société française de photographie. Bulletin*. Série 2, vol. 25 (1909): 292–97. Also printed in *British Journal of Photography* 56 (September 1909), Colour Photography Supplement: 69–71.

Hovey, Clarissa. "Color Photography." *Photographic Times* 64, no. 9 (September 1912): 354–59. Originally given as a paper to the Women's Federation of Photography at Philadelphia; a variant appeared in *Wilson's Photographic Magazine* (August 1912): 340–44.

Howard, April. "Autochromes: The First Color Photography." *Darkroom Photography* (July 1989): 42–48, 57–58.

Huebl, Arthur, Freiherr von. "The Colour Properties of the Autochrome Plate and the Processes of Producing Autochromes." *British Journal of Photography* 55 (November 1908), Colour Photography Supplement: 82–85.

———. "The Colours of the Autochrome Pictures in Regard to Their Production." *British Journal of Photography* 55 (December 1908), Colour Photography Supplement: 93–95.

———. "The Compensation Filter for the Autochrome Plate." *British Journal of Photography* 56 (September 1909), Colour Photography Supplement: 14–15, 17–18.

———. "The Correction of Prevailing Tints in Autochromes by Coloured Screens." *British Journal of Photography* 60 (September 1913), Colour Photography Supplement: 33–34.

———. "The Effect of Illumination on Exposure and Viewing of Autochromes." *British Journal of Photography* 56 (April 1909), Colour Photography Supplement: 26–29.

———. "Die Farbenphotographie." *Photographische Korrespondenz* 45 (1908): 446–50.

———. "Gelbscheiben für Autochromaufnahmen." *Photographische Rundschau* 50 (1913): 79.

———. "Metallic Screens for Autochromes." *British Journal of Photography* 56 (June 1909), Colour Photography Supplement: 47.

———. "On the Sensitiveness of the Autochrome Plate." *British Journal of Photography* 55 (April 1908), Colour Photography Supplement: 30.

———. "The Production of Pure White in Autochrome Plates." *British Journal of Photography* 59 (April 1912), Colour Photography Supplement: 13–14.

———. "The Reproduction of Autochromes and Other Screen-Plate Transparencies." *British Journal of Photography* 57 (August 1910), Colour Photography Supplement: 59–61. On copying one autochrome on another autochrome plate.

———. "Steigerung der Empfindlichkeit der Autochromplatte." *Photographische Rundschau* 50 (1913): 81.

———. "Temperature in Development." *British Journal of Photography* 55 (November 1908), Colour Photography Supplement: 88.

———. *Die Theorie und Praxis der Farbenphotographie mit Autochromplatten*. (Halle a. S.: Wilhelm Knapp, 1908). There were additions to text

and illustrations in the 1912 and 1916 editions.

———. "The Theory of the Autochrome Plate." *British Journal of Photography* 55 (January 1908), Colour Photography Supplement: 5 – 7.

———. "Zur Charakteristik der modernen Farbenphotographie." *Photographische Korrespondenz* 45 (1908): 496 – 502.

Husník, Jaroslav. "Meine Erfahrungen mit Lumières Autochromplatten." *Photographische Korrespondenz* 45 (1908): 49 – 57. Also printed in *British Journal of Photography* 55 (November 1908), Colour Photography Supplement: 20.

———. "Ueber die gleichmässige Farbenempfindlichkeit bei Autochromplatten." *Jahrbuch für Photographie und Reproductionstechnik für 1908* 22: 127 – 28.

C.J. "Single-plate Colour-photographie." *Nature* 76 (August 1907): 317.

Jones, Chapman. "Autochrome Plates." *Knowledge and Scientific News* 5 (May 1908): 104. Also printed in *British Journal of Photography* 55 (June 1908), Colour Photography Supplement: 46.

———. "The Photography of Colour." *Scientific Progress* 2 (1908): 349 – 68.

Jones, T. H. "Simplified Development of Autochromes." *British Journal of Photography* 55 (February 1908): 171.

Klein, Henry Oscar. "My Experience with the Autochrome Plate." *American Annual of Photography for 1910* 24 (1909): 130 – 33.

Knapp, Ulrich. *Heinrich Kühn: Photographien* (Salzburg and Vienna: Residenz Verlag, 1988). Discussion of Knapp's autochrome work, pp. 21 – 23.

Knowles, Hugh C. "Progress in Screen Plate Photography." *American Annual of Photography for 1911* 25 (1910): 140 – 42.

———. "Screen Plate Color Photography." *American Annual of Photography for 1910* 24 (1909): 38 – 41.

Koenig, Ernst. *Die Autochrom-Photographie und die verwandten Dreifarbenraster-Verfahren* (Berlin: G. Schmidt, 1908), Photographische Bibliothek, XXIII. Not included in OCLC international interlibrary loan network; however, a copy does exist at the New York Public Library.

———. "Duplicates of Autochromes." *British Journal of Photography* 57 (September 1910), Colour Photography Supplement: 67 – 68.

"Kopierung von Farbenphotographien auf Autochromplatten im Kontakt." *Photographische Korrespondenz* 47 (1910): 115 – 17. On work done in the Lumière laboratory.

Kruegener, R. "Die neue Farbenphotographie von Auguste und Louis Lumière in Lyon." *Photographische Korrespondenz* 45 (1907): 337 – 41. Also printed in *Photographische Welt* 21 (1907): 113 – 15, 131 – 33.

Lartigue, Jacques-Henri, Georges Herscher, and Yves Aubry. *The Autochromes of Jacques-Henri Lartigue* (New York: Viking, 1981).

Laurvik, John Nilsen. "The New Color Photography." *International Studio* 34 (1908): xxi – xxiii. Stieglitz exhibited Laurvik's autochromes in 1909.

Lavédrine, Bertrand, Jean-Paul Gandolfo, and Jean-Michel Susbielles. "Analyse des colorants dans les autochromes" in *Sauvegarde et conservation des photographies, dessins, imprimés et manuscrits* (Paris: Association pour la Recherche Scientifique sur les Arts Graphiques, 1991), pp. 91 – 103.

Lefort, V. "Les peintres et la photographie des couleurs." *Photo-gazette* 19 (May 1908): 136 – 38.

Legeret, E. "Using Autochrome Plates in a Changing Box." *British Journal of Photography* 58 (June 1911), Colour Photography Supplement: 44.

Lehmann, Johannes. "Highly Reflecting Lantern Screens for Autochrome and Other Projections." *British Journal of Photography* 56 (June 1909), Colour Photography Supplement: 44 – 47.

———. "Über die direkten Verfahren der Farbenphotographie nach Lippmann und Lumière." *Physikalische Zeitschrift* 8 (1907): 842 – 49. Also printed in *Deutsche physikalische Gesellschaft. Berichte* 5 (1907): 624 – 38.

Leiber, Ferdinand. "Making the Best of Under-Exposed Autochromes." *British Journal of Photography* 58 (October 1911), Colour Photography Supplement: 57.

Lelong, Adrien. "Autochrome Work without a Darkroom." *British Journal of Photography* 56 (August 1909), Colour Photography Supplement: 60.

Leon, L. C. "An Unsuspected Cause of Failure in Autochrome Work." *British Journal of Photography* 56 (August 1909), Colour Photography Supplement: 64.

Le Roy, George. "Rectification des épreuvessur plaques autochromes." *Société française de photographie. Bulletin.* Série 2, vol. 23 (1907): 473. Abstract in *British Journal of Photography* 55 (February 1908), Colour Photography Supplement: 11.

———. "Vernis pour plaques autochromes." *Société française de photographie. Bulletin.* Série 2, vol. 23 (1907): 472. Abstract in *British Journal of Photography* 55 (February 1908), Colour Photography Supplement: 11.

Lester, Peter. "Travel and Early Colour." *Photography* (March 1992): 24–27. On Helen Murdoch's and Fritz Paneth's autochromes.

Lewis, Alfred Holmes. "The Autochrome in Winter." *Photo-Era* 28 (January 1912): 10–12.

"The Light of Egypt: Natural Colour Photographs of the Glorious Effects of Egyptian Sunsets and Sunrise." *Illustrated London News* 138 (February 25, 1911, supplement). The work of Gervais Courtellemont.

Litchfield, Charles. "Exposure in Autochrome Work and the Use of Different Compensation Filters." *British Journal of Photography* 55 (March 1908), Colour Photography Supplement: 24.

Locquin, René. "Autochromes by Artificial Light." *British Journal of Photography* 55 (October 1908), Colour Photography Supplement: 75–76.

Loewy, Alfred. "Über Dunkelkamerbeleuchtung Haltbarkeit der Autochromplatten und anderes aus der Praxis der Autochromphotographie." *Photographische Korrespondenz* 46 (1909): 121–23, 159–66. Technical discussion; translation in *British Journal of Photography* 56 (May 1909), Colour Photography Supplement: 37–38.

———. "Simplifying the Handling of Autochrome Plates." *Bulletin of Photography* 3 (October 1908): 259.

Lumière, Auguste. "Traitement simplifié des plaques autochromes." *Société française de photographie. Bulletin.* Série 2, vol. 25 (1909): 449–51.

Lumière, Auguste, and Louis Lumière. "Color Photography." *American Photography* 8 (1914): 358–64.

———. "Kontakkopien von Autochromaufnahmen." *Photographische Mitteilungen* 47 (1910): 22–24.

———. "A Magazine Apparatus for the Viewing of Autochromes." *British Journal of Photography* 56 (January 1909), Colour Photography Supplement: 8. On the chromodiascope.

———. "A New Method for Developing Autochrome Plates." *American Photography* 2 (July 1908): 361–66.

———. "A New Method for the Production of Photographs in Colours." *Photographic Journal* 28 (July 1904): 226–28. Also printed in *British Journal of Photography* 51 (July 1904): 605; *Camera Craft* 11 (1904): 212; and as "Sur une nouvelle méthode d'obtention de photographie en couleurs" in *Académie des sciences. Comptes rendus* 138 (1904): 1337–38; *Société française de photographie. Bulletin.* Série 2, vol. 20 (1904): 333–34; and as "Vorläufige Mitteilung über ein neues Verfahren der Farbenphotographie" in *Photographische Korrespondenz* 41 (1904), opp. 210; *Photographische Kunst* 3 (1904–1905): 337–39.

———. "Note sur un dispositif permettant de reproduire, par contact, des chromotypes obtenus sur plaques autochromes." *Société française de*

photographie. *Bulletin.* Série 2, vol. 25 (1909): 457–59.

———. "Notice de MM. Lumière sur le mode d'emploi des plaques autochromes." *Société française de photographie. Bulletin.* Série 2, vol. 23 (1907): 358–68. Complete directions for the process.

Lumière, Auguste, and others. "Desensitising Autochromes before Development." *British Journal of Photography* 68 (August 1921), Colour Photography Supplement: 29–30. Also printed in *Photo-Era* 47 (December 1921): 297–300.

———. "Flashpowders for Autochrome Work." *British Journal of Photography* 57 (October 1910), Colour Photography Supplement: 74–75.

———. "Methods of Control in the Development of Autochrome Plates." *British Journal of Photography* 54 (December 1907), Colour Photography Supplement: 90–93.

———. "A Simplified Method of Developing Autochrome Plates." *British Journal of Photography* 66 (October 1919), Colour Photography Supplement: 37. Also printed in *Camera Craft* 26 (1919): 478–79.

———. "Sur la correction de la surexposition et de la sousexposition au cours du développement dans le traitement simplifié des plaques autochromes." *Société française de photographie. Bulletin.* Série 2, vol. 25 (1909): 210–13. Also printed in *British Journal of Photography* 56 (September 1909), Colour Photography Supplement: 67.

———. "Sur le développement des plaques autochromes." *Société française de photographie. Bulletin.* Série 2, vol. 23 (1907): 515–28.

———. "Sur l'emploi des poudres éclairs comme source de lumière artificielle dan la photographie sur plaques autochromes." *Société française de photographie. Bulletin.* Série 3, vol. 1 (1910): 285–88. Also printed in *Photographic Journal* 34 (September 1910): 315–19; *Photographische Mitteilungen* 47 (1910): 324–27.

———. "Ueber die Entwicklung der Autochromplatten." *Jahrbuch für Photographie und Reproductionstechnik für 1908* 22: 179–88. Also printed in *Photographische Korrespondenz* 45 (1908): 197–207.

———. "Ueber die Möglichkeit, den Expositionsgrad der Autochromplatten absuschätzen und die Zusammersetzung des Entwicklers im Laufe der Entwicklung zu modifizieren, um die über- oder unterexponierten Bilder zu verbessern." *Jahrbuch für Photographie und Reproductionstechnik für 1909* 23: 27–31.

Lumière, A., and Ses Fils. "Sensitized Plates for Colour Photography." *British Journal of Photography* 52 (January 1905): 10. Abstract of their English patent for plates prepared with starch grains.

"The Lumière Autochrome Color Process." *Wilson's Photographic Magazine* 44, no. 610 (October 1907): 433.

"The Lumière Autochrome Plates." *British Journal of Photography* 54 (December 1907), Colour Photography Supplement: 51–53, 65–68.

Lumière's Autochrome Plates: Instructions for Their Use (Paris: Lumière and Jougla/R. J. Fitzsimons Co., n.d.). Reprinted in R. Sobieszek, ed., *Early Experiments with Direct Color Photography* (New York: Arno, 1979).

"Lumières Verfahren der Photographie in natürlichen Farben mittels Autochromplatten." *Photographische Korrespondenz* 44 (1907): 434–38.

Luther, R. "Some Points in Stereoscopic Photography with the Autochrome Plate." *British Journal of Photography* 55 (November 1908), Colour Photography Supplement: 85–87.

Mairot, F. "Developing Autochromes in Green Light." *British Journal of Photography* 59 (April 1912), Colour Photography Supplement: 16.

Maisch, Fred D. "The Autochrome Plate in Its Relation to the Colour-Theory of Young and Helmholtz." *British Journal of Photography* 57 (1910),

Colour Photography Supplement: 5–6, 13–14. Also printed in *Photo-Era* 23: 262–67; 24: 8–12.

"Making Autochromes by Enclosed Arc Light." *British Journal of Photography* 56 (January 29, 1909): 86.

Malby, H. T., and others. "The Autochrome Process in Many Hands." *Photographic Journal* 33 (March 1909): 136–42.

Mancini, E. "La photographie à couleurs aux plaques autochromes des Frères Lumière." *La Fotografia Artistica* 8 (August 1907): 122 sgg.

"The Manipulation of Autochromes When Traveling." *British Journal of Photography* 57 (October 1910), Colour Photography Supplement: 73–74.

Maraglia, Marina. *Culture Fotografiche e Società a Torino 1839–1911* (Turin: Umberto Allemandi & C., 1990). Reproduces twenty-six autochromes by Secondo Pia, Adriano Tournon, and Giuseppe Gallino.

Mareschal, G. "La cuvette 'Marbach' pour développement en plein jour des plaques autochromes." *Société française de photographie. Bulletin.* Série 2, vol. 24 (1908): 289–91.

———. "The Effect of Developing Solution on the Sensitiveness of the Autochrome Plate." *British Journal of Photography* 55 (November 1909), Colour Photography Supplement: 88.

———. "Emploi des plaques autochromes ayant subi l'action du développement." *Photo-gazette* 19 (October 1909): 213.

———. "Emploi de plaques autochromes en voyage." *Photo-gazette* 18 (May 1908): 130–31. About experiences of Courtellemont.

———. "Nouvelle méthode de développement des plaques autochromes." *Photo-gazette* 18 (June 1908): 152–55.

———. "Persistance de la sensibilité chromatique des plaques autochromes." *Société française de photographie. Bulletin.* Série 2, vol. 25 (1909): 410–11.

———. "Photographie des couleurs par les plaques autochromes Lumière." *Photo-gazette* 17 (May 1907): 121–23.

———. "Reproduction des plaques en couleurs." *Photo-gazette* 19 (December 1909): 37–38. On results of a prize contest.

Marriage, Ernest. "Autochrome Lantern Slides." *British Journal of Photography* 55 (December 1908): 970.

Martin-Duncan, F. "The Autochrome Plate Applied to Natural Science." *Photographic Journal* 32 (April 1908): 172–78. Abstracted in *Wilson's Photographic Magazine* 45, no. 618 (June 1908): 283–86.

———. "The Autochrome Plate in Natural Science." *British Journal of Photography* 55 (January 1908), Colour Photography Supplement: 1.

———. "Autochromes of Nature Subjects." *British Journal of Photography* 54 (November 1907): 834–35.

———. "Some Further Experiments with the Autochrome Plate." *British Journal of Photography* 56 (April 1909), Colour Photography Supplement: 25.

———. "Some Notes on the Microscopic Appearance of the Lumière Autochrome Plate." *British Journal of Photography* 54 (September 1907), Colour Photography Supplement: 68–69.

Martiny, Gaston. "Quelques conséquences de l'emploi des plaques autochromes." *Photo-gazette* 17 (July 1907): 165–67.

Massiot, G. "Matériel complet pour la projection des vues en couleurs sur plaques autochromes." *Société française de photographie. Bulletin.* Série 2, vol. 24 (1908): 207–208.

Mayer, Emil. "Notes on Experience in the Autochrome Process." *British Journal of Photography* 57 (October 1910), Colour Photography Supplement: 43–44, 52–53.

McCord, Bennet. "Why Not the Autochrome?" *The Camera* 18 (1914): 679–82.

McIntosh, J. "The Autochrome Process." *Photographic Journal* 36 (November 1912): 320–29.

Mebes, Albert. *Farbenphotographie mit Farbasterplatten. Theorie u. Praxis d. Autochrom-, Thames-, u.s.w.* (Bunzlau: Fernbach, 1911).

———. *Farbenphotographie mittels einer Aufnahme. Der Autochrom-Prozess u.d. Verfahren von L. Ducos du Hauron, u.s.w.* (Bunzlau: Neudecker, 1909).

Miethe, Adolf. "Mitteilung über ein neues Verfahren der Farbenphotographie von August und Louis Lumiere." *Photographische Chronik* 11 (October 1904): 576–78.

Miller, Malcolm Dean. "The Autochrome Process." *American Annual of Photography for 1909* 23 (1908): 77–78. The *Annual's* first review of the process.

Monpillard, Félix. "À propos des autochromes: leur emploi pour la reproduction des tableaux dans les musées; multiplication des épreuves autochromes par contact ou à la chambre noire." *Société française de photographie. Bulletin.* Série 3, vol. 1 (1910): 239–43. Also printed in *British Journal of Photography* 58 (February 1911), Colour Photography Supplement: 11–12.

———. "Écran pour la microphotographie sur plaques autochromes, avec la lumière oxyhydrique." *Société française de photographie. Bulletin.* Série 2, vol. 25 (1909): 245–47. Also printed in *British Journal of Photography* 56 (August 1909), Colour Photography Supplement: 61–62.

———. "Étude sur les dominantes colorées en photographie autochrome." *Société française de photographie. Bulletin.* Série 2, vol. 25 (1909): 404–409, 419–26.

———. "Indoor Autochrome Portraits by Flashlight." *British Journal of Photography* 56 (July 1909), Colour Photography Supplement: 51–52.

———. "Methods of Development and After-Treatment." *British Journal of Photography* 55 (July 1908), Colour Photography Supplement: 49–51. On autochrome positives.

———. "Observations sur la technique des manipulations des plaques autochromes." *Société française de photographie. Bulletin.* Série 2, vol. 24 (1908): 231–42.

———. "On the Causes of Prevailing Tints in Autochromes." *British Journal of Photography* 57 (March 1910), Colour Photography Supplement: 10–12, 22.

———. "Sur l'utilisation des plaques autochromes avec les lumières artificielles pour la photographie directe et la reproduction." *Société française de photographie. Bulletin.* Série 3, vol. 1 (1910): 104–12. Also printed in *British Journal of Photography* 57 (April 1910), Colour Photography Supplement: 25–27.

Montminy, M. A. "The Autochrome Process." *Wilson's Photographic Magazine* 44, no. 611 (November 1907): 486.

Morton, Arthur E. "Conversion of Autochromes into Paget Colour Slides." *British Journal of Photography* 60 (December 1913), Colour Photography Supplement: 45–47.

Mueller, Gustav. "On the Redevelopment of Autochromes Which Have Practically Disappeared in the Fixing Bath." *British Journal of Photography* 56 (May 1909), Colour Photography Supplement: 40.

Murdoch, Helen. "Colour Photography." *British Journal of Photography* 61 (July 1914), Colour Photography Supplement: 28. On work in India.

———. "Colour Photography in Ceylon." *British Journal of Photography* 61 (October 1914), Colour Photography Supplement: 40.

Namias, Rodolfo. "Some Notes on Autochrome Work." *British Journal of Photography* 58 (May 1911), Colour Photography Supplement: 38–39.

———. "Bermerkungen und Beobachtungen aus der Praxis der Autochromphotographie." *Jahrbuch für Photographie und Reproduktionstechnik für 1913* 27: 162–67. Also printed in *Photo-Era* 32 (June 1914): 280–82.

———. "Fehler bei Autochromaufnahmen und

deren Abhilfe." *Photographische Rundschau* 50 (1913): 47–48. Also printed in *Photographische Chronik* 20 (February 1913): 71–73.

Naumann, Helmut. "Autochrom und Agfarraster." *Zeitschrift für wissenschaftliche Photographie* 22 (1923): 85–91.

"Eine Neue Lumièresche Farbrasterplatte." *Photographische Korrespondenz* 45 (1908): 372–73.

"New Lumière Plate." *Bulletin of Photography* 5 (December 1909): 408. On stereoscopic autochrome plates.

"The New Lumière Screen-Plate." *British Journal of Photography* 55 (August 1908), Colour Photography Supplement: 57–58.

"A New Lumière Screen-Plate Process." *British Journal of Photography* 55 (July 1908): 557–58.

"A New Method of Copying Autochromes on Paper in Colour." *British Journal of Photography* 70 (September 1923), Colour Photography Supplement: 34–36.

"A Note on Varnishing Autochromes." *British Journal of Photography* 54 (November 1907): 859.

"Notes and Comment." *The Photo Miniature* 7, no. 82 (October 1907): 494. Notes on early results of Bayley, Steichen, Dillaye; 7, no. 83 (November 1907): 540–41. Discusses Stieglitz's first showing of autochromes upon return from Europe.

"Notes and Comment." *Camera Craft* 21 (1914): 611. Note on exhibition of two hundred autochromes by Helen Messinger.

Notice sur l'emploi des plaques autochromes (Lyon: Société Anonyme des Plaques et Papiers Photographiques A. Lumière & Ses Fils, n.d.).

Novak, Franz. "Gelbfilter für Autochromblitzlichtaufnahmen." *Jahrbuch für Photographie und Reproductionstechnik für 1911* 25: 190. Also printed in *British Journal of Photography* 58 (December 1911), Colour Photography Supplement: 8.

"O. Edis Galsworthy." *Camera* 58 (1979): 44–47.

On Olive Galsworthy, well-known English autochromist who made portraits of many famous English men and women.

"Le palais de l'autochrome." Illus. *Photo-gazette* 21 (April 1910): 117–18. Also printed in *British Journal of Photography* 58 (August 1911), Colour Photography Supplement: 51–52. Description of Gervais Courtellemont's studio.

Palocsay, Albin von. "Fremde und eigene Versuche zur Abkürzung der Expositionzeit bei Autochromaufnahmen." *Photographische Korrespondenz* 41 (1911): 483–94. Also see the abridged "Shorter Exposures with the Autochrome Plate" in *British Journal of Photography* 58 (April 1911), Colour Photography Supplement: 29–30.

———. "Wichtiger Fortschritte und Enfahrungen betreffend die Photographie mit Farbasterplatten." *Jahrbuch für Photographie und Reproductionstechnik für 1911* 25: 194–228.

Payne, Arthur. "Stereoscopic Photography with Autochrome Plates." *British Journal of Photography* 54 (November 1907): 784–85, 803–804.

Pellerano, Luigi. *L'autocromista e la Pratica Elementare della Fotografia a Colori* (Milano: Ulrico Hoepli, 1914). A 500+ page history of color photography and autochrome manual containing much valuable information, including one of the few references to Rudolph Dührkoop's autochromes (p. 258). Pellerano's own autochromes can be seen in *National Geographic* 48, no. 2: 140–49; 49, no. 4: 464–73; 52, no. 4: 432–49.

Penrose, Frank. "The Use of Autochromes in Bird Photography with Examples of Protective Coloration." *Photographic Journal* 29 (June 1915): 215–18. Also printed in *British Journal of Photography* 62 (July 1915), Colour Photography Supplement: 27–28.

Perkins, Henry Farnham. "Interiors in Natural Colours by Reflected Light." *British Journal of Photography* 62 (June 1915), Colour Photography Supplement: 22–24.

———. "Pictures from Autochromes." *American*

Annual of Photography for 1912 26 (1911): 121–22.

"Permanganate Stains on Autochromes." *British Journal of Photography* 55 (June 1908): 465.

Personnaz, Antonin. "À propos des autochromes." *Société française de photographie. Bulletin.* Série 2, vol. 24 (1908): 179–83, 368–78.

———. "Apropos of Autochromes." *British Journal of Photography* 56 (September 1909), Colour Photography Supplement: 67–68. On autochromes as art.

———. "L'autochromie." *Société française de photographie. Bulletin.* Série 3, vol. 3 (1912): 58–61. Discusses article, "L'automne à Versailles," by critic Robert de la Sizeranne in the Christmas *l'Illustration* with autochromes by Huchard, Bouëtard, Gimpel, and Courtellemont.

Piper, Charles Welborne. "Duplicates of Autochromes by Contact Printing and Copying." *British Journal of Photography* 54 (November 1907), Colour Photography Supplement: 81–82.

Les plaques autochromes: notice sur leur emploi (Paris: Lumière et Jougla, n.d.).

"Plauderei über die Farbenphotographie nach Lumière." *Photographische Chronik* 14 (August 1907): 423–25.

Pledge, John H. "Photo-micrographs of Starch Grains in the Lumière Autochrome Plates." *British Journal of Photography* 54 (September 1907): 721.

Poulenc Frères. "Appareil pour l'examen des vues par transparence et notamment des vues sur plaques autochromes." *Société française de photographie. Bulletin.* Série 2, vol. 25 (1909): 39–40.

———. "Lanterne spéciale pour plaques autochromes, construite par les Établissements Poulenc." *Société française de photographie. Bulletin.* Série 2, vol. 24 (1908): 487–88.

Power, H. D'Arcy. "Autochrome Notes." *Camera Craft* 15 (1908): 31–33.

———. "Color Photography." *Camera Craft* 15 (1908): 311, 353; 16 (1909): 29, 73–74, 186–87, 321, 369. Regards his ongoing progress.

———. "The Lumière Autochrome Plate." *Camera Craft* 15 (1908): 20–23.

———. "A New Color Plate." *Camera Craft* 15 (1908): 229–30.

———. "A New Method of Developing Autochrome Plates." *Camera Craft* 15 (1908): 353–54.

———. "Progress in Autochrome Color Work." *Camera Craft* 15 (1908): 353–54.

———. "Screen-Plate Color Photography." *Camera Craft* 15 (1908): 110–11. Opinions on development of autochromes.

———. "Simplified Development of Autochromes." *Camera Craft* 15 (1908): 215–16. Also printed in *British Journal of Photography* 56 (January 1909), Colour Photography Supplement: 5–6.

"Practical Methods of Autochrome Photography." *British Journal of Photography* 56 (April 1909), Colour Photography Supplement: 29–31.

"A Precaution in the Autochrome Process. Securing White in Autochromes." *British Journal of Photography* 54 (October 1907): 761–62.

Prilejaeff, Alexandre. "Gelbscheiben für Autochromplatten." *Photographische Mitteilungen* 48 (1911): 294–98.

"'Pyro-Reed,' révélateur spécial pour plaques autochromes." *Société française de photographie. Bulletin.* Série 2, vol. 23 (1907): 529–31.

Rawlins, G. E. H. "Persulphate v. Permanganate as the Reversing Solution for Autochromes." *British Journal of Photography* 55 (June 1908), Colour Photography Supplement: 43–44.

Raymond, R. "Paper Prints from Autochromes." *British Journal of Photography* 55 (February 1908): 97–98.

"Real Color Photography." *Outlook* 87 (1907): 238–39.

Reeb, Henri. "De l'estimation du temps de pose sur plaques autochromes." *Société française de pho-*

tographie. Bulletin. Série 2, vol. 23 (1907): 490–95.

"Reproduction of Autochromes." *British Journal of Photography* 56 (December 1909), Colour Photography Supplement: 96.

Rimmer, John Brown. "Simplified Autochrome Work." *American Photography* 14 (September 1920): 516–19. Also printed in *British Journal of Photography* 67 (October 1920), Colour Photography Supplement: 39–40.

Rockwood, George A. "Color Photography Direct in the Camera—Impressions of a Veteran Professional." *Bulletin of Photography* 3 (July 1908): 30–31. About his work with autochromes.

Roumette, Sylvain, and Michel Frizot. *Early Color Photography* (New York & Paris: Pantheon/Centre National de la Photographie, 1986). A translation of the 1985 *Autochromes*, good reproductions, flawed text.

Rypenski, M. C. "Color Photography." *American Annual of Photography for 1914* 28 (1913): 116–26. Also printed in *Illuminating Engineering Society. Transactions* 9 (1914): 579–92; *Scientific American Supplement* 79 (February 1915): 134–35.

G.S. "L'amélioration des autochromes." *Photo-gazette* 20 (July 1910): 177–79.

J.C.S. "The Autochrome Process." *British Journal of Photography* 55 (September 1908), Colour Photography Supplement: 72. Deals with sulphide toning.

Saal, Alfred. "Autochromplatten." *Jahrbuch für Photographie und Reproductionstechnik für 1910* 24: 212–15.

Scheffer, A. *Manuel pratique de photographie des couleurs par les plaques autochromes* (Paris: C. Mendel, 1909).

Scheffer, W. "Mikroskopische Untersuchungen der Autochromplatten." *Jahrbuch für Photographie und Reproductionstechnik für 1908* 22: 96–110. Also printed in *British Journal of Photography* 55

(April 1908), Colour Photography Supplement: 25–27.

————. "On the Resolving Power of the Autochrome Emulsion." *British Journal of Photography* 57 (September 1910), Colour Photography Supplement: 70–72. Also printed in translation in *Photographische Korrespondenz* 47 (1910): 588–92.

————. "La photographie des couleurs avec les plaques à réseaux colorés." *Société française de photographie. Bulletin.* Série 3, vol. 11 (1910): 70–86. Discusses different plates.

————. "Stripping Autochromes." *British Journal of Photography* 55 (November 1908), Colour Photography Supplement: 87–88.

Schmidt, Fritz, et al. *Meesterwerken der kleuren-photographie. Eene verzameling van opnamen in de natuurlijke kleuren door middel van Lumières autochroomplatten* (Leiden: Sijthoff, 1912–1913). Twelve parts in one volume; only library copy available in U.S. at New York Public Library. A similar sounding volume entitled *Farbenphoto-graphie: Eine Sammlung von Aufnahmen in na-tuerlichen Farben* (Leipzig: E. A. Seemann, n.d.), also by Schmidt, with plates in text and tipped in, twelve numbers, only ten of which were present, appeared as lot 64 in Swann Galleries' October 30, 1988, sale.

Schrott, Paul, Ritter von. "Abschwächen von Autochromplatten." *Photographische Korrespondenz* 50 (1913): 397–400. Also printed in *Société française de photographie. Bulletin.* Série 3, vol. 5 (1914): 170–71.

[Scott, Dixon.] "The Painters' New Rival: Color Photography as an Expert Sees It." *Liverpool Courier* (October 31, 1907), two-column interview. Reprinted in *American Photography* 2, no. 1 (January 1908): 13–19, as "The Painters' New Rival: An Interview with Alvin Langdon Coburn" by Dixon Scott.

Seyewetz, A. "Die Autochromplatte." *Photogra-*

phische Mitteilungen 46 (1909): 295–300, 309–12.

———. "Copies of Autochrome Transparencies." *British Journal of Photography* 57 (January 1910), Colour Photography Supplement: 1–2.

Sforza, Francis. "Autochromes and the Sterry Method." *British Journal of Photography* 56 (December 1909), Colour Photography Supplement: 95–96.

Sheahan, David J. "The Autochrome. Possibilities of Its Use as a Pictorial Medium." *American Annual of Photography for 1916* 30 (1915): 188–96.

———. "A Few Words about Autochromes." *American Annual of Photography for 1917* 31 (1916): 104–106.

———. "The Making of Autochromes." *American Annual of Photography for 1915* 29 (1914): 284–86.

Shivas, E. "The Autochrome Process." *British Journal of Photography* 55 (April 1908), Colour Photography Supplement: 32. His blacks are blue.

Simmen, Charles. "An Amidol Formula for Development of Autochromes by Inspection." *British Journal of Photography* 55 (February 1908), Colour Photography Supplement: 9–10.

———. "Nouveau procédé permettant la prise de vues instantanées sur plaques autochromes." *Société française de photographie. Bulletin*. Série 3, vol. 1 (1910): 275–78. Also printed in Série 3, vol. 2 (1911): 383–85; *British Journal of Photography* 57 (September 1910), Colour Photography Supplement: 65–66; *Photographische Mitteilungen* 47 (1910): 292–95; *Photo-gazette* 20 (September 1910): 214–18.

———. "Possibilité de développer les plaques autochromes en lumière rouge, jaune ou verte. Variation de leur sensibilité. Appréciation du temps de pose." *Société française de photographie. Bulletin*. Série 2, vol. 24 (1908): 36–43.

———. "Quelques mots sur l'hypersensibilisation des plaques autochromes." *Société française de*

photographie. Bulletin. Série 3, vol. 2 (1911): 403–406.

"Simplified Treatment of Autochrome Plates." *British Journal of Photography* 56 (April 1909), Colour Photography Supplement: 26.

Smillie, Thomas W. "Recent Progress in Color Photography." *Smithsonian Institution. Annual Report 1907* (1908): 231–37.

Smith, John H. "Printing Frame for Autochrome and Other Colour-Screen Positives." *British Journal of Photography* 56 (March 1909), Colour Photography Supplement: 23.

"Some Effects on Stale and on Fresh Autochrome Plates." *British Journal of Photography* 57 (November 1910), Colour Photography Supplement: 87.

"Some Points in the Manipulation of Lumière's Autochrome Plates." *British Journal of Photography* 54 (October 1907): 746–47.

"Spots on Autochromes." *British Journal of Photography* 55 (December 1908), Colour Photography Supplement: 95.

"Spots on Autochromes." *British Journal of Photography* 56 (January 1909), Colour Photography Supplement: 76.

"Stained Hands in Autochrome Work." *British Journal of Photography* 55 (November 1908), Colour Photography Supplement: 87.

Starr, William Ireland. "Why Not Make Color Photographs?" *American Annual of Photography for 1912* 26 (1911): 228–34.

Steadman, Frank Morris. "Color Photography with Lumière Autochrome Plate." *Camera Craft* 14 (1907): 395–400.

Steichen, Eduard J. "Color Photography." *Camera Work* no. 22 (April 1908): 13–24. Also printed in an abridged version as "Colour Photography with the Autochrome Plates" in *British Journal of Photography* 55 (April 1908): 300–302.

Stenger, Erich. "Die Autochromplatte." Illus. *Zeitschrift für wissenschaftliche Photographie* 5 (1907): 372–82.

———. "Zur Kenntnis der Autochromplatte." *Photographische Chronik* 14 (1907): 499–502, 527, 543–45, 605–607; 15 (1908): 9–11, 37–39, 137–40, 247–48, 259–61, 283–86, 360–63, 395–97, 432–35, 446–48, 569–72, 593–95, 617–19; 16 (1909): 97–99, 104–106, 132–35, 182–85, 191–93, 207–10, 317–19, 325–27, 433–37, 469–71, 481–83, 577–80; 17 (1910): 9–13, 259–61, 283–85, 331–34, 367–70, 515–18, 527–29; 18 (1911): 25–26, 35–37, 46–49, 206–208, 264–66, 307–308, 315–16, 331–32. Continuing review of what is known about the autochrome plate.

Stenger, Erich, and Ferdinand Leiber. "The Preparation of Paper Prints from Autochrome Plates by Means of the Leuco Bases." *British Journal of Photography* 55 (May 1908), Colour Photography Supplement: 34–35.

"Stereoscopic Autochromes." *British Journal of Photography* 56 (August 1909), Colour Photography Supplement: 59.

Stieglitz, Alfred. "Formalin for Obviating the Frilling of Autochrome Plates." *British Journal of Photography* 55 (July 1908), Colour Photography Supplement: 53–54.

———. "The New Color Photography—A Bit of History." *Camera Work* no. 20 (October 1907): 20–25. Reprinted in Jonathan Green, ed., *Camera Work: A Critical Anthology* (Millerton, N.Y.: Aperture, 1973), pp. 124–29.

Streissler, Alfred. "Ein neues Raster für die Farbenphotographie der Gebr. Lumière." *Photographische Welt* 23 (August 1909): 121–22.

"The Success of Color Photography." *The Craftsman* (March 1912): 687. Discusses major autochrome exhibition including work by Genthe, Falk, A. H. Lewis, H. H. Pierce, S. L. Stein, Frances B. Johnston, and F. J. Sipprell.

Szczepanik, Jan. "Protective Varnishes for the Autochrome Plate." *British Journal of Photography* 56 (June 1909), Colour Photography Supplement: 48.

———. "Transformation Photographs on Auto-chrome Plates." *British Journal of Photography* 55 (October 1908), Colour Photography Supplement: 80.

[Tennant, R. Dixon.] "Exhibition of 'Autochrome' Photographs." *Wilson's Photographic Magazine* 44, no. 611 (November 1907): 483–84.

Thieme, Paul. "Autochrom-Aufnahmen auf Reisen." *Photographische Mitteilungen* 46 (1909): 81–84. Also printed in *British Journal of Photography* 56 (May 1909), Colour Photography Supplement: 40.

———. "Autochromaufnahmen bei natürlichem un künstlichem Licht." *Photographische Rundschau* 49 (1912): 135–37.

Thovert, J. "Instantaneous Exposures on the Autochrome Plate." *British Journal of Photography* 56 (July 1909), Colour Photography Supplement: 52–53.

———. "Sensibilisation de plaques autochromes: influence de la qualité de l'éclairement sur la reproduction photographique des couleurs." *Société française de photographie. Bulletin.* Série 3, vol. 2 (1911): 379–81.

Tilney, F. C. "Where We Stand in Pictorial Colour Photography." *British Journal of Photography* 55 (September 1908), Colour Photography Supplement: 66–68. A major critique of Charles Holme/Dixon Scott, *Colour Photography and Other Recent Developments of the Art of the Camera*, Special 1908 Summer Number of *The Studio*.

"The *Times* on Colour Processes." *British Journal of Photography* 54 (September 1907): 718. Account of autochrome exhibition.

Tobler, Friedrich. "Einige Erfahrungen bei Autochromaufnahmen in den Tropen." *Photographische Rundschau* 50 (1913): 297–300. Also printed in *British Journal of Photography* 61 (April 1914), Colour Photography Supplement: 16.

Toch, Maximilian. "The Lumière Color Process Simplified." *American Photography* 3 (May

1909): 274–78. Also printed in *Photo-Era* 23 (July 1909): 20–23.

———. "The Simplified Autochrome Process." *American Annual of Photography for 1910* 24 (1909): 245–46.

Toni, S. *I Lumière all'alba del colore: gli autocromi Lumière e i primi autocromisti* (Bologna: Dineteca del Comune di Bologna, 1982).

Torchon, Paul. "A New Method of Developing Autochrome Plates." *Bulletin of Photography* 3 (August 1908): 117–18. Also printed in *Photo-Era* 21 (November 1908): 222–23.

Valenta, Eduard. "Über die Autochromeplatte." Illus. *Photographische Korrespondenz* 45 (1908): 24–29.

———. "Zur Kenntnis der Autochromplatten." *Jahrbuch für Photographie und Reproductionstechnik für 1908* 22: 143–45.

Vallot, Émile. "Hypersensibiliation des plaques autochromes." *Société française de photographie. Bulletin.* Série 3, vol. 2 (1911): 389–91. Also printed in *Photographische Mitteilungen* 48 (1911): 369–71.

Vidal, Léon. "The Lippmann and Lumière Processes." *British Journal of Photography* 53 (February 1906): 125–26.

Vies, Guilliam de. "Autochrome Work in Tropical Africa." *Amateur Photographer and Photography* 49 (March 1920): 236.

Wall, Edward John. "A Diagrammatic Explanation of the Autochrome Process." *British Journal of Photography* 55 (July 1908), Colour Photography Supplement: 55–56.

———. "The Lumière Autochrome Plate." *Photographic News* 52 (July 1907): 63.

———. "The Lumière Autochrome Plates." *British Journal of Photography* 54 (August 1907), Colour Photography Supplement: 57–58.

———. "A Review of the Exhibition." *British Journal of Photography* 54 (October 1907), Colour Photography Supplement: 73–75. Mentions

two of Warburg's autochromes and excellent work by a Mr. Wilwar.

———. "The Society of Colour Photographers' Exhibition." *British Journal of Photography* 55 (June 1908), Colour Photography Supplement: 41–42.

Wallace, Robert James. "The Autochrome Plate." *Popular Astronomy* 16 (1908): 83–91.

Wallon, Étienne. "Autochromie et trichromie." *Société française de photographie. Bulletin.* Série 2, vol. 24 (1908): 381–402. Also printed in *Photo-gazette* 19 (December 1908): 23–30.

———. "L'oeuvre de Louis Lumière." *Société française de photographie. Bulletin.* Série 3, vol. 8 (1921): 225–49. Pages 237–41 deal with color work.

———. "Paysages autochromes." *Photo-gazette* 17 (October 1907): 221–25.

———. "Photographie des couleurs." *Photo-gazette* 14 (September 1904): 205–11.

———. "La photographie des couleurs et les plaques autochromes." *Société française de photographie. Bulletin.* Série 2, vol. 23 (1907): 336–58.

———. *La photographie des couleurs et les plaques autochromes; conférence faite devant la Société française de photographie le 27 juin 1907, par E. Wallon; suivie d'une Notice sur le mode d'emploi des plaques autochromes par MM. Lumière.* Paris: Gauthier-Villars, 1907. A 39-page pamphlet.

Warburg, J. C. "Autochrome Prices—A Protest." *British Journal of Photography* 56 (May 1909), Colour Photography Supplement: 40.

———. "Monsieur Meys' Autochrome Pictures." *British Journal of Photography* 55 (May 1908), Colour Photography Supplement: 33–34, 48. On exhibition at Cannes.

———. "Possibilities in Colour Photography." *Photographic Journal* 47 (April 1923): 192–96. On autochromes by Warburg and H. C. Messer.

Ward, John J. "A Remedy for Flat Autochromes." *British Journal of Photography* 55 (January 1908): 8.

Waterhouse, James. "The Photographic Work of Messrs. A. Lumière et ses fils, of Lyons." *Photographic Journal* 33 (March 1909): 143–45.

Watkins, Alfred. "The Light Filter in Autochrome Photography." *British Journal of Photography* 55 (December 1908), Colour Photography Supplement: 96.

———. "A Simple Autochrome Method." *British Journal of Photography* 55 (October 1908), Colour Photography Supplement: 73–74. Also printed in *Bulletin of Photography* 3 (November 1908): 293–96; *Photo-Era* 22 (February 1909): 83–89.

Wentzel, Volkmar K. *Autochrome: The Vanishing Pioneer of Color* (Washington: National Geographic Society, 1980). Checklist to accompany Library of Congress autochrome exhibition.

Wentzel, Volkmar, and Peter Krause. *Abstract National Geographic Society Autochrome Preservation Pilot Project July 1981–July 1982.* The only conservatorial study of the autochrome.

Weston, A. W. H. "Autochromes in the Reception Room." *British Journal of Photography* 62 (June 1915), Colour Photography Supplement: 21–22.

Wilcox, Walter Dwight. *Autochrome Photography: A Paper* (Canada: American Alpine Club, 1920).

Wolf-Czapek, Karl Wilhelm. "Einige Beiträge zur Autochromphotographie." *Photographische Korrespondenz* 44 (1907): 461–64.

———. "Einige Versuche mit der neuen Autochromplatte." *Photographische Chronik* 14 (September 1907): 447–48.

Worel, Karl. "Das Verfahren mit den Autochromplatten der Gebrüder Lumière." *Jahrbuch für Photographie und Reproductionstechnik für 1908* 22: 49–53.

Wychgram, Engelhard. "Autochrom Tierphotographie an der Nordsee." *Photographische Rundschau* 50 (1913): 229–31.

X. "La reproduction des couleurs des photographies en couleurs." *Photo-gazette* 20 (January 1910): 46–49. Gimpel and Villain explain their methods.

"A Year of Colour Photography." *British Journal of Photography* 54 (December 1907): 918–19.

"Zeiss Autochrome Accessories." *British Journal of Photography* 55 (January 1908): 30–31.

"Zur Entwicklung der Autochromplatten." *Photographische Mitteilungen* 46 (1909): 347–48.

ABOUT THE AUTHOR

John Wood is professor of English and director of the Master of Fine Arts Program in Creative Writing at McNeese State University in Lake Charles, Louisiana. His *The Daguerreotype: A Sesquicentennial Celebration* (University of Iowa Press, 1989) won the American Photographic Historical Society's 1989 Photo History Book Award for the outstanding book of the year. His subsequent *America and the Daguerreotype* (University of Iowa Press, 1991) is serving as the basis of a major exhibition of daguerreotypes at the Smithsonian Institution's National Museum of American Art. His poems and essays have appeared in a variety of journals.